WILD FLOWERS · A SKETCHBOOK

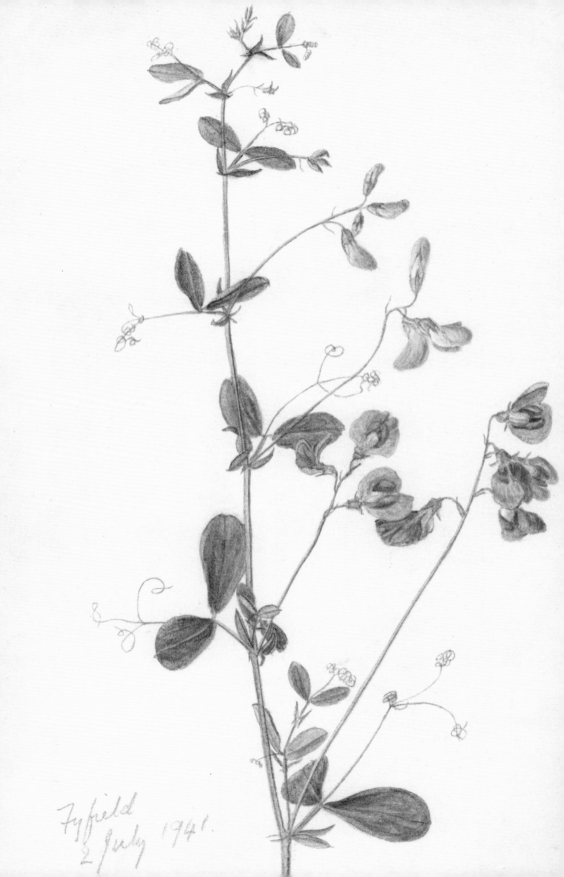

Fyfield
2 July 1941.

Wild Flowers
a sketchbook

BY CHARLES AND
JOHN RAVEN

Edited by H.J. Noltie

Royal Botanic Garden Edinburgh
MMXII

For Mary Raven
on the occasion of her centenary

Published by the
Royal Botanic Garden Edinburgh, 2012
20A Inverleith Row, Edinburgh EH3 5LR

www.rbge.org.uk

ISBN 978 1 906129 85 9

Designed by Dalrymple
Typeset in Juliana and Verdigris
Printed in Belgium by die Keure

Frontispiece: *Lathyrus tuberosus*,
earth-nut pea. Fyfield, Essex, 2 July 1941.
[C·E·R]

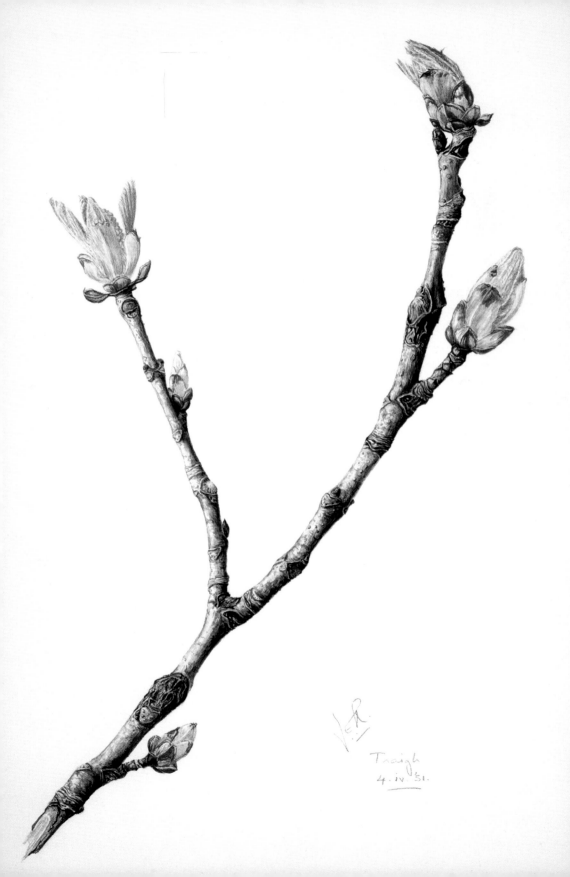

Traigh
4. iv. 51.

Preface

I am delighted to write a preface to this book. For many years I have been enthusiastic that the text and some of the watercolour paintings by my husband, John Raven, and his father, Charles Raven, should be published. It was their great wish that this should be achieved. It is a record of a project that they enjoyed doing together. They hoped it would increase general interest in the British flora and it reminded them of happy days hunting for plants, common as well as rare, during family holidays. All the driving for the search was done by the female members of the family so we include them in the dedication. My husband also painted some more 'set pieces' of the twigs of British trees in early spring and we include one of the horse chestnut, which he gave me for my twenty-first birthday.

Many problems have had to be overcome in the intervening years and it is due to the willingness of the Royal Botanic Garden Edinburgh to undertake the publication, and to the skill and energy of Henry Noltie that this has finally been achieved.

FAITH RAVEN

Horse chestnut, Traigh, Morar, Inverness-shire,
watercolour by John Raven, 4 April 1951

ISOETACEÆ.

Isoetes Hystrix.

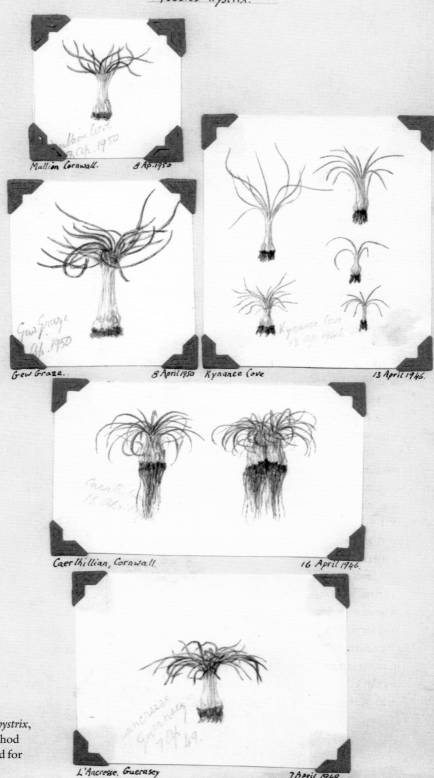

[Fig.1]
Drawings of the quillwort *Isoetes hystrix*, showing the method of mounting used for the collection

H. J. NOLTIE

INTRODUCTION

If not born a collecting maniac, I was infected in infancy.
C.E. Raven, *Memories and Musings*, 1931

*The exact reproduction in shape and colour of innumerable plants
and flowers was a means, more satisfying even than photography,
of retaining the delight of the initial vision.*
F.W. Dillistone, *Charles Raven: naturalist, historian, theologian*, 1975

APPEARING SEVENTY YEARS AFTER ITS CONCEPTION, THIS BOOK
concerns a remarkable family, above which towers the figure of Charles
Earle Raven (1885–1964) 'one of the outstanding figures in Church and
University circles of the twentieth century' [fig.6]. The work of two commit-
ted pacifists, it was conceived by Charles's son John in an East-end mission
house, as a solace from the depths of a war-torn London and can, in some
ways, be seen as a latter-day supplement to the four immensely popular
books on birds that Canon Raven wrote in the 1920s. As related in chapter
one, the illustrations began as a family project to keep the children – Mary
(b. 1912) and Betty (1913–2010), John (1914–1980) and Peg (1918–1997)
[figs 2–5] – usefully occupied during a series of vacations (still recalled with
pleasure by Mary) in what seems like another world – the Co. Cork of 1930,
where for six years Charles took the locum tenancy of various deeply rural
parishes as a means towards an economical August holiday. Charles was
a man of quite phenomenal ability and energy: classicist and theologian,
preacher and author, naturalist and historian of science, lecturer and
university administrator, ardent pacifist and amateur artist. Underlying all
of these was the passion of a collector, applied consecutively to birds, lepi-
doptera (especially moths) and, latterly, vascular plants (from 1951 to 1955
he served as president of the Botanical Society of the British Isles). What
started as a family project was taken over by Charles and John in collabora-
tion – ambitiously expanding the field to paint every British flowering plant
and fern. John's contribution, as the more active of the two, was largely the
obtaining of specimens from far-flung localities. Also a remarkable figure
in terms of presence John carried on several of his father's interests – nota-
bly the Classics, pacifism, university research, teaching and administration
and, perhaps above all, what he called 'field botany'. The idea of the 'words'

[Figs 2–5] *clockwise from top left* Mary, Betty, John and Peg Raven, photographed *c.*1930 by Chidley, Liverpool

for *Wild Flowers* came from John (Appendix), and it is the combination of text and image – a selection from the vast corpus of drawings linked with the story of their creation – that justifies this book's belated appearance. As well as being seen as a posthumous supplement to Charles's popular natural-history writings, it can also be seen as following John's notable contributions to the genre – his *Mountain Flowers* of 1956 (written with his friend Max Walters and dedicated to Charles) and *A Botanist's Garden* of 1971.

This is not the place, were the author qualified to do so, to enter deeply into biographical details of either man, fascinating though such a dual study would be. But it is necessary to give some outline of the factors that made *Wild Flowers: a sketchbook* possible. There are two key sources: a hefty biography of Charles by Frederick William Dillistone (1975); and a memorial collection of essays concerning John edited by his brother-in-law John Lipscomb, and his angling and sedge-loving friend R.W. ('Dick') David (1981).

CHARLES EARLE RAVEN [C·E·R]

The Dillistone biography is worthy but hard-going – the work of a professional theologian, and therefore concentrating at tedious length on Raven's theological thought and writings, in which the human element is given short shrift and becomes completely submerged; though the loneliness and sense of exclusion often felt by his subject is addressed. (Raven's passionately held opinions, for example on pacifism, and antagonism to contemporary Germanic (Barthian) theology, led to a certain academic isolation. The charismatic personality and showmanship, which lay behind his outstanding gifts for preaching and broadcasting, doubtless fuelled suspicion from green-eyed, conservative elements within the Anglican hierarchy, and resulted in his lack of preferment within the Church of England). The underlying theme to the beliefs that underpinned Charles's life appear to have been his deep loathing of anything that smacked of dualism, and the need to incorporate the findings of modern science (including Darwinian evolution, and the Mendelian genetics that he studied under William Bateson) into his belief in a Creator whose highest achievement was manifest in human 'personality', and which reached perfect expression in the figure of Jesus Christ who was to be seen not as an historical figure, but as an active, living and inspiring presence. Raven's love of nature, its study and depiction, was part of this belief system, which also lay behind his pioneering work in the field of the history of science – an investigation of the period leading up to that in which Science and Religion were seen to diverge, and a major biographical study of his hero John Ray, who gloriously managed to

keep the two views within one framework; it also led to Charles's pleasure, as Vice Chancellor of Cambridge, in installing Jan Christiaan Smuts, who held similar beliefs in an holistic view of life, as Chancellor of his beloved university in 1948.

From 1932 to 1950 Charles was a fellow of Christ's College, serving as Master from 1939; among the most distinguished alumni of the college were the Cambridge Platonist Ralph Cudworth in the seventeenth century and Charles Darwin in the nineteenth, both of whose work Raven greatly

[Fig.6] Charles Earle Raven, photographed *c.*1960, by Ramsey & Muspratt, Cambridge

admired. But the 1930s was also an interesting period at Christ's. Dillistone pointed out that 'it must be without parallel … that within one College there should have been three men, each distinguished in his own subject … and yet at the same time displaying outstanding talent in a quite different area of scientific or artistic competence'. The other two were Charles Percy Snow (1905–80) and Conrad Hal Waddington (1905–75). C.P. Snow was a physicist and novelist; he and Charles heartily disliked each other and the story of the 1936 election at Christ's (in which Charles was unsuccessful at his first attempt) is fictionalised in *The Masters*. Snow also famously wrote on the 'two cultures' of the humanities and sciences, and the need for a reform of the education system that led to the damaging split between them. In fact thirty years earlier Charles, in his *A Wanderer's Way*, had made a critique along exactly the same lines – how science was not only neglected, but despised, in the more traditional of the public schools. For Charles the problem was not only the resulting ignorance of science (which he felt as a personal handicap), but the effect of leaving religion entangled with archaeology: 'to give us God in terms of Sinai and Olympus rather than of evolution and experience, and to suggest that Jesus belonged only to the world of the first century'. Waddington as a zoologist combined major work in the field of developmental genetics with a deep appreciation, and subtle analysis, of advanced contemporary painting from Cubism onwards, and its relation to contemporary developments in the physical and natural sciences and in philosophy. The significance is therefore greater than Dillistone's surprise at the three being active in disparate fields: all were concerned with the connections between their two specialisms. In Snow's case how a strictly Classical education led to a diminished world view (with severe practical consequences), and in Waddington's how advances in science were mirrored (if not always consciously or deliberately) in the work of artists. Like Raven they were interested in a more holistic view of life, in breaking down artificial boundaries and seeing connections, which is as relevant now as it was in the 1930s.

Charles's views on art were deeply conservative and in Chapter 1 he is typically frank about his own taste (though calling on the Führer as a witness for the defence of his traditionalism comes as something of a shock from a Christian pacifist). As a child Charles had been taught to sketch in watercolour by his mother Alice Comber, and he painted landscapes and detailed studies of birds [fig.8] before launching on his ambitious project to illustrate the British flora. As he also explains, the paintings were made in moments snatched from a hectic schedule, which accounts for the fact that he did not always have time to take the care seen in the best of the works.

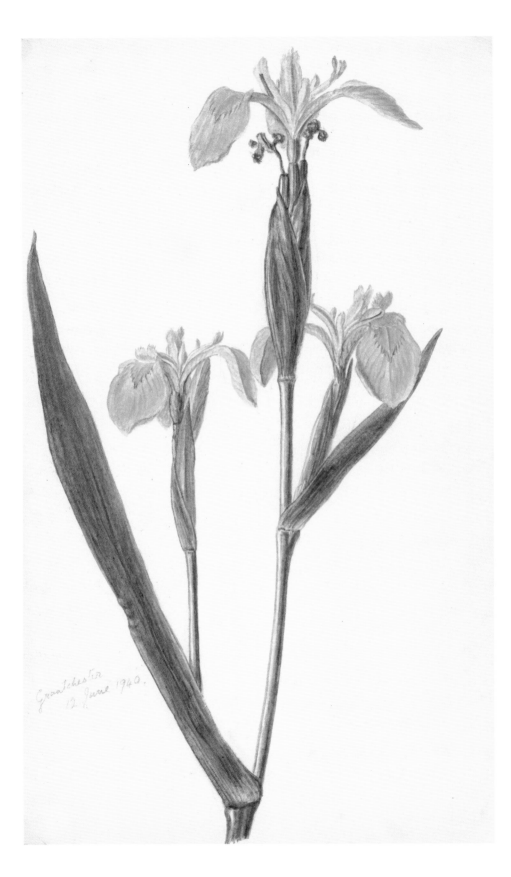

Grantchester
12 June 1940.

It is harder to find a similarly strong underlying life-theme or belief system for John, unless it is his passion for botany. The traditional education dictated by his family led not to the Church or the Law as in the three previous generations, but to an academic career in the Classics and major contributions in the field of ancient Greek philosophy. As the First World War had interrupted Charles's career, so did the Second for John. Whereas Charles experienced the horrors of the trenches at first-hand as an army chaplain, leading, from around 1930, to passionate advocacy of pacifism, for John this belief came from theoretical principles – that war, and the taking of life, could under no circumstances be justified. His own form of national service as a conscientious objector (which lies behind this book) was in the form of social work based at Oxford House, Bethnal Green. After the war Cambridge called him back and he pursued a career as an influential lecturer and tutor. He started as a research fellow at Trinity in 1947; the following year he moved to King's and combined a Fellowship with a University Lectureship, giving inspiring lectures on Ancient

[Fig.7] *Iris pseudacorus*, yellow flag, watercolour by Charles Raven
[Fig.8] Drake gadwall in flight, watercolour by Charles Raven

Greek Philosophy, especially Socrates and Plato, and working for the successful reform of the content of the Classical Tripos. While finding the act of lecturing nerve-racking to the point of nausea, these lectures were extremely popular, delivered from a script that was marked as if it were a musical score. Of related publications the 1957 textbook *The Presocratic Philosophers*, with Geoffrey Kirk, was perhaps the most significant, and the later *Plato's Thought in the Making* (1965) a valuable introduction to the subject. At King's John was College Lecturer as well as Lay Dean in charge of discipline and then Senior Tutor in charge of admissions, in which he played an important role in broadening the range of schools from which undergraduates were recruited.

John's humanity and sense of humour were the foundation of his popularity with undergraduates, expressed in the hospitality given with his wife Faith (whom he married in 1954) at their beautiful house, and the garden they jointly created, at Docwra's Manor, Shepreth and at Faith's family estate of Ardtornish. But as his interest in academic classicism gradually waned, John's interest in botany waxed. Despite the lectures on Greek botany that he gave in 1976, he seemed unable to combine his two great interests in a seriously scholarly way and to do what, in his father's generation, Sir D'Arcy Thomson had done for Greek zoology. But John's botanical interests were less analytical – stemming from what he himself described as a 'mystical' feel for vegetation. (Faith has described him as an artist without a medium, and it was plantsmanship and gardening that most nearly approached such). Inheriting strong collector's genes, John loved the thrill of the chase for particular plants (including, but not exclusively, the rare), and the feel for why a plant grew in a particular place: his eye for beauty and sense of place led to remarkable powers of observation and prediction. This cannot in truth be called ecology, he was uninterested in scientific analysis – the best label for his approach is that of the 'botanophil'. His botanical identification skills, and willingness to spend time in the herbarium, were certainly far greater than those of his father (while happy to skewer moths, Charles despised the herbarium specimen: 'the pressed plant is a monstrosity').

Those who knew John speak of his generosity in the sharing of knowledge and of his gift for friendship – and these shine out from his two botanical books. Inevitably he took pleasure in passing on of a love of British plants to his own children, especially Anna and Sarah. It was not only attention to detail in botany but John's appreciation of art, as acknowledged by his father in Chapter 1, that went far deeper than Charles's. This revealed itself not only in John's technique as a botanical draftsman, but

as honorary curator of the Broughton Collection of botanical paintings at the Fitzwilliam Museum, Cambridge, the cataloguing of which, and selection for a series of exhibitions, brought pleasure in his last years.

'THE COLLECTION'

The start of the collection of botanical drawings, and some of the methods by which it was achieved, are described in Chapter 1, but a little more needs to be added. Ambitious though the scheme may seem the Ravens were not the first, nor are they likely to be the last, to make such a collection of drawings of the British flora. Between 1784 and 1816, Lady Louisa Finch, Countess of Aylesford, made a collection of 2830 such drawings (collected in 25 volumes, now sadly dispersed), and at the same time the Sowerby family undertook similar work specifically for publication, as would Stella Ross-Craig in the twentieth century. In salerooms and antiquarian bookshops one occasionally comes across at least parts of similar sets made by nineteenth-century ladies, and then there was the Rev. William Keble Martin (1877–1969). Martin's project was remarkably similar to that of the Ravens and was being undertaken simultaneously, though as a busy parish priest without the benefit of long vacations, it took him about twice as long. Keble Martin, who was only eight years Charles's senior, was a pupil at Marlborough (as later was John), where curiously one of his best friends was called Hugh Raven (apparently not related); he then went to Christ Church, Oxford where, in addition to Greek philosophy and church history, Keble Martin studied botany under Sydney Vines and had the benefit of learning to draw under that most meticulous of botanical artists Arthur Harry Church. Keble Martin's project was more consciously artistic, individual drawings being used as the basis for exceptionally decorative composite plates captioned with attractive calligraphy. An imaginative publisher, George Rainbird (and the support of the Duke of Edinburgh), made the publication of the collection in 1965, when Keble Martin was 87, a richly deserved triumph and a huge commercial success, though it was one of the dampers on any idea of a similar publication of the Raven drawings.

Such drawings were all *de novo*, made from nature, but a common pursuit in the first part of the twentieth century for amateur botanists with more modest artistic ambitions was that of colouring-in their copies of 'Bentham & Hooker'. Prior to 1952 this (and to a slightly lesser extent the multiple editions of Babington's *Manual of British Botany*) was the standard guide for the serious student of British plants. The second edition (1865) of Bentham's original *Handbook of the British Flora* was illustrated in the text

with exquisite miniature wood engravings by Walter Hood Fitch. Later editions were revised by Sir Joseph Hooker who assumed (posthumous) joint-authorship and under his aegis, in 1880, the wood engravings were printed in a separate volume of *Illustrations* four to a page (with additional plates by William Gardner Smith). To the last (1924) edition of this pair of volumes a supplement was added in 1930, with full-page illustrations by Roger Butcher and Florence Strudwick, the *Further Illustrations* described by the Ravens as the 'Supplement' to 'B & H'. Faith has described how her Owen Smith aunts painted their copies, and encouraged their nieces to follow suit. The Ravens were more independent, and used the text as a guide to which species to paint – the number was more or less manageable, as very few introduced plants are included, and even with the *Further Illustrations* it was by no means a 'critical' Flora. In total the Ravens painted 2109 species (of which 228 were hawkweeds); starting the task today would be a rather more formidable undertaking, as in today's standard Flora,

[Fig.9] *Salix caprea*, great sallow, watercolour by Charles Raven

[Fig.10] *Carduus arvensis*, creeping thistle, watercolour by Charles Raven

Clive Stace's *New Flora of the British Isles* are no fewer than 4800 species (and this excludes the nearly thousand microspecies of dandelion, bramble and hawkweed now recognised – the inflation being accounted for by the huge number of exotic species now treated as part of Britain's flora).

In painting the main protagonist came to be Charles, but the role of the children should not be forgotten. Peg was the one who started the project, aged 12, and it is good to be able to include here her sea holly, rejected from the final 'master set', but unearthed from the Docwra's attic. She went on to study art at Cambridge Art School then at the Euston Road School, and continued to paint (landscapes) all her life. Mary drew the outlines of some of the early works, though insists that she never did any of the colouring. The ones that bear her initials 'MER' (about 40) can be assumed to have been coloured by 'Pa'. After her mother's death in 1944 Mary's support of her father, not only as chauffeur, but as a lively hostess for him at Christ's then at Madingley Hall, must have been a major factor in allowing him time to complete the project. John's contribution started with colouring Mary's outlines (17 drawings are signed 'MER & JER'), but even as a schoolboy his distinctive style began to emerge. Though his approximately 60 works form only a small fraction of the total (excluding the hawkweeds there are some 3541 drawings between the main set and a 'reserve' collection); these are recognisable not only by their style, but John's dating using Roman numerals for the month. Betty seems to have taken no role in the project other than as a companion on field excursions; her interests tended towards the more energetic – butterflies, birds (helping Charles with his pioneering bird photography) and sport (achieving half-blues in both tennis and hockey while reading Modern Languages and Arabic at Girton). The understated supporting role of Bee, as mother and wife, will be discussed later.

The life-size drawings, which range from about $1\frac{1}{2} \times 1\frac{1}{2}$ to $12 \times 7\frac{1}{2}$ inches, were made on good watercolour paper, then cut out (with minimal margins) and attached to regrettably poor backing sheets (8×13 inches) by means of distracting, dark brown adhesive corners [fig.1]. The sheets were filed in a series of forbidding black ring binders, of which the rings had a tendency to rust. The contrast, in matters of presentation, with the care taken by Keble Martin is striking, but a benefit of the amateur mounting method is that the drawings were easily extracted for photography for reproduction in this book. Plants would often be drawn a second or third time and mounted where earlier, unsatisfactory, works had been removed (though not always their captions, so that the inscriptions do not always refer to the drawing now on the sheet). The old binders have now been dispensed with and the twenty volumes of the main sequence (and two of

hawkweeds) rehoused – the original backing sheets retained, but placed in transparent 'mylar' sleeves, in modern archival quality cardboard boxes with ring binders that will not corrode.

SOME HISTORICAL & BIOGRAPHICAL BACKGROUND

Details on particular points raised by the text are supplied in the form of Endnotes, but a few more general points require to be made here. The setting of chapter one, 'Beginnings', is Liverpool, whither, following an unsatisfactory and constraining time as a parish priest (at Bletchingley, Surrey), Charles took his young family in 1924 [fig.11]. Already a Royal Chaplain, he was appointed a Canon of the great cathedral being raised to the design of Giles Gilbert Scott, but then consisting only of the chancel and eastern transept. He started the Liverpool job in time for the consecration service in the presence of George V and for his last two years Charles served as Chancellor of the diocese. Despite immense hard work there was time to pursue hobbies of 'birding' and 'mothing' in environs he had known from childhood holidays. His biographer Dillistone considered the eight Liverpool years to be the 'happiest years of his life', though from comments in chapter three of the present work this seems to be stretching a point; Mary remembers that even if the job had its satisfactions for her father, her mother was out of place and unhappy in an industrial metropolis. This was the period of the first six Irish holidays in Co. Cork. Marlborough school-days form the background to chapter two – John's account of the pursuit and recording of the orchid family. He went as a foundation scholar in September 1928, winning an open classical scholarship a year later. The strikingly close family bonds were maintained, with the family visits to the school recorded in the text and on some of the drawings.

Charles's recall to Cambridge (which, with a characteristic note of martyrdom, had ended chapter one) is celebrated at the start of chapter three with a paean of praise to the city he loved, and which would be a base for the rest of his life. The connection with the great cathedral of the fens came about because in 1932 the Cambridge Regius Chair of Divinity was linked to a residentiary canonry at Ely. So the romantically mediaeval Prior's House in the Close became the family home [fig.12], despite the problem of Bee or Mary having to drive 'Pa' between Ely and Cambridge twice or thrice daily (he did once try to learn to drive, but a close encounter with some railings ensured that the experiment was not repeated). Charles had been elected to a fellowship at Christ's in 1932 and when, at a second attempt, he was elected as its Master in 1939 the family moved to the Master's Lodgings, with its fine garden; it was here that war-time

fire-watching duties in the small hours allowed time for the massive task of researching and writing his authoritative biography of John Ray.

Given John's later fondness for the family Umbelliferae revealed in *A Botanist's Garden* it is noteworthy that at this point it was not among his favourites. So it was Charles who wrote chapter four, which takes the depiction of the family as an exemplar, with its somewhat daunting analysis of

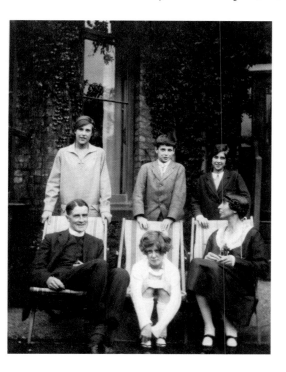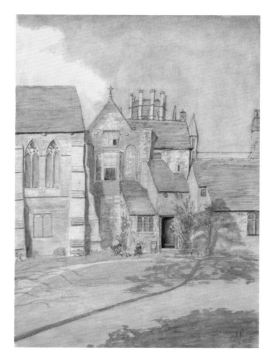

[Fig.11] The Raven family at Parkfield Road, Liverpool, c.1925

[Fig.12] The Prior's House, Ely, watercolour by Charles Raven, 21 March 1935

the improving uses to which leisure hours can be put by those capable of fanatical dedication. The 1935 Silver Wedding trip to Teesdale, written by John as chapter five, calls for little by way of comment, though as with other choice botanical localities this chapter was by no means the end of the story as some treasures were left for subsequent visits. One of the fascinations of the collection is the window it allows, from the annotations of dates and localities on the drawings, on the life and travels of the Raven family – not only holidays, but visits to family members, and places where sermons were delivered or retreats led. In the case of Teesdale subsequent visits were made in 1936, 1941, 1946, 1947 and 1948. Likewise, although the account

of Ben Lawers given in chapter six refers specifically to the years 1935 and 1937, the botanist's paradise was revisited in the years 1945, 1947, 1949 and 1951, to mop up and delineate those final elusive sedges and hawkweeds.

For the Ravens Glen Trool [fig.13], the subject of chapter seven, was linked with the Russell family. Hastings Russell (1888–1953), as Marquess of Tavistock, was a close friend of Charles. They met over the influential Conference on Politics, Economics and Citizenship (COPEC) held in Birmingham in 1924, for which Tavistock was a committee member and Charles a joint secretary. Tavistock (from 1940 12th Duke of Bedford) was also a committed pacifist and shared the ornithological interests of his mother the 'Flying Duchess'. Charles had a knack for 'getting people to be nice to him', and this is a case in point. Though Charles was close friends both of Tavistock and of the 10th Duke of Devonshire (High Steward of Cambridge, who shared Charles's botanical interests), it was not so much a case of snobbery, and he was doubtless sincere in an oft-repeated statement that he would be 'content to spend eternity in the company of a working-class moth collector' of the sort he encountered in Liverpool. Nonetheless the placing of a fully staffed Glen Trool Lodge at the disposal of the family for the whole of each August from 1931 to 1938 (with the exception of 1932), when the children learned to shoot grouse and fish for salmon and trout, was a much appreciated gesture.

Galloway is a rich area botanically – from the cliffs of the Mull of

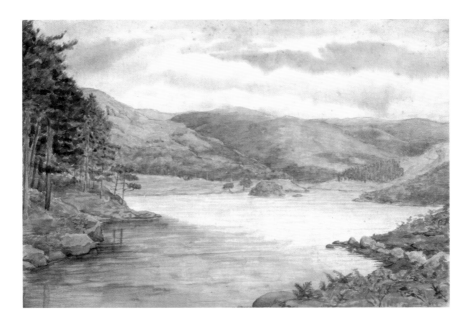

[Fig.13] The head of Loch Trool, from the shore opposite the Lodge, c.1935. [C·E·R]

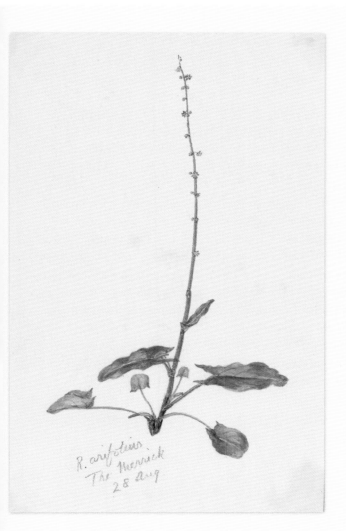

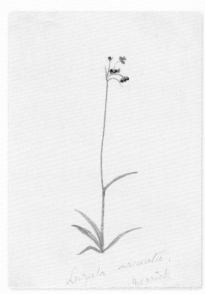

[Fig.14] *Rumex arifolius* (left) and *Luzula arcuata* (right), watercolours by Charles Raven

Galloway to the near-Munro summit of the Merrick (2764 feet). It was the latter that yielded the two most surprising records in the whole of this book: *Luzula arcuata* and *Rumex arifolius* [fig.14]. The curved woodrush is a diminutive plant of exposed summit plateaux of the higher mountains of central and north-western Scotland: its nearest confirmed site is Ben Nevis, some 115 miles due north of the Merrick. John discussed this record and

the drawing, which he finally came to doubt, in *Mountain Flowers* (p. 122). I have recently revisited the site, and there is an extremely small area of fairly suitable habitat on the summit. But although the least willow (*Salix herbacea*) is present and would be a suitable companion, there is none of the *Juncus trifidus* that almost always accompanies the woodrush further north. It will remain a mystery, but – just perhaps – the plant was there for a brief period that happened to be recorded by the Ravens, transported in the crop of a migrating dotterel that stopped for a breather on its way to or from the Cairngorms? The sorrel (now known as *Rumex alpestris*) is a widespread species of Fennoscandia and the mountains of central and southern Europe, for which there is only a single British record. This is from 2900 feet on Lochnagar, and was made in 1923 by the colossus of early twentieth-century British field botany, George Claridge Druce, owner of a pharmacy shop on the High and one-time Lord Mayor of Oxford. This record is the only indication that the Ravens had anything to do with the Botanical Exchange Club (the web through which Druce operated), as the name can only have been suggested to Charles by the Lochnagar record in the Club's

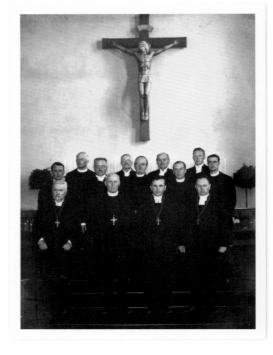

[Fig.15] The Helsinki conference. Charles Raven stands on the extreme right, Bishop Aleksi Lehtonen is second from right in the front row. Photographed by Neittamo, 1934.

annual report. John Akeroyd, the current expert on the genus, has kindly looked at the drawing which he identifies (as with Druce's specimen) as only a form of the widespread and variable common sorrel (*Rumex acetosa*).

The background to Charles's visit to Finland described in chapter eight (and curiously overlooked by Dillistone) was a conference on intercommunion between the Church of England and the Evangelical Lutheran Church of Finland held on 17 and 18 July 1934 on the island of Brändö [fig.15]. This chapter is the only one to have been previously published, the 'manuscript' being a series of annotated cuttings from a printed periodical. It has not yet been possible to identify the publication, but, from a

[Fig.16] *Bromus sterilis*, watecolour by Charles Raven

Fen Drayton
15 Oct '48

list of contributors on one of the pages, it had quakerish/pacifist leanings and dates from during or immediately after the war. Its published status accounts for the fuller and more polished style as compared with the other essays included here and is a good example of Raven's fluent writing – with its surreal account of an episcopal sauna bath; and its account of a friendship across generations that could probably not be written in such a frank and innocent voice today. Despite the non-British setting the chapter had to be included here – not only for the quality of the writing, but because, as Charles noted, much about Finland, not least many of its plants, appeared to him to be very Scottish. With the horror of identifying individuals typical of a more formal era ('to introduce living people except anonymously would have been an outrage'), names are scrupulously avoided. The bishop with whom Charles stayed at Vihti can now be identified as Aleksi Emanuel Lehtonen (1891–1951) who in 1934 had only recently become Bishop of Tampere. The young Samuel (1921–2010) followed his father's footsteps into the Finnish church ending up, from 1982 to 1991, as Bishop of Helsinki.

In 1938, the family had toured the west and south-west of Ireland for the first time since Goleen days, but returning in August 1939 they can have had only an uneasy fear that the holiday might come to the abrupt end described in chapter nine. Charles's profoundly moving account of the outbreak of war, as seen from the western fringes of Europe, provides a powerful demonstration of one of the motivations for making the drawings. It is not only a catalogue of spoils of the hunt: the images contain the power to recall the moment of their creation – often perhaps no more than a beautiful place or the delights of companionship: here the horror of approaching war. One can imagine the red veins of the translucent pondweed, *Potamogeton coloratus* [107], as almost literally suffused with the blood that was about to be shed – an outcome that Charles, as a pacifist throughout the 1930s, strove so hard to try to prevent.

The final chapter, on the treasures of the upper reaches of Glen Clova, represents an escape from the dark days of the Blitz. On this holiday the family was accompanied by Peter Kuenstler, then working with John in Bethnal Green. An almost visible absence in the chapters of this book is the figure of Bee, mother and wife, and it comes as a relief to find her mentioned in the very last paragraph. The omission was due to no lack of appreciation on the part of her husband or children – more an all-too-common failure to mention those on whom we depend most. Dillistone explained that Charles was 'strengthened and supported to a degree impossible to estimate or assess by the devoted care of Bee … and for thirty-four years he depended upon her at every turn'. When she died, suddenly and

unexpectedly, on holiday in Anglesey in 1944, Charles and John were especially devastated. It was from Bee, née Margaret Ermyntrude Buchanan-Wollaston, that some of John's naturalist's genes came, the Wollaston family providing more Fellows of the Royal Society than any other in its history (seven between 1723 and 1829). Though as the 'Rosarian' Dean Hole, mentioned in chapter one, was on the Raven side, being Charles's paternal grandmother's brother, there was some green DNA there as well.

Of the chapters anticipated in the 1942 letter (Appendix), but which remained unwritten, the greatest losses are those on John's expeditions from London, and that on south-west England, which would have included an account of the botanical riches of the Lizard peninsula. John did write his 'Glimpses of Greece', but, not only is its subject too far removed from the present ten chapters, there are too few related plant drawings with which it could have been illustrated. It is unfortunate that its manuscript was not discovered in time for its publication in *Plants and Plant Lore in Ancient Greece* – which would have been its rightful place.

WHAT HAPPENED NEXT

The last chapter of *Wild Flowers* takes us only to 1942, but the Ravens' project continued for more than another decade – the last plant, *Inula salicina*, referred to in chapter nine, not being completed until 1955. After the war John continued to travel and collect plants, duly posted in tobacco tins to 'The Rev. the Master, Christ's College, Cambridge'. Many of the letters accompanying these packages survive, and a selection written from Scotland is included as an Appendix to give a flavour of John's rigour in the chase for the last rarities. The rate clearly dropped as the chosen asymptote – those described in 'Bentham & Hooker' and 'Further Illustrations' – was approached. Latterly effort went towards some of the more difficult genera such as *Sorbus* and *Rosa*, but the initial field was never expanded – for example, by choosing to depict more aliens, varieties or hybrids (there are only 56 paintings of hybrids in the collection, compared with 626 definite and 122 possible ones recognised for Britain by C.A. Stace in 1975).

To this, however, there was one major exception – the decision to cover the enormous, critical genus *Hieracium* (which then included *Pilosella*), and to follow in the footsteps of the great clergymen 'hieraciarchs' of the late nineteenth century: Augustine Ley, E.S. Marshall and the brothers E.F. and W.R. Linton. Again the Ravens followed a text, and in fact they could only have contemplated their work following the appearance of H.W. Pugsley's monograph of the genus published in 1948. A few hawkweeds had, more or less incidentally, been painted from the very beginning, but from 1949

[Fig.17] *Hieracium opsianthum*, watercolour by John Raven

H. scoticum
melvich
8 July 1951

[Fig.18] *Hieracium scoticum*, watercolour by Charles Raven

an extraordinary effort was embarked upon, reaching a positive frenzy (88 drawings) in 1953. Father and son revisited the type localities of many of the 260 species treated by Pugsley (though very few of his varieties or subspecies, which is unfortunate, as most of these have since been raised to specific rank). In this project they were helped by the young Peter Sell of the Cambridge Botany School herbarium, who, at this very time, was starting his work on the genus that culminated in 2006 in a monograph that includes no fewer than 421 species of *Hieracium/Pilosella* (among the many new species is *Hieracium raveniorum* endemic to Argyll, particularly Morvern). Peter tells the tale of accompanying the Ravens on a field trip to Gloucestershire, Wales and Yorkshire in 1953 in search of hawkweeds, on which occasion Charles painted the leaves and stems and John the inflorescences. To the open-mouthed astonishment of Claude Andrews, the Botanical Society referee for the genus (who happened to be staying in the same Breconshire hotel), a drawing was held up, and if Peter could not recognise the depicted species across a table it was modified accordingly. It seems unlikely that this method was used on other occasions, as the painting style of father and son is distinct [figs 17 and 18], and most seem to be in a single hand, but between them Charles and John completed the remarkable feat of illustrating some 228 species and 16 varieties within seven years (the total number of hawkweed drawings is 319, including a 'reserve' collection of dubious or unchecked species).

With this the Ravens' massive undertaking of depicting the British flora reached a conclusion only 25 years from its inception. Though the hawkweed drawings may not show details of the all-important microscopic hairs, they are fine portraits of the habit and character of the plants, and it is hoped that they might one day be published – they are certainly vastly more inspiring than the silhouettes of herbarium specimens (or, as Charles would have considered, 'monstrosities') used to illustrate the latest handbook of the British hawkweeds .

SCOTLAND

Hawkweeds took the Ravens to Wales and Ireland, but above all to Scotland – their love for which is revealed in the chapters on Ben Lawers, Glen Clova and Galloway, and even more so in *Mountain Flowers*, written by John with Max Walters, for the Collins New Naturalist series. In this Max Walters commented on the dual professional/amateur authorship as an example of the bridging of the 'two cultures' of Charles's erstwhile colleague C.P. Snow (John was at all times at pains to protest his 'amateur' status – as at the start of chapter two of the present work). But this double act proved to be

a pre-echo of the present book with which, in the topographical chapters, it shares the affectionate and inspirational accounts of what grows where. It so happened that the early 1950s was the period when a trio of arctic-alpines was, very unexpectedly, found for the first time in Scotland: *Artemisia norvegica*, *Diapensia lapponica* and *Koenigia islandica*. John described these discoveries in *Mountain Flowers*, but in what has ended up being a Scottish publication, it seems appropriate to take the opportunity to reproduce John's own drawings of these diminutive plants [figs 19–21].

Scotland, in particular the Inner Hebridean island of Rum, was also the location for what is John Raven's best known botanical exploit: the unmasking of Heslop Harrison. This story, which epitomises John's meticulous attention to detail and his forensic powers as applied to the specificity of where plants grow, is a tale of scientific fraud; but as it has been fully told by Karl Sabbagh, only the briefest précis can be given here. In Sabbagh's book, *A Rum Affair: the exposure of botany's 'Piltdown Man'*, incidentally, are (muzzily) reproduced the only two of the Ravens' drawings ever to have been published, one by each artist. John William Heslop Harrison (1881–1967), Professor of Botany at King's College, Newcastle, had been leading a series

[Fig.19] *Artemisia norvegica*, watercolour by John Raven

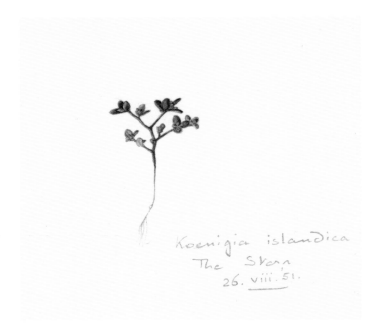

[Fig.20] *Koenigia islandica*, watercolour by John Raven
[Fig.21] *Diapensia lapponica*, watercolour by John Raven

of expeditions to the Inner and Outer Hebrides, studying both entomolgy and botany. He started to publish records of various unexpected insects and plants that supported his theories on the survival of plants through the last ice-age, and on the occurrence in western Scotland of plants previously known in Britain only from the south-west extremity of England. Of the former group one was *Carex capitata* allegedly found by Heslop Harrison on South Uist, of which Charles asked for material that he painted in October 1943 (and then cultivated in Cambridge, painting a series showing the development of the inflorescence – see Appendix, letter of 22 vii 1945). Suspicion of such records mounted and in 1948 John was sent, informally, on behalf of the botanical community, on a conscience-troubling espionage mission, during which he showed that some of the plants (of relict arctic-alpines *Carex bicolor*; of the south-west floristic element *Juncus capitatus*) had, beyond reasonable doubt, been cultivated elsewhere and transplanted to Rum. Subsequent to the publication of Sabbagh's book, the complete text of John's report was published in the journal *Watsonia* in 2004, and a set of related papers lodged with the Keeper of Botany at the Natural History Museum came to light and received press coverage in 2008.

Then there was Ardtornish, Faith's family estate in the West Highlands, which covers a large part of the Morvern peninsula. The rather institutional mansion-house provided a base from which to run botany courses, the rivers with fishing, and John helped with the general running of the estate. The garden started by Faith's parents Owen and Emmeline Hugh Smith offered a striking contrast, in terms both of scale, precipitation, and soil pH, with the Shepreth one as described in *A Botanist's Garden*. With the help of friends John explored and recorded the plants in the four whole (and eight partial) ten by ten kilometre squares that fall within the Morvern peninsula, first used for the BSBI mapping scheme started by his friend Max Walters. Being fascinated by rarity and plant distribution John was intrigued by the similarities and differences between the flora of the peninsulas of Morvern and Ardnamurchan with that of adjacent Mull – the latter the subject of a long-running project by the botany department of the Natural History Museum. John wrote a paper on the comparison for *Watsonia*, which he sadly missed seeing in print by only a few weeks.

Charles died after a long and richly fulfilled life in July 1964 at the age of 79; John aged only 65 in March 1980, when his twin daughters were only 17. In the summer of 1981, in the annual exhibition at the Fitzwilliam Museum of works from the Broughton Collection, a selection of the Raven paintings was included as a tribute to John, the collection's honorary curator. Most of the fourteen were by John – nine hawkweeds, a crocus and three of a series of studies of winter twigs [see pages 6 and 186], but one was Charles's drawing of the lady orchid (*Orchis purpurea*) included in the present book [**20**]. This was the only occasion on which any of the drawings has been exhibited in a gallery setting, though some had been shown at informal meetings such as the Cambridge Natural History Society annual conversazione where the ferns were displayed in 1950. After John's death the drawings were given to his daughter Sarah, and with them were bequeathed some of her father's and grandfather's botanical genes. Though initially trained as a doctor, the love of botany has triumphed: Sarah's passion for plants and gardening is well known from television appearances, and has been gloriously revealed in her recent book describing 500 British wild flowers, with stunning photographs by Jonathan Buckley, jointly dedicated to the memory of her father 'who first set me on the wild flower path'.

HISTORY OF (NON-)PUBLICATION

When John first mooted the idea of a 'little collection of essays and illustrations' in a letter to his father written in 1942 (Appendix) it must have been more of a dream than a firm intention – even with a date 'long after the

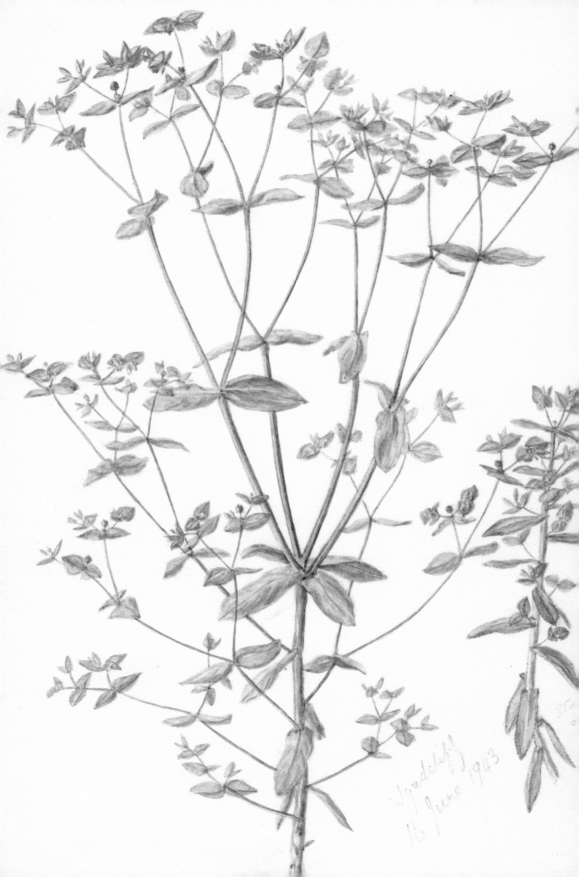

Lyndcliff
16 June 1943

war' in view. One has only to think of the dismal quality of colour reproduc-
tion of the following two decades (for example, the early New Naturalist
volumes). Reproduction in black-and-white would have been a nonsense,
and it is inconceivable that such a book could have been produced until rela-
tively recently. The drawings, however, continued to be regarded as treas-
ured family possessions – Faith describes them as having an aura of 'holier
than holy'. After Charles's death John had a cupboard shelved to house
the ring binders; though, of white-painted deal, this was of a decidedly
more utilitarian nature than the exquisite, nineteenth-century, mahogany
cabinet that houses his father's moth collection, which stands next to the
cupboard at Docwra's. At one point the National Trust seemed interested
in publishing a selection of the drawings, but this came to nothing; then in
1965 came the Keble Martin phenomenon.

In 2010 Faith asked me if it might be possible to resurrect the project.
As a child I had been brought up on Canon Raven's bird books, and at the
age of ten my family moved from Leeds to Dundee – so botanising in the
Yorkshire Dales was replaced by excursions to Glen Clova, Ben Lawers and
even the Cairngorms. 'Raven & Walters', rather than their friend J.E. Lous-
ley's *Wild Flowers of Chalk and Limestone*, became my bible. As horticultural
interests evolved I was inspired by suggestions in *A Botanist's Garden* and
those beautiful Scottish umbellifers meum and lovage soon found a place,
from wild-collected seed, among Himalayan meconopses and primulas
from Ascreavie in a peat bed that I made in our modest suburban garden.
I had known of the creation of the drawings from references in *Mountain
Flowers*, and from Duncan Robinson's chapter in *John Raven by his Friends*,
but had no idea if they even still existed. And when I came to read the text
there were extraordinary parallels with my own family's botanising trips
– not only to the Craven limestone and mica-schist mountains of central
Scotland, but three, month-long camping trips around Ireland in the late
1960s and the thrill of finding St Dabeoc's heath in Co. Galway and a violet
sea-snail on a Co. Kerry strand. We too had annual holidays in Glen Trool,
though a week at Whitsuntide rather than the month of August – the time
of May blossom, meadows of trollius, and 'wood lysimachia' (my mother
was also brought up on Bentham & Hooker). Having no tame marquess
to call on, our accommodation was a tent in a field on Caldons Farm at the
west end of Loch Trool.

There was therefore no possibility of turning the offer down, though
there were certain concerns about the undertaking. Faith showed me a

[Fig.22] *Euphorbia stricta*, watercolour by Charles Raven

1984 letter from Crispin Fisher of Collins (the publisher of John's botanical books), which was rather more than a polite brush-off. Some colour proofs had been made, but those of Charles's drawings were considered unsuccessful due to the 'very delicate and understated style of the artist', and there were too few of John's in crisper, more easily reproducible, style. At this point Faith also muttered something darkly about hoping I 'wouldn't get murdered' if I did take the project on. It emerged that in 1980, while Faith was interviewing for a stalker at Ardtornish, John had had a productive meeting with John Calman, then starting to make a name for himself in the publishing world as a packager of fine-art books, who thought that a book might be possible. John died the very next week, and only a few weeks after that the 37-year old Calman was murdered. The circumstances were macabre – Calman had been visiting his mother in France and she had given him a set of kitchen knives that he put on the back seat of his Bentley. He stopped to pick up a hitch-hiker, things turned nasty, the boy stabbed him and stole the car. So the project stalled for a penultimate time and it is with some satisfaction that the jinx has finally been broken in time to celebrate Mary's centenary.

SELECTION OF ILLUSTRATIONS

The hardest task of the editor was undoubtedly the selection of illustrations for reproduction – from a collection of 3643 drawings. Using the Ravens' chapters as the basis for the book immediately limited the choice, as only drawings of plants referred to in their text could be used. This had its own frustrations due to the limited number of plant families and localities treated (there were to have been other essays that never got written). Also, although a majority of the paintings had been made by time the extant text was finished, work continued on the drawings (including virtually all of the hawkweeds) for a further decade after the end of the war. Often one had to skip over fine drawings because they were not mentioned in the text, though room for some of these has been found to enliven this Introduction. There was also a problem in that a plant mentioned in the text for its botanical interest was, perversely, often not matched by its visual interest, or, if it was, then the drawing might be substandard. Hard decisions had to be made and it can only be hoped that the resulting compromise is not considered too idiosyncratic, and is seen as being fair to the intentions and sensibilities of the author-artists. Great restraint has been exercised in the matter of interpolations but just occasionally the text has been modified to allow the inclusion of a relevant, notable species or a good painting.

It should be added that, as the Ravens frequently redrew what they considered to be poor earlier efforts, some of the drawings reproduced here are later drawings, not done in the time or place referred to in the text (the details are provided in the List of Plant Sketches, p. 203). It was also felt important to include works not only by Charles, but also some of the children's contributions to the project as described in the first chapter.

NOMENCLATURE

As this book is effectively a period piece, the Ravens' nomenclature – that of the 'ninth' edition of Bentham & Hooker – has been left intact. This applies both to the Latin names and to the English ones. In those days there was less of a concern for common names (at least among serious naturalists) than has now become the case, and many of those given in Bentham & Hooker are merely partial translations of the Latin binomial – such as the fatuous 'Common Limosel' for *Limosella aquatica*, or 'Littorel' for *Littorella aquatica*. More meaningful common names taken from Bentham & Hooker have been added where these were not given in the manuscript, but names of the other sort have been eschewed, as they were by the Ravens – so not every plant is accompanied by a common name. In recent years, as a result of molecular systematic research, there has been a positive epidemic of changes to long familiar binomials, notably the reassigning of species among the traditional orchid genera. Rather than cluttering up the text and figure captions with names in parentheses, the most up-to-date names are given here only in the index.

Wild Flowers

A SKETCHBOOK

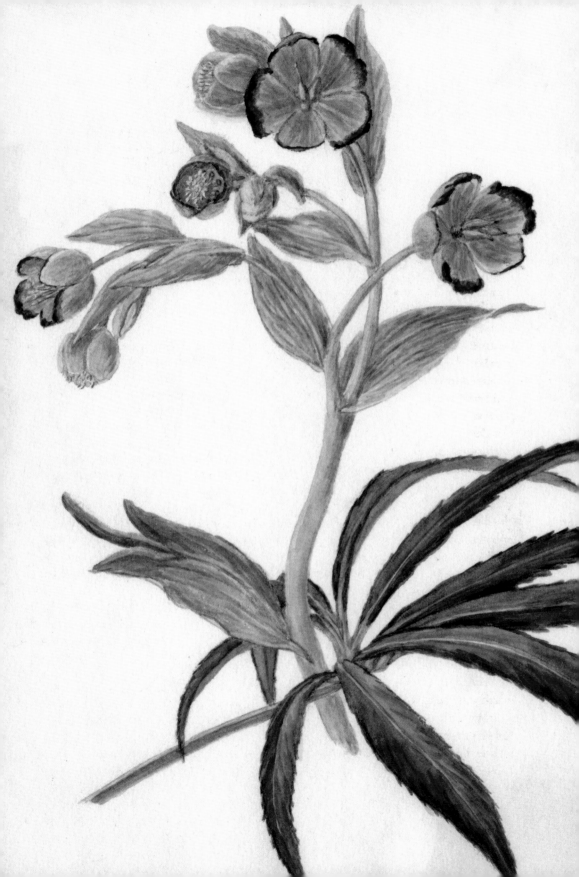

CHAPTER ONE

THE BEGINNINGS OF IT
Ireland and Liverpool 1930–1

[C·E·R]

IT WAS ON THE 13TH SEPTEMBER 1930 THAT I PAINTED MY FIRST wild-flower and that this book became inevitable. If anyone had told me that that picture was a mile-stone or a finger-post or a starter's pistol I should have called him, *sans phrase*, a liar. Yet few events have been more decisive. Looking back it is easy to surmise that, with my inheritance – Dean Hole the Rosarian was my father's uncle,[1] and two of my mother's brothers were ardent botanists – and with my son John's love of flowers, and uncanny perception of their form, we should slip from birds to insects, and from insects to their food-plants (we had in fact slipped, if that is the right term, thus far already); and that thereafter botany would entice us. But developments, which afterwards look predestined, go on unnoticed until the appropriate and usually trivial incident reveals and fixes their power; and if the incident does not occur – I wonder?

We were spending a belated summer holiday, and for the third year in succession, in the rectory at Goleen.[2] From Liverpool to Cork by cattle-boat; from Cork to Skibbereen by rail; thence by the Skibbereen, Ballyde-hob and Schull express whose engine's name was *Gabriel* and who moved with less than angelic speed along a miniature tram-line beside the road-way; and so by car, sixpence a mile and no extra charge for numbers or luggage, into the wilds of the promontory that separates Bantry Bay from Roaringwater, and has the Fastnet rock as its outpost in the Atlantic: that was our route. Its destination was worthy of it. Perched on a miniature headland between a little river-mouth and the huge land-locked harbour of Crookhaven, the house and Church commanded a wide prospect of islands and ocean and were set on rock-strewn slopes of purple and gold. To the north was the tiny village, a general shop, a beer-house and a tumble-down smithy: to the south, Crookhaven, once the last harbour of the Old World for ships travelling to the New, now visited only by an occasional Breton lobster-boat or the little collier calling for road-metal on its way home from Limerick; and beyond the haven the three great capes, Brow Head, smooth

1 *Helleborus foetidus*, stinking hellebore

and rounded, the Mizen, stark and sheer, and Three Castles Head, whose romantic beauty cannot be condensed into a *mot juste*. Between the capes lie sandy bays, iridescent in the sunlight with amber and aquamarine, emerald and sapphire, and the blue topaz which is the jewel of the western sea; beaches thick with shells and all the jetsam of the gulf-stream; and a great lagoon home of a flock of swans, and visited in heavy weather by a multitude of sea-fowl. The coast is marvellously varied: cliffs and dunes, bog and hillside, clusters of twisted trees, tiny corn-fields, outcrops of lichen-coloured rock, and over all the soft brilliance of the Irish air, more variable than the scenery in its moods of sunshine and of rain.

We had visited it twice already. Our first year had been devoted to its exploration; to finding purple shells and Portuguese Men of War in our bathing cove,[3] and caterpillars of eyed hawks and puss moths on the dwarf willows at our gate; to watching the choughs playing hide and seek in the crannies of the rock-face and the gannets plunging dizzily when the mackerel came into the bay. In 1929 we had collected butterflies, dark-green fritillaries and painted ladies on the headland; wood arguses in every orchard and copse; varieties of the small copper – my son caught two streaked with silver on the same day; and late in our visit the clouded yellow. Edusa is always irresistible:[4] so splendidly golden, so tantalising in her pauses and dallyings and sudden bursts of speed: but when she floated over the rocks from which we were bathing, and my son rushed mother-naked in pursuit, and yelled to me to follow, my affection for her was seriously strained: bare feet and Irish gorse combined to strain it.

In 1930 we had taken our holiday late; for I had been doing a vacation term of lecturing in Columbia University and getting parboiled and Americanised in the process. Humidity, heat waves, hospitality – and a vast output of oratory – had left me disinclined for any further exertions.[5] I had seen Richard Harrison play the Lord God in *The Green Pastures* to a Broadway matinee crowd in a temperature of 105 in the shade;[6] had seen 'Babe' Ruth hit a home run over the longest boundary of the Yankee Stadium,[7] and an audience of 30,000 listen to the Ninth Symphony, played out of doors in the same stadium; had studied the parkways of Westchester County and the ethics of prohibition in New York City; and for two months had wondered whether I was in hell or heaven. A rest was very necessary.

We collected a few larvae – the black form of the lychnis moth (*Dianthoecia capsincola*), tolerably abundant in the seed-heads of sea campion and easy to rear, and the very different caterpillar of the grey coronet (*D. caesia*) which feeds up nicely and then (with me) stubbornly refuses to pupate;[8] we made a few of my execrable sketches – the last time that I have wasted paper

and paint on subjects entirely beyond my capacities; and we paid a visit to Three Castles Head – a visit which for me at least was probably decisive.

The place would be a haunt of pilgrims in any country where the past was less alive, or a tourist-centre among folks more ready to make money. Being in Ireland it is utterly solitary and accessible only on foot. Nothing known to me in Britain can compare with it in its combination of historic significance and grandeur of scenery. A narrow promontory half a mile in length and wholly inaccessible from the sea is barred from the land by a lake, 300 feet up, which stretches almost from side to side of the headland. On the north a narrow defile winding under steep rocks separates the water from the cliff edge. On the south there is a smooth sward between lake and precipice; and across it a castellated wall, impregnable to anything but artillery and shutting off all access to the camp of refuge beyond it. In this camp where the harried tribesmen could find pasture and protection is now an abundance of white heather and with it a plant as exquisite as it is rare – the spotted rock-rose (*Helianthemum guttatum*) of Southern Europe and the Channel Islands, here found as a tiny annual, two or three inches high.

Long ago, when I took no interest in wild plants – except indeed as food for larvae in my moth-collecting days – there had been unforgettable moments when some lovely thing, suddenly seen, stopped my breath. The marsh gentian (*Gentiana pneumonanthe*) standing up in a hollow among bracken on Chailey Common when I was still a school-boy: the pasque

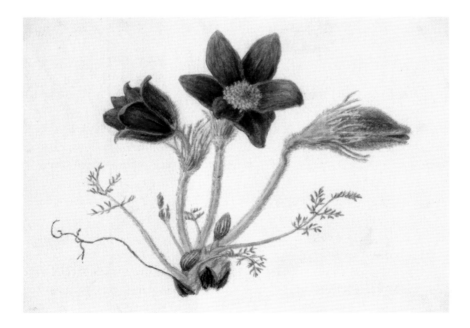

2 *Anemone pulsatilla*, pasque flower

flower (*Anemone pulsatilla*) [2] cupped against the chalk of the Devil's Dyke in my first May term at Cambridge: mezereon (*Daphne mezereum*) in full flower in a Kentish wood in early March: these have thrilled me as poignantly as my first sight of Tintern or of dawn in the Alps. And the rock-rose at Three Castles Head had the same immediate effect. It grows in colonies on the bare black peat, its leaves spread out close to the ground and the delicate yellow flowers with the crimson blotches at their base looking very large for the size of the plant. They have that air of distinction and quality which belongs to few of our native flora – and those mostly species of real rarity, denizens of mountains or moorland or in one or two cases of the coast.

The finding of *Helianthemum guttatum* [3] gave a bent to our interests. My youngest daughter Peg, fresh from a junior form at school, had been instructed to make a collection of pressed flowers as a holiday task: even then she had begun to paint, and was supplementing the herbarium with watercolour pictures. Mary, my eldest, discovered a desire and skill for drawing plants. John, now my partner and then a sixteen-year old at Marlborough, was ready to colour her outlines. My brother who was staying with us suggested a family album of life-sized portraits.[9] The two elder children responded with enthusiasm, and insisted on impounding Peg's collection as a start. She protested. There was a day of wrath and rivalry; and in the course of it I painted the flower that led to this book.

It was a devil's-bit scabious (*Scabiosa succisa*) [4], of a pure pink, free from all tang of magenta, one of those rare flowers that go straight into rose madder and give no trouble. Peg, I think, had found it: but was too

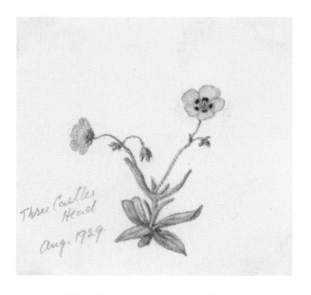

3 *Helianthemum guttatum*, spotted rockrose

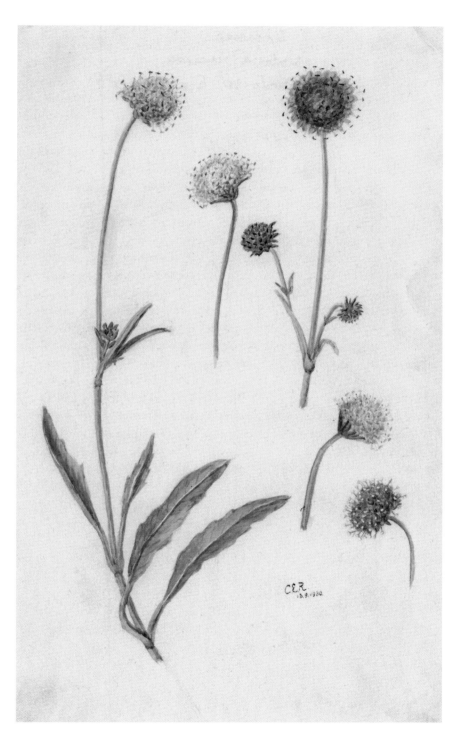

4 *Scabiosa succisa*, devil's-bit scabious

occupied with other cares to paint it: the others wanted it, but had no rights: a family contretemps was to be avoided. I offered to have a try; and, though I say it myself, the effort was a huge success. Not only was the result uncommonly like the flower, but it was a simple gracious piece of work; and, which was more important, I had discovered the exceeding beauty, the delicacy, symmetry and structure of plant-life. It is of course true that one never really sees a thing until one tries to paint it. I had proved this a dozen times with birds and moths and caterpillars. But, partly perhaps because flower-painting seemed the particularity of the Chinese and the mid-Victorians, and partly because botany had never appealed to me, I had never before looked at a plant with eyes that saw. Now my eyes were open; and the spectacle and its perpetuation became irresistible. We finished our holiday in an orgy of collecting and coloration.

It was one thing to find the plants and quite another to name them. We had an ancient copy of the one-volume edition of Sowerby's *English Botany*, with small coloured pictures arranged twenty to a plate and with two pages of description to each plate. None of us, except perhaps Peg, had the faintest idea of botanical systems or of even of the common names of any but the most familiar species. Structure and characters were meaningless, and affinities, never superficially very obvious except in families like the Legumiosae, Umbelliferae and Labiatae, did not obtrude themselves. It is (I confess) still somewhat mysterious to me why the delphinium should be brigaded with the buttercup, and the potentilla be banished to the roses; or why the crowberry should have no connection with the heaths; or the veronicas find themselves along with the mulleins, the linarias, and the louseworts. Taxonomists may have good reason for these perversities; but for the beginner who wants to identify his finds they are inexplicable and annoying.

On the whole it is remarkable how easy our British plants are to identify – if, as is the case with us, you decide that hawkweeds can be left to the splitters, that brambles and roses are almost equally negligible, and that willows, sedges and pondweeds had better be postponed till a more convenient season. In fact (if I remember rightly) we paid little heed at first to anything except the definitely 'flowering' species. Docks, oraches, even umbellifers, were lumped together in a single condemnation: rushes, and everything beyond them, were left severely alone: weeds and anything which we knew to be abundant were ignored. When everything was new, and we were searching a rich locality in high summer, it was hard to know where to begin.

In fact we did not make many mistakes in identification. I still blush to remember that I wagered my youngest daughter that what she (rightly)

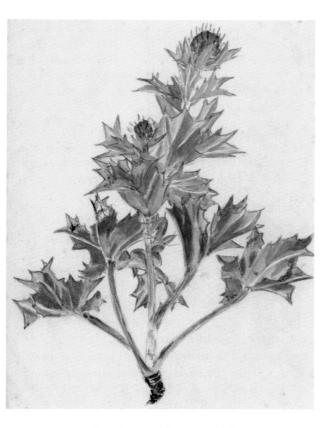

5 *Eryngium maritimum*, sea holly 6 *Glaucium flavum*, horned poppy

declared to be bog pimpernel (*Anagallis tenella*), was really twinflower (*Linnaea borealis*): but that was partly Sowerby's fault: and no one would expect those exquisite pink bells and delicate trailing stems to be own cousin of the scarlet pimpernel (*Anagallis arvensis*). I confess, with much deeper shame that I have twice been deceived by the knotted pearlwort (*Sagina nodosa*), once on Widdybank Fell when for a glorious hour I thought I had found the bog sandwort (*Arenaria uliginosa*); and once again on Ben Bulben when, despite my son's warning, I painted a fine bushy specimen of it in the faith that it was the rare fringed sandwort (*Arenaria ciliata*). I misnamed the tuberous pea, which we first found in a woodland ditch of the New Forest – and the mistake cost us an opportunity to paint *Vicia orobus*. We took time to make certain of the persicarias and the chenopodiums (what is the plural of goose-foot? My pen refuses to write goose-foots – or geese-feet!) but the umbellifers, when honestly tackled, were unexpectedly easy. My own training with Lepidoptera no doubt stood me in good

stead: if you can discriminate the wainscot moths on a sugar patch and box *Leucania straminea* out of a crowd of *L. impura* and *L. pallens*, or if, as has happened to me, you can correct the greatest of collectors on his specimens of *Boarmia repandata* and *B. gemmaria*,[10] the British flora is relatively easy: even when I came to the grasses and to *Carex* there were very few that gave me serious hesitation. And my son has a flair for discriminating species which seems to me positively uncanny.

But our success was largely due to books. We bought the *Handbook of the British Flora* of Bentham & Hooker as soon as we got back to Liverpool and the two volumes,[11] dogs-eared and broken-backed by now, gave us all that we wanted, clear descriptions and adequate pictures. These, and the three ancient tomes of the excellent Miss Anne Pratt's *Flowering Plants and Ferns of Great Britain* (which I inherited from a botanically-minded aunt), were all our literature until lately when we have added the supplement to 'B. & H' and a few local floras. So far as my small experience goes (and it is perhaps unkind to say so) most of the books for beginners are very inadequate. Certainly the 'Wayside and Woodland' series, which has Richard South's admirable volumes on lepidoptera, T.A. Coward's on British birds and Travis Jenkins's on fish, has nothing else so inexcusably bad as those on 'Blossoms'; pictures, letter-press, arrangement – all contribute to their condemnation. The Rev. C.A. John's familiar and oft-reprinted volume has now some pleasant pictures,[12] but it is incomplete; and a flora that does not include everything is fatal for the novice: he gives up the pursuit far too easily under the pretext that his find is not in the book. As for all the guides of the 'Name this flower' variety, they may be of assistance to infants and half-wits, but anyone who can use them can, with a little practice, as easily use Bentham & Hooker. The fact is that there are a few genera difficult even when they are in flower: but we who started from scratch did not find the course too heavy – even though certain famous fences, the willowherbs, the mints, the oraches, still, and very properly, give us pause.

The painting was more of an adventure. John and I can both draw – accurately if without distinction; and have both dabbled in water-colours all our lives. My son has, I suspect, an appreciation of art that is denied to me: he certainly enjoys music and has a keen eye for a picture. But when we paint it is in the meticulous and highly elaborated style which uses the finest of brushes and a magnifying glass; and our intention is to reproduce the object as exactly as may be – the object, not our impression of or reaction to it. For myself my best sketches always resembled inferior chocolate-box lids, and my pictures of ducks in flight had every feather well and truly rendered. If I were in a palace of truth, I should have to confess that

without any strong affection for either, I would sooner live with Landseer's 'Stag at Bay' than with Gazelle, or with a landscape by Leader than with a Gauguin or even a Van Gogh.[13] Indeed if Hitler really said to the Surrealists of Berlin 'Gentlemen if you see things like this, you are mad and shall be sent to an asylum: if you only pretend to see them so, you are bad and must go to gaol', then for once he said something worth saying.

But for our purpose in painting plants a discussion of the philosophy of aesthetics is unnecessary. We are agreed that the corolla of a gentian or the symmetry of cow-parsley or even what John Ray called 'a spoyle or smile of grass' is a beautiful object in its own right; that human artistry is not likely to improve on it; and that the truest service is to produce as exact an imitation of it as can be managed on a flat surface and within the compass of a palette. To gild the lily is always questionable taste. We at least have no desire to improve upon nature. If the result challenges comparison with a colour photograph, we are content.

About our earliest attempts it must be confessed that there was little either of art or of nature. We were in a hurry; for there were always specimens waiting to be painted: and we were inexperienced. A few, a very few, of those earliest pictures still remain in our collection. Nearly all have been condemned in one or other of the purges with which each new season is begun. Occasionally we got an immediate effect that was not unpleasing – our 'primitives' might even appeal to some tastes more strongly than their successors. But in the main colours were crude, shadows messy, leaves

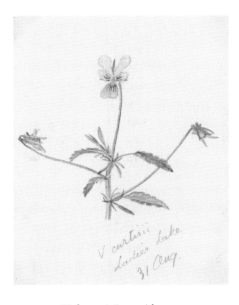

7 *Viola curtisii*, seaside pansy 8 *Erica tetralix*, cross-leaved heath

[49]

9 *Centaurea scabiosa*, greater knapweed

carelessly drawn, and greens sadly mismanaged. They were good enough to encourage perseverance: but that is all the praise that they deserve.

It is not in fact as easy a business as one would suppose. Anyone who can draw and match colours correctly ought to be able, with patience, to transfer the likeness of a plant to paper. It sounds, and sometimes is, quite simple. But there are difficulties: and anyone who tries it or even who studies flower-paintings will soon discover them. Let him try his hand on (say) a forget-me-not, a daffodil, and a rose-bay; and he will discover first the limitations of our pigments and then the problem of shading.

There are certain hues not infrequent in our flora which watercolours are not able to reproduce. As no one has ever really succeeded in rendering a blue-bell wood in sunshine or a stretch of heather-purpled moor, so the colour of many blue and nearly all pink flowers defeats the paint-box. In some cases wizard-work can be done with Chinese white mixed with colour or laid on separately: this, I may add, is a device of my son's and when it comes off is excellent. In others, as for example in the bloody cranesbill, a light wash of pure ultramarine, and then when it is bone dry a similar wash of rose madder, will preserve something of the brilliance and transparency of that terrific magenta. But for flowers like the birds-eye primrose or St Dabeoc's heath, the purple saxifrage, the marsh orchid or the corn cockle, no possible combination of paints will suffice. White, though it gets nearer to the shade, deadens and dulls the tone; mixing merely muddies the effect; successive washes cannot be bright enough. For years we wrestled with the problem, gradually being compelled to admit that though our blue flowers were tolerably exact, and our yellows and reds at least recognisable, everything pink except a few very rare rosy flowers was a mere travesty. Considering how many are the British plants that sport this colour, and, whatever the critics of magenta may affirm, how attractive many of them are, it was sad to have to apologise whenever we looked at our pictures of them.

One summer when I spent some days in a deliberate succession of attempts upon the bell heather, a request for a 'nature article' in a monthly paper gave me the chance to appeal for advice. Along with several letters informing me of the difficulty (which I had admitted) and suggesting combinations of cobalt or ultramarine with rose madder or alizarine crimson (which I had not ignored) came a bit of experience that has solved the problem. It was supplied by a lady who had been painting in India and found our paints too dull for the climate; and it consisted of the words 'try Stevens' magenta ink'. We tried it, and though it needs caution – being ferocious and almost indelible, it supplies the necessary range of colour, combines reasonably with other paints, and produces not only the exact

shade for the pink flowers but an admirable series of mauves and purples.

Shading remains a difficulty, even when the correct tint has been matched. One soon discovers why so many flower-painters prefer a flat technique; for to touch a yellow petal with any sort of shadow-colour is to make it look dirty. Yet flat treatment leaves both shape and texture to the imagination; and destroys the chief charm of the blossom. Shadow must be attempted; and a careful study of complementary colours will help to make it look clean. But that a full-face view of a trumpet daffodil has never yet been properly painted is an opinion for which evidence would not be hard to collect. And though yellow is the most difficult colour, white is not far behind it.

At first, like most beginners, we concentrated on the flowers and were content to wash in the leaves with a nondescript green. It took us a long time to realise how many colours the word green covers, or how subtly the texture affects the appearance of the leaf. The exquisite detail of veining and the symmetrical but never mechanically exact proportion of the parts; the set of the leaves on the stem; the draftsmanship of their foreshortening and the play of light on their surfaces – these only came to us gradually as by experience we learnt to see and to depict. Aureolin (no other yellow can take its place) and cobalt with prussian blue and cadmium, ochre and black in reserve will cover most of the variations required: but there is always room for experiment and fresh combinations. If anyone tells me that it is foolish not to use the green pigments so lavishly manufactured, we shall be quite ready to believe them – though we decline to regard emerald as fit for anything except mixing with rose madder for opalescent skies.

That first Irish August saw Mary and John very active. Between them – she drawing and he painting – they did a couple of dozen or more. Peg did another dozen in her own more dashing style. A sea-holly (*Eryngium maritimum*) [5] was artistically the masterpiece; and yellow bartsia (*Bartsia viscosa*) the only species besides the rock-rose that could be called scarce. It grew in a bit of moorland bog between ridges of rock not far from the Rectory tennis-court: and we confused it at first with the yellow rattle! But there was sufficient variety of terrain to give us samples of different groups. The coastal rocks provided sea aster (*Aster tripolium*), goldenrod (*Solidago virgaurea*), rock spurrey (*Spergularia rupestris*) and English stonecrop (*Sedum anglicum*). The dunes at the head of Crookhaven gave us horned poppy (*Glaucium flavum*) [6], seaside pansy (*Viola curtisii*) [7] and masses of a dwarf form of lady's tresses (*Spiranthes spiralis*), of which the twisted flower-spike gave us much interest. From the moors we got white bell heather and white ling (*Calluna vulgaris*), cross-leaved heath (*Erica tetralix*) [8], sheep's-bit (*Jasione*

10 *Chrysanthemum segetum*, corn marigold

11 *Pyrola rotundifolia*, larger wintergreen

montana) and field gentian (*Gentiana campestris*); from the roadsides greater knapweed (*Centaurea scabiosa*) [9] and toadflax (*Linaria vulgaris*); from the bits of corn-field corn marigold (*Chrysanthemum segetum*) [10] and purple dead-nettle (*Lamium purpureum*). It was of course impossible to try to do everything: in fact the children did what took their fancy: and I looked on, fairly confident that their interest would not survive the winter or be as permanent as the shell-collecting which we always renew at the sea-side but never dream of taking seriously then or thereafter.

Ainsdale
Oct 1930.
Var. condensata.

Girvan
15 Aug.

Nevertheless interest had been more deeply aroused than I had imagined; and certain principles had been adopted which we have not changed. Plants were to be done life-size and in the natural positions of their growth – not flattened or simplified or dissected. They were to be on white paper, even if they were white-flowered. If the species was too big to get onto a foolscap size mount, a spray of it should be chosen. All pictures should be trimmed and mounted with adhesive corners on plain white perforated leaves held in a ringed binding case. On the leaf should be entered the Natural Order, Latin and English name, the locality and date. It would thus be possible to expand the collection indefinitely without remounting. We have now, I suppose, some 1500 sheets of plants each containing a separate species.

But despite these arrangements the hobby might well have followed Peg's *hortus siccus*, or my pictures of larvae, into oblivion. It was a considerable surprise when next spring on joining the family for a few days in the Lakes I found the partnership drawing and painting vigorously; and still more so when paintings began to be done at Marlborough. We spent a few days there in May that year and though we did not quite forsake butterflies plants occupied most of our attention. We did one expedition to the New Forest, hoping (I think) for hibernated large tortoiseshells; but the day was showery and we botanised instead, discovering among other things the vetch which proved so hard to identify.

It was in that visit that I began to be taken into partnership over the painting. Mary drew diligently: John as at school and had only time to collect: obviously I must lend a hand and carry on what he had to leave unfinished [the drawing of stinking hellebore, *Helleborus foetidus*, appears to be one of these, **1**]. So he and I did the colouring between us; and when our visit was over, the habit of it had begun to grip me. Mary and I did a few orchids, the large butterfly collected on a speech-day expedition to Llangollen; the two helleborines, *Epipactis palustris* and *E. dunensis*, which grow in the bird-sanctuary at Ainsdale; and a fly orchid, and herb paris found when we were hunting for the marsh ringlet at Witherslack. My one discovery of a plant 'on my own' was bastard balm (*Melitis melissophyllum*) – in its way one of the most striking of British species – which was shown me by a kindly naturalist whom I met at a school for clergy in Exeter and which I carried home to Liverpool in my sponge-bag: my daughter's delight in it decided me that such collecting was worth while.

For me the new interest was a godsend. The two bits of work in which I had been absorbed were now well started, and the authorities decided, no doubt wisely, to hand them over to others: the book which had occupied

12 *Parnassia palustris*, Grass of Parnassus

three years in the writing had been finished:[14] it seemed clear that the Church had no further use for me, and very uncertain whether any opening, in Britain, was available. It is difficult not to feel depressed under such circumstances especially if one has more time than usual for leisure. Plants, the finding and painting of them, came as a consolation and a delight. By the time of our annual holiday I had become almost as keen as my son and had realised that if we were to make progress there must be a big effort to increase the number of our specimens. Rarities were very well: it would always be exciting to look for them. But at present we could not go fifty yards without finding something unpainted, even if we left grasses, and duller weeds out of account. That state of affairs must be remedied; and this would mean hard work.

So when we got to our new and lovely holiday on Loch Trool in Galloway it was with the intention of painting steadily. Between us I suppose we did four or five plants every day for a month: by the end of it we had made a good beginning, and most of the commoner species of moorland, riverside and coast had been portrayed. Before winter we had added a number of cornfield and wayside species such as the environs of Liverpool could produce; and a conference at Oxford had given us a day on the White Horse Hill above Uffington and a very productive weed-field beyond Headington. The collection was becoming representative. Another year's energy and we should have got abreast of the commonalty. An expedition in early April 1932 to Pen-y-gwrhyd cemented the alliance with my present collaborator. After a long morning's search for purple saxifrage (*Saxifraga oppositifolia*) under Cwm Glas – a morning during which we were first nearly blown off our feet by wind and then bombarded on our bare heads by hailstones as large as sparrow's eggs – John and I decided to have one more try for it, went over to the Nant Francon Pass, visited Llyn Idwal, and found our plant on the slope between the little lake and the Devil's Kitchen.

Then, when the miracle happened and my University recalled me to its service in 1932, it was good to have some concern which would prevent anxieties and apprehensions and the fussy preparation for a strange job which is always a waste of time and often a disaster. In that year we included umbellifers and docks, and even made a start with pondweeds. By the end of it we had painted most if the common flowering plants of England; and the fun of the game could begin.

Yet to put it so is to give a false impression. It is to suggest that rarities are the object of our interest; and that it is only in Teesdale or on Ben Lawers that we get our thrills. There *is* a fascination about novelty and the uncommon: there *is* a distinction about the small vivid plants of the high hills. But

our main debt to our botanising is not the research after particular treasures: it is the opening of our eyes to the beauty and attraction of common plants in common places. John Ray, the Father of Natural History, has described in the Preface to his first book – the 'Catalogue of Plants Growing Wild Around Cambridge'[15] – how after an illness he found himself with leisure to see what he had previously trampled and ignored; and how first their beauty and variety, the '*polydædala artificis **naturæ** opera*',[16] fascinated him, and then detailed interest and the desire to know, were aroused. So it was with us. To walk along the banks of the Mersey between Dingle and Otterspool was to discover between the flotsam of the high-water-mark and the rubbish-heaps of the foreshore first a straggling border of unexpected herbage, coltsfoot and goatsbeard, orache and dock, and then a scurvy-grass that was not the miniature *Cochlearia danica* of the Menai straits or the robust *C. officinalis* of Great Orme's Head, but the longer leaved, larger flowered *C. anglica* of the mud-flats. To paint the local rarities, the larger wintergreen, *Pyrola rotundifolia* [11], which springs up like great spikes of lily of the valley through a carpet of dwarf willow at Ainsdale or the dune-land form of Grass of Parnassus (*Parnassia palustris* var. *condensata*) [12] which clusters at its feet, was a delight: but my picture of the pink clover, gathered at Oglett, or of the wild radish from a rubbish heap in Mossley Hill gave me every bit as much satisfaction. It was not certain new plants that we had discovered; it was a new world: and the entrance to it even in Liverpool lay just outside our front door.

THE ORCHIDS

Marlborough, 1931–3

[J · E · R]

I AM NOT A BOTANIST. WHAT I AM IS FORTUNATELY IRRELEVANT
– fortunately, because it would be difficult to find any description more
definite than that of a dilettante. But I choose to say at the outset that I
am not a botanist in order to deprive others of the malicious pleasure of
discovering it for themselves and saying it for me. In company with a grow-
ing number of my fellow-men I am, it is true, filled with a fervent devotion
to the objects of the botanist's study; but I lack both the leisure and, I fear,
the inclination, having once set eyes upon the flower for which I search,
to dissect and examine it limb by limb beneath a microscope. To watch
a branch of sallow bursting, as even now it is bursting in a vase upstairs,
into a misty glory of golden pollen is, in its small way, a pleasure hardly
surpassed: while to be ignorant, as ignorant I am, of which of the countless
sallows it is, affords me no grief whatever.

And yet it is not simply an eye for beauty of colour or of form that
has bred in me so deep a love for flowers: for if it were so, the primrose
must excite me more than, say, the fringed sandwort (*Arenaria ciliata*) or
field artemisia (*Artemisia campestris*). The first primrose of the year, and
even more, to me, the first brimstone butterfly, is always and always will
remain a source of surging joy; and throughout its season I cannot see a
primrose without a silent thanksgiving for the art that made it. But the
Arenaria and the *Artemisia* have afforded me another joy, no more acute,
perhaps, at the instant of discovery, but with the passing of time more
dearly treasured and more readily recaptured. Once again it is not the
obvious reason, the almost universal and often misguided craving for
the uncommon, that most truly accounts for this peculiarity in such as
me; though doubtless the satisfaction of that craving is an ingredient in
our joy. The true cause, though admittedly related to this perversity, is, I
think, deeper and less misguided. It is another of the emotions common
to all men, the intense satisfaction of difficulties eventually overcome, of
an aim sought and, as seldom in human life, completely attained. This it

13 *Orchis hircina,* lizard orchid

is primarily which endows the ardent plant-hunter with many of his most enduring memories.

There is a time for all things. Wartime, or rather the little leisure that wartime permits, is, for me at least, a time to peer forward into the future or to gaze back upon the past. Of these two activities the former fills me always with a vague anxiety which, if I am already tired or depressed, serves but to increase my despondency; while the latter, thanks to memory's happy habit of preserving the pleasant long after it has jettisoned the painful, is a widow's cruse of refreshment. The pleasures of memory are, it is true, tinged always with nostalgia; but such nostalgia, like many of the milder aches, is a pain that is hardly distinguished from pleasure. At any rate, in the blend of emotions that accompany the memory I personally find, thank God, that pleasure preponderates far over pain. When I sit, therefore, as I sit now, among the slums of a battered city, my mind wanders forth again and again over the hills and the moors that I have tramped, I come once more upon the plants which I have successfully sought, I feel again the elation of achievement, and I return always grateful and refreshed. That is the chief reason for which I now write. I write primarily for my own recreation, to take my mind for a time from the squalid horror of the present: but if by some unlikely chance I can persuade but one reader in similar surroundings to accompany me upon my wanderings and to share my triumphs and disappointments, then indeed shall I have achieved something worth achieving and have added yet one more to the pleasures that I owe to plants.

A love of nature is a characteristic which, unless it is implanted in you from birth, you will not easily acquire; and the passion for collecting is also, I fancy, usually hereditary. But both characteristics may well lie dormant for many years until the right environment evokes them to self-expression. My father lived the first twenty years of his life in the heart of London, and yet contrived during those years, by familiarity with many a game-dealer or poulterer, to acquire a life-long interest in, and a considerable knowledge of, the plumage variations of British ducks. But his case is no doubt exceptional. In my own case, though I undoubtedly inherited from him both the love of nature and the collecting mania, neither characteristic began to crystallise into a permanent interest until I was nearly past the years of my adolescence. I went to Marlborough at the age of 14, and during my first summer there joined the Natural History Society, caught a certain number of butterflies and began to explore the neighbourhood; and so for three summers I continued, escaping when I could from the cricket-field to Savernake Forest or Rabley Copse. Then in 1932 I attained the Sixth and

14 *Orchis morio*, green-winged orchid

Cricket
Dorset

Bottisham
Cambs
14 May 1950

with it immunity from the tedium of enforced cricket. The flower collection, as my father has said, was already two years old; but as far as I was concerned at least, it was still an open question whether it would become an absorbing interest or join the lumber, already considerable, of collections enthusiastically begun and rapidly discarded. The summer of 1932 for me was the crucial time. With three long afternoons a week at my disposal, a bicycle standing ready, and the downs, the Forest and the water-meadows all near at hand to entice me, I came to know the country as I had never known a stretch of country before; and during that one summer it repaid my attentions by giving me the one of my various interests which I am sure above all others that I shall never lose.

Wiltshire has, in common with Dorset and Gloucestershire, that combination of slow, weedy trout-streams winding between willowed buttercup fields, of oak- and beech-woods carpeted with primroses and bluebells, and of open windy chalk-down, that is, for me, the most typically English of all our varied landscape. Marlborough itself nestles beside the Kennet; on one side rises Granham Hill, the white horse revealing from afar the nature of its soil; on another the Forest of Savernake rears some of the noblest beeches in the land; and on a third the playing-fields rise steadily to a wide circle of close-turfed, lonely downland, topped at intervals by a little round copse or an ancient camp. Whichever direction you take you pass through a green and peaceful land, yet a land of richly varied beauty. But if you would see this countryside stretched out before you, its little red villages in the wooded valleys and its curving escarpments of downland pasture, you had best take the road over Granham Hill and bear left over Clench Common, blue and gold with its bluebells and gorse, to the crest of Martinsell, a high chalky spur, capped by a ragged coppice, that juts steeply out into the Plain of Pewsey. You will feel, I think, as I did on my many long summer afternoons spent on that windy ridge, that here on Martinsell you are near the heart of England.

In my plant-hunting there are to this day several families that arouse in me such dislike or such bewilderment that I invariably leave them – the search, the identification and the painting of them – to my less discriminating father. Among these families the most notable perhaps are the Cruciferae, the Umbelliferae and the Polygonaceae. Every aspiring botanist, I imagine, has his particular likes and dislikes; but it is sometimes the case that such instinctive prejudices can be overcome. For myself, it was not until 1939 that I would consent to look twice at a *Potamogeton*; yet now the tribe of potamogetons ranks perhaps surprisingly among my especial favourites. But of all the British families there is none with

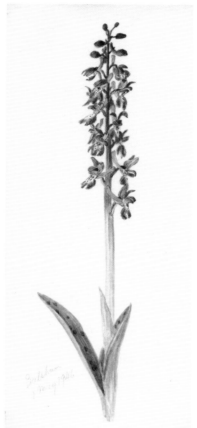
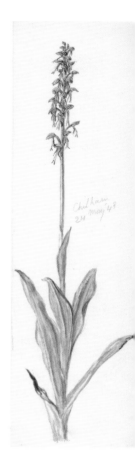

15 *Orchis ustulata*, dwarf orchid
16 *Orchis mascula*, early purple orchid
17 *Aceras anthropophorum*, man orchid

a greater or more universal fascination than the orchids; even the least botanically minded of men can sometimes be stimulated to take an interest in them. Orchids were my first great love among our native flowers, and they have occupied ever since a unique place in my affection. And it is to Martinsell more than any other single place that I owe my original devotion, a love which has since embraced many other families and one day in the future may perhaps – though I doubt it – develop to include even the crucifers. All chalk hills have their orchids: Martinsell is peculiarly rich in them. My searches for orchids in that summer of 1932 converted my plant-hunting from a passing whim to a permanent passion. We added

many other desirable plants to our collection from the neighbourhood of Marlborough; green hellebore (*Helleborus viridis*) from a belt of trees near Ogbourne; tuberous thistle (*Carduus tuberosus*) and round-headed rampion (*Phyteuma orbiculare*) from Avebury; Solomon's seal (*Polygonatum multiflorum*) from Rabley Copse; wild tulip (*Tulipa sylvestris*) from Brimstone; and many other commoner plants of woodland and down. But it was on the orchids that I chiefly concentrated, and my father too when he joined me for an occasional weekend. By the end of that summer we had amassed an imposing list. From Martinsell itself came the little chocolate-tipped *Orchis ustulata* [15], the bee (*Ophrys apifera*) and its very much rarer cousin, the wasp (*Ophrys trollii*).[1] The early spider, a small colony of which had been found on the side of Martinsell the previous year, had, alas, entirely disappeared; but a kind friend from near the Dorset coast sent me a specimen to cheer me, a picture of which found its way into the collection along with our own finds. From Oare Hill, a continuation of the ridge of which Martinsell is the highest spur, came the white helleborine, *Cephalanthera latifolia*. The pitted slopes below Savernake Forest provided the frog, Rabley Copse the greater butterfly, Cherhill Down towards Devizes the lesser butterfly, a meadow at Axford the green-winged *Orchis morio* [14], and finally, after several unsuccessful searches, a narrow valley in the downs north of Mildenhall yielded the diminutive green rarity, the musk orchid (*Herminium monorchis*). Thus, with the five abundant species, early purple, spotted and pyramidal (*Orchis mascula* [16], *maculata* and *pyramidalis*), fragrant orchid (*Habenaria conopsea*) and common twayblade (*Listera ovata*), one summer in one locality yielded no less than fourteen species of this single family; and though two or three of these fourteen had already been painted from elsewhere, the great majority was new. It was hardly surprising that by the end of the year it was destined that we should continue the collection.

Nor, as a matter of fact, were the Marlborough orchids the only members of the family we had so far acquired. Lady's tresses (*Spiranthes spiralis*) had been one of the very first flowers we had painted, as it grew in a stunted form in the sandhills of Goleen; and other sandhills at Ainsdale had early added the dune form of *Epipactis leptochila* and the lovely *E. palustris*. Then, while I was searching out the Marlborough orchids, my father had been doing his part elsewhere. He had found the man (*Aceras anthropophorum*) [17], a species which to this day I have never seen, on White Hill above Bletchingley in Surrey. *Habenaria albida* he collected in Cwm Idwal under Snowdon. The fly (*Ophrys muscifera*) came from Witherslack in northern Lancashire. The big marsh orchid (*Orchis latifolia*) was added from Ranworth in the Norfolk Broads. Finally, during our family holiday

in August, at Lapford in the heart of Devon,[2] we had found and painted a fine specimen of the typical, upstanding, green and purple *Epipactis latifolia*. The exciting stage had already been reached with this family when it only remained to track down one by one the relative rarities still undiscovered. Already, it will be noticed, my father's discoveries had been made in widely separated corners of the country. Whatever its disadvantages plant-hunting is not a sedentary occupation: indeed in that fact lies one of its main attractions. Rare plants grow usually in remote and lovely places, and a botanically planned holiday will take you often to places that for other reasons also you will be grateful to have visited. Connemara or County Kerry, Teesdale or Ingleborough, Ben Lawers or Glen Clova – who would complain at the necessity of exploring any of these places? My father and I have often succeeded in silencing the criticism of the less enthusiastic members of the family by a gentle reminder that to our alleged lunacy they owe many of their best holidays. And if, as is my father's lot, your work involves you in travelling often across the length and breadth of Britain, then nobody can deny that you are lucky to have a hobby as well as a business that thrives on the exploration of new areas.

The business of tracking down the rarer orchids is still some way from completion. Apart from the few that are so rare that I never expect to see them, there are still four that I have every expectation of eventually finding. Two of them, narrow helleborine (*Cephalanthera longifolia*) and the bog orchid (*Malaxis paludosa*), are widely distributed and should by rights have been found long ago; and in the case of *Malaxis* at least it is not for want of diligent searching in eligible sites that we have failed. Of the other two, coralroot (*Corallorhiza trifida*) will necessitate an expedition to the east coast of Scotland, dense-spiked orchid (*Habenaria intacta*) to the west coast of Ireland; and the two expeditions will have to be made at almost precisely the same season of the year. If you have anything else to do except botanize you will find it a lengthy undertaking to collect all the wild flowers of these flowering islands.

Yet we have made steady progress. Even in 1942, when the number of flowering plants still to be found barely exceeded a hundred, we added three new orchids – though one of those, admittedly, was sent to us by a friend. Since this chapter seems to be concerned largely with orchids, it may perhaps afford a revealing illustration of the way the whole collection has developed – of the way indeed that any such collection will most probably develop – if we trace our gradual, though as yet uncompleted, conquest of this one family since our first determined assault in 1932.

In 1933 we added *Orchis incarnata* and *O. praetermissa* [**18**], the big pink

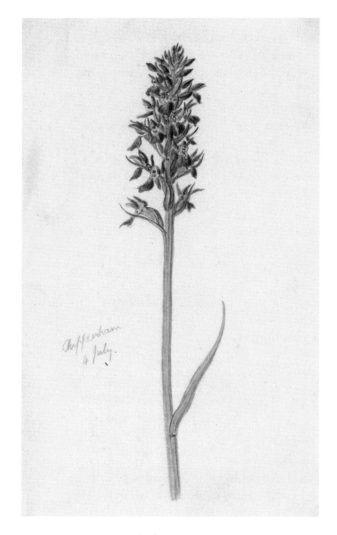

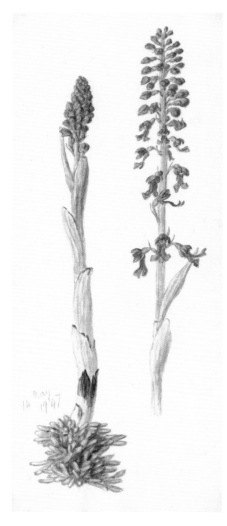

18 *Orchis praetermissa* 19 *Neottia nidus-avis*, bird's-nest orchid

orchids that abound in many a marsh around Cambridge, and the much more interesting bird's-nest, *Neottia nidus-avis* [**19**]. The finding of the last-named was a signal triumph over circumstance. We had spent most of a Sunday morning searching unavailingly for it in the thickets of Rabley Copse, where, together with the greater butterfly, it is reported to grow. Then in the afternoon my father had been driven down to Bryanston,3 where he was due to preach to the school in the evening. The chaplain of the school proved to know where the bird's-nest was to be found. By the time the service had ended evening was already falling. Pausing only to

arm themselves with a torch, the chaplain and my father tumbled into the car and drove with all speed through the gathering gloom. In the twilight, dressed still in their cassocks, they searched a beechwood by the light of a torch; and they found the orchid which, in the broad light of day, we had sought to no avail.

The next years, up till 1938, were, as far as orchids concerned, lean years. We were paying the penalty for our early concentration upon them, and were busily occupied in bringing other less interesting families up to the same standard. 1934 brought only the rare lady orchid (*Orchis purpurea*) [20], from a devoted helper who lived near Canterbury. The following year another helper sent us *Orchis laxiflora* [21] from Jersey; and we ourselves found, in an all too brief stay in Teesdale, quantities of the little crimson rarity of those marshy hills, *Orchis purpurella*. But that was our last addition for many months. The next two years, 1936 and 1937, saw no further successes, but only the beginning of our long, diligent and still unsuccessful quest for the diminutive *Malaxis paludosa*, and an equally diligent and, as far as I was concerned, an almost equally unsuccessful attempt to convince ourselves that a tiny specimen of *Listera ovata* which I had found with *Dryas octopetala* on the hills above Loch Assynt was actually the much desired lesser twayblade (*Listera cordata*).

Then in the summer of 1938 there came a spurt which in two months added more treasures than all the previous four years. It started when a friend of mine at Trinity told me that the previous year he had found a single specimen of the lizard orchid (*Orchis hircina*) [13] near his home on the chalk outside Hitchin. Though not wholly convinced – for I had never heard of the lizard being recorded from Hertfordshire – I extracted a solemn promise that he would let me know at once if it reappeared; and at the end of the term I returned to Ely, forgot the lizard, and became preoccupied with preparations for my youngest sister's wedding which had been fixed for July 1st.[4] On the morning of June 30th I was called to the telephone; the lizard had reappeared, and if I could get down to Hitchin that very day my faithful friend would drive me out to see it. Wedding or no wedding, I went; armed with painting materials and (since the day was showery) an umbrella, I caught the first train down to Hitchin. There could, of course, have been no mistake: of all British flowers the lizard orchid is perhaps the most unmistakable. It was a noble spike, its topmost flowers just beginning to unfurl those long twisting tails. Lying flat upon my stomach I began its portrait; and no sooner had I begun than a thunder-storm broke above and the heavens descended in torrents. There was no time to pause: I could not desert the family for the whole of this hectic day. Holding

the umbrella over my head with my left hand I continued to paint with my right; and meanwhile my nether half, wholly unprotected, was steadily drenched. In the circumstances the resulting picture is, I think, one of my better achievements; it is at least a tolerable likeness of one of the rarest and quite the most fantastic of our British orchids.

July brought a second triumph. My father, with the aid of the keeper, at last discovered the greatest of the botanical treasures of Wicken Fen,[5] *Liparis loeselii*. It is an inconspicuous object, being small and entirely green, and grows as a rule, I believe, hidden in the middle of the thick clumps of sedge which constitute much of the fen. I had sought for it unsuccessfully in the remarkable marsh at Redgrave where the two rivers, the Waveney and the Little Ouse, rise to flow in opposite directions. I know it is there, and it is not an extensive marsh. A prolonged and careful search had shown how hard a treasure it is to unearth. It was the more gratifying finally to have found it. It is one of several plants which, being a lover of bogs and primarily East Anglian, has become very much scarcer since the draining of the fens; but it illustrates the often unaccountable distribution of many of the rarer British flowers by its very local appearance also in South Wales. Why it should be found in East Anglia and in Glamorgan and nowhere in between is a question that I at least cannot attempt to answer. But I know that peculiarities of distribution such as this provide one of the major interests of field botany.

In August of that year we left our beloved Galloway earlier than usual for an expedition down the west coast of Ireland. Ireland has two other orchids besides *Habenaria intacta* that are not to be found elsewhere in these islands, two species of lady's tresses: *Spiranthes stricta* and *S. romanzoffiana*.[6] The latter is supposed to grow in sandhills around White Cove, south of the Kenmare River. We sought it there but found not a trace of it. *Spiranthes stricta* is almost equally local, but in its one locality, the marshes at the top of Lough Neagh, far more abundant. In a very hurried drive from Larne round the north of the Lough and down to Belleek we spent some five minutes on a bleak shingly beach dotted here and there with bushes and little outcrops of grass; and in one of these outcrops we found a single fine specimen of the *Spiranthes*. It caused us, perhaps, less trouble than any other plant of comparable rarity in the whole collection.

It was, however, our last find of any note until 1942. The only new species in the next three years was *Epipactis atropurpurea*, a single plant of which, growing in a cleft in the limestone pavement near Ribblehead and showing no signs of flowering, fired us with a short-lived hope that we had found in its old haunt the greatest treasure of all, the lady's slipper (*Cypripedium*

20 *Orchis purpurea*, lady orchid

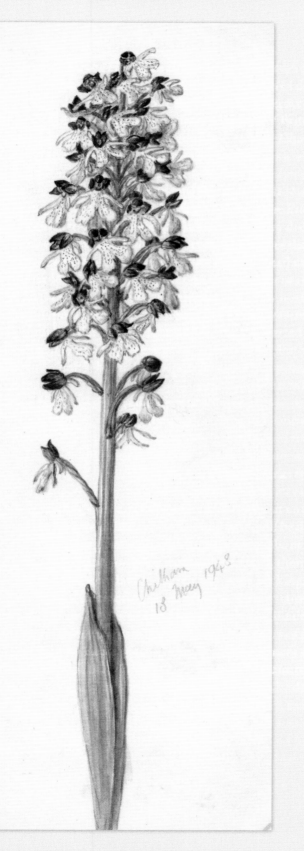

Chilham
18 May 1948

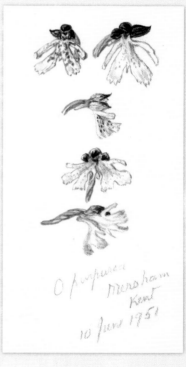

O purpurea
mersham
Kent
10 June 1951

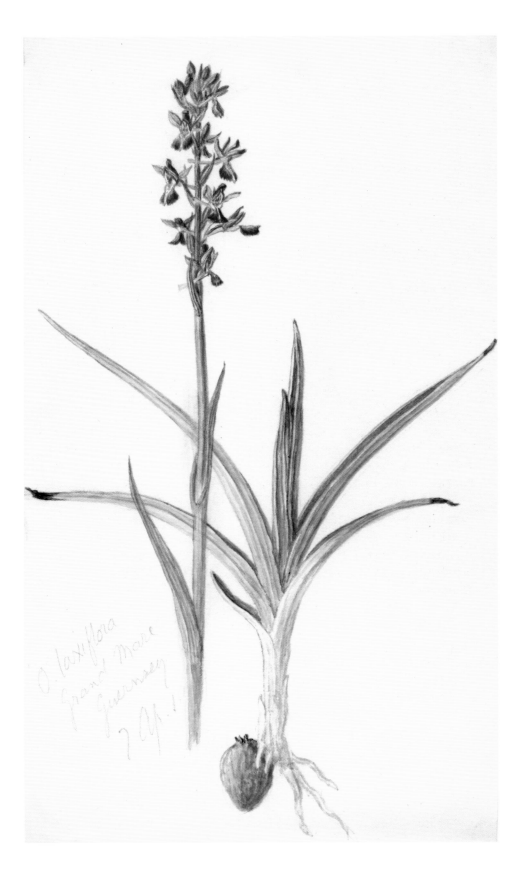

O. laxiflora
Grand Mare
Guernsey
? Ap.

calceolus). As it was, it caused me little enthusiasm. In reckoning our total of new plants for a season I am guided by a simple and no doubt childish rule. Any plant in the first volume of Bentham & Hooker counts as one, whereas the great majority of those in *Further Illustrations* count as, at most, a half. Whatever the experts may say, the multiplication of species is to the non-expert confusing and undesirable. *Epipactis atropurpurea*, and likewise, of course, *E. purpurata* which my father painted in Sussex in 1942, will continue to be stigmatized by me, a non-expert, with the title 'sub-species'. And if once you start on what I call sub-species, abandon hope of ever finishing: the sallows alone will take a life-time, and there will still be the roses for the after-life.

The year 1942 will prove, I fear, to have been the last year in which we added more than one new orchid; but even if we never found a single other, the collection will always henceforth have a rare distinction. For in June of 1942 the miracle of the lizard was repeated, this time with an orchid even rarer than the lizard itself. Another friend at Cambridge had reported to my father that the previous year he had found red helleborine (*Cephalanthera rubra*) [22], and he too had solemnly promised that if it reappeared we should be immediately summoned. Again there was urgent telephoning, and again I took my painting materials, mercifully including at the last moment my bottle of magenta ink, caught a train and was conducted to the spot – though this time I had passed through four days of anguished doubt about whether my journey was really necessary before I reached the conclusion that 'necessary' was a relative term; and this time also, though once more I lay flat on my stomach, there was no thunderstorm to souse my lower half. The locality of *Cephalanthera rubra* – surely the only locality in which it still survives – I am sworn never to reveal. In that one locality I saw for myself, in 1942, at least thirteen plants (though only one of the thirteen was flowering); and I have the best authority for believing that there are in fact many more than that number.

I painted *Cephalanthera rubra* on June 22nd, the very day on which its first flower opened in the sunlight. On June 23rd, still convinced that 'necessary' is a relative term, I travelled with my family to Glen Clova for our annual fortnight's botanical holiday. On the way up from Kirriemuir to the inn near the head of the Glen I searched the pine-woods for *Goodyera repens*, but found nothing but an old friend, *Trientalis europaea*. *Goodyera* eventually had to be sent to us from Argyll by a kindly fellow-botanist whom we met – and indeed helped considerably – under the cliffs of Craig Maud. It was not until we had been in the Glen for nearly a week that I first noticed *Listera cordata* [24] raising a diminutive spike from its pair of small bright green

21 *Orchis laxiflora*

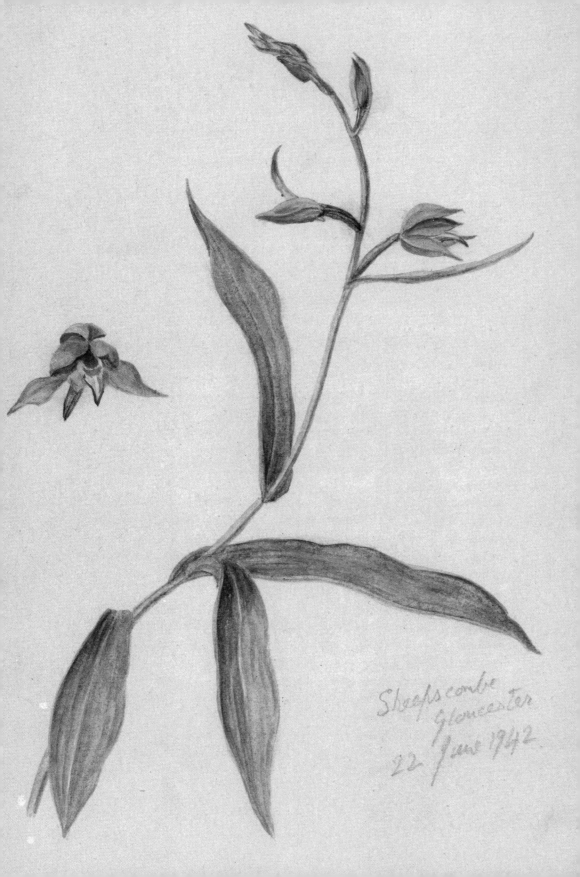

Sheepscombe
Gloucester
22 June 1942

leaves at the edge of a patch of sphagnum. It was immediately distinguishable from my small specimen of *L. ovata* by the deep cleft in its lip, which gives it the appearance, as in *Aceras anthropophora*, of a pair of dangling legs. Once we had seen it, we saw it, of course, everywhere we went. It is always infinitely easier to find a plant that you have found before than a new one; and with each successive rediscovery it becomes less likely that you will fail to see it again. Indeed in the end it becomes possible, even in tracts of country that are unfamiliar and the flora of which is unknown to you, to be certain, by some conditioned sense, that you are about to find a certain plant; and that sense, I find is much more often right than wrong. I have once gained by this process a reputation for second sight. Walking with two non-botanical friends along a lane that I had never before trodden, I suddenly felt the presence of two familiars of the Marlborough days, toothwort (*Lathraea squamaria*) and moschatel (*Adoxa moschatellina*). Describing these flowers in detail, I told my friends to find them. They found them almost at once. And though these two may be common flowers, I have known it happen with rarer plants too. Next time I notice *Listera cordata* again – and years may well pass before I do – I fancy it will be by this sense.

Listera cordata is the latest addition to our catalogue of orchids found. We are proud of that catalogue, not so much because it has upon it, as in fact it has, three or four notable rarities as because of the time and labour bestowed upon, and the diversified entertainment derived from, amassing it. Look at the localities of this one family alone – Devon, Dorset and Wiltshire in the west; Surrey, Kent and Cambridgeshire in the east; County Durham and Lancashire in the north; Caernarvon in Wales, Angus in Scotland, County Antrim in Ireland. It is perhaps not surprising that it has taken us more than ten years to get even thus far in the collection. But we shall get further yet. Even when the exigencies of war and our own work put a stop to wandering, there is still no need to be botanically wholly inactive. So long as there are plants still to find, there is information still to be gathered. The hobby of field botany creates, as, I imagine, do all hobbies, a fraternity. Life for most of us is too busy, and for all of us too short, to enable us to build up our own Floras independently of the aid and experience of others of this fraternity. There are therefore always notes to be compared and hints to be gathered. My father and I have now reached the stage when it is easy for either of us to write out from memory a pretty complete list of all the British plants remaining to be found – though in my own case, not being prepared to put complete confidence in my memory, I have also a little loose-leaf note-book with the list in full and a space beneath each name for entering information acquired. Wherever I go these

22 *Cephalanthera rubra*, red helleborine

4 June '50
J. E. R.

Corrie Clova
30 June '42

days my botanical memory, needless to say, goes with me, and usually also my botanical note-book. Our experiences with the orchids show how much we owe to our friends of the botanical fraternity. There are many field-botanists dotted around the country; and nothing is more enthralling than to talk with a fellow-botanist, when the opportunity arises, about the particular rarities that each has found. Again, the majority of British counties have their own Floras, though several of them are by now sadly out of date; and there are few counties that cannot boast at least one desirable plant. We ourselves make extensive use of a third source of information, Babington's herbarium in the Botany School at Cambridge,[7] every specimen in which is labelled with at least an approximate locality, while some of the rarer are favoured with detailed instructions for the would-be-finder. A fair proportion of our leisure-time, therefore, even when we are cooped up, without prospect of escape in Cambridge or in London, is spent in the pursuit, however distant, of our passion. Discretion is required to avoid exasperating others with our monomania. But for ourselves we find that our hobby affords us an added zest in all we do (for a walk even in the dingiest corner of London may always yield a new goosefoot), and, when an hour of leisure enables us to do nothing, an unfailing source of contented recreation. Few things, I believe, are more desirable for a man than to know how to spend his leisure. We can fairly claim to know how to spend ours. In summer we search for plants – or, failing plants, for birds or butterflies – and in winter we plan what we shall search for when summer comes again.

[In 1947, after this chapter was written, the Ravens' friend Job Edward Lousley rediscovered the military orchid (*Orchis militaris*) in Buckinghamshire, which for 25 years had been believed to be extinct. John painted it on 4 June 1950 [**23**] though did not reveal the locality].

23 *Orchis militaris*, military orchid

24 *Listera cordata*, lesser twayblade

Whittlesford
21 May 1943

CHAPTER THREE

AMONG THE EAST ANGLES
Cambridge, Ely and the Breck

[C·E·R]

CAMBRIDGE – IS THERE ANOTHER PLACE-NAME IN THE LANGUAGE
that stirs so deep an emotion in so many folk? Oxford? In as many, but not,
perhaps so deep. I wonder – and am obviously too prejudiced to decide. To
me the other University always seems so much more studied in its charms,
so much more truly represented by its picture-postcards. It is magnifi-
cent, but on that account less a home than a tourist-centre. Its name is
a trade-mark for shoes, and marmalade, and Dr Buchman's church.[1] It
cannot surely strike a note so intimate, so native to its sons as our less
pretentious town.

For whatever the case with Magdalen Tower, or the spire of St Mary's
and the dome of the Radcliffe Camera, Cambridge does not live in the
hearts of its children by virtue of King's Chapel from the river, or the
Great Court of Trinity; nor even if the red-brick of St John's library and the
timber-work of the Lodge of Queens'! It lives, if I am any judge, by memo-
ries more simple and universal, by the gaudy fruit-stalls of the Market
Place, or the elms and weeping willows of the Backs, or the narrow lanes
where the gas-lamps shine double in the wet. Certainly for me, in all the
years of my exile, the word called up a picture of the alley-way by the Round
Church, of Ram Yard, and the barber's with the unpronounceable name, as
I used to see them in the winter of my fourth year when I lived in rooms in
St John's Road. And if, when my retirement comes, I have to go away again,
I expect to be haunted not by the gracious presence of the Fellows' Build-
ing of my college, but by some wholly unexpected vision like the glimpse
of Falcon Yard as one turns into St Tibbs Row on the way back from the
lecture-rooms to lunch.

Such memories, like the rest of our life-stuff, are not of the highlights
and important occasions: all the more on that account do they and the
place to which they belong sink deeply and spread widely. Cambridge,
though no doubt there are many who sojourn here as strangers, gives
lavishly of her citizenship and into those who receive it instills a secret

25 *Aristolochia clematitis*, birthwort

and more than filial devotion. In 1932 we had been away for twelve years. The family, all Cambridge-born, had left almost too early in their lives to remember it. To me and to my wife (though for myself the interval had had its compensations) the return was Paradise Regained.

For the botanist there are few towns or counties in the Kingdom more reverend or more interesting.[2] When the quaint but illustrious Pole, Samuel Hartlib, wrote in 1661 to his friend the Master of Jesus College of John Ray that his 'Catalogus Plantarum will be a florid ornament to Cambridge' he not only sealed an achievement, but predicted an inheritance. For from the date of that first record of its flora – the first British county record – Cambridge has had a continuing succession of field-workers and a series of admirable catalogues. Peter Dent, Ray's collaborator, published in 1685 the second Appendix to the Catalogus. John Martyn and his son Thomas Martyn, both Professors of Botany in the University covered the period from 1727 to 1763 with lists that add a number of other plants to those recorded by Ray and his friends. In 1763 Israel Lyons' Fasciculus listed 105 plants not noted by Ray; in 1785 Richard Relhan published the first of the three editions of his Flora Cantabrigiensis; and in 1829 and 1835 the Rev. John Stevens Henslow, Darwin's teacher and friend, indicated in his Catalogue of British Plants all the species found within the county. Then in 1860 came Charles Cardale Babington's admirable Flora of Cambridgeshire, a little volume excellent in its record of previous literature and thorough in its reports of localities. A.H. Evans' 1939 book, A Flora of Cambridgeshire,[3] brings the list up to date and contains some notable additions made chiefly by himself, by Alfred Fryer and Dr W.H. Mills.[4]

From so full a set of documents it is easy not merely to discover the distribution of our plants, but to trace the history of their status. Ray wrote when the fenland had hardly yet been drained; when treasures like the fen orchid (Liparis loeselii) and at least two of the three sundews were found on 'Hinton and Leversham Moors' within an easy walk of Great St Mary's; and when the 'Hill of Health' now, and less appropriately, called 'Mount Pleasant' was one of the special sites to whose wild-flowers he devoted a separate list. Considering how impassable was the north of the county, and how vastly its whole character has been changed by drainage and agriculture, it is astonishing to find how little of its flora has been lost, and how persistently plants once established in a locality maintain themselves. It is recorded of Stephen Hales, the first great physiological botanist, that when in 1704 he explored Cambridgeshire for 'simples' he did so 'armed with candle boxes and Ray's Catalogus'. It would be worthwhile to do the same today; for the bloody crane's-bill (Geranium sanguineum) still has its only station at the

Hildersham
29 June
1940

26 *Astragalus danicus*,
purple milk-vetch

27 *Dianthus deltoides*,
maiden pink

place described by Ray – 'in the Devil's ditch also in a wood adjoining to the highway between Stitchworth (Stechworth) and Chidley (Cheveley)'; the spiked speedwell (*Veronica spicata*) has recently been rediscovered 'in a close near the Beacon on the left-hand of the way from Cambridge to Newmarket, in great plenty'; the 'Mountain Stone-parsley', as he named it, (*Seseli libanotis*), holds its own 'on Gogmagog Hills in Cambridgeshire' as do the field ragwort (*Senecio campestris*) that we found on the Fleam Dyke, the bastard toadflax (*Thesium humifusum*), the purple milk-vetch (*Astragalus danicus*) [26] and, very splendidly, the perennial flax (*Linum perenne*). And if the broad chervil (*Caucalis latifolia*) 'by the foot-way side to Cherry-hinton church and in many other places' has now disappeared, its smaller cousin *Caucalis daucoides* was found in 1939, after thirty-five years' absence from our records, by me and my son-in-law in a ploughed field above the Linton to Balsham road.

The same persistence is true of plants recorded since Ray's time. Thus in the very rare Second Appendix to his *Catalogus* published by his friend the Cambridge chemist and doctor Peter Dent in 1685 occur the maiden pink (*Dianthus deltoides*) [27] on the Furze Hill at Hildersham and the birthwort (*Aristolochia clematitis*) [25] 'in several hedges at Wittlesford'; the former is still found in at least two big patches at the same station, and almost opposite the present Whittlesford post-office there is a flourishing growth of the *Aristolochia* between the road and an allotment. So too the tower rock-cress (*Arabis turrita*) [28] unknown to Ray except as a foreigner, but in 1722 shown to his friend Samuel Dale 'by Mr J. Andrews on the garden walls of Trinity College'. First recorded in 1763 by Thomas Martyn, this rock-cress can still be seen in what is probably its sole remaining station in Britain 'near the brook in the walks of St John's College' – as Babington put it. Babington's own first record, in 1828, of the grape hyacinth (*Muscari racemosum*) [29] 'under hedges between Hinton and the Gogmagogs' refers no doubt to the same place in which my son found it in April 1934; and the hyssop loosestrife (*Lythrum hyssopifolium*), though no longer found as in Ray's time 'in the corn fields and shadowy lanes about Hoginton (Oaking-ton) and Histon' or 'in many other places about Cambridge', still abounds, or did when I saw it in 1941, in Babington's locality, the 'damp hollow by the Chippenham Avenue'. Even in the town of Cambridge itself the stink-ing goosefoot (*Chenopodium vulvaria*), which Ray noted as 'under the wall that joynes to Peter-house Tennis-court, and at the Tennis-court end and backside, and in several other places', survived – at lest until 1941 – where Babington recorded it on Mount Pleasant. And I found myself a plant of balm (*Melissa officinalis*), which Israel Lyons reported from Garret Hostel

28 *Arabis turrita*, tower rock-cress

9 Aug. '48.

St John's College
Cambridge
23 April '48

Lane in 1763, in the lane at the side of the old wall between Emmanuel College and Park Terrace – though this should doubtless be treated as a casual rather than a denizen.

Considering the huge development of modern drainage, agriculture and building it is remarkable that the losses in our flora have been so few. In the fens the two great ragworts that Ray knew well have disappeared: so has the marsh sowthistle which Relhan recorded from the neighbourhood of Stretham; this unlike the *Senecios*, still survives in a single locality in Norfolk where we saw and painted it in 1933. The water germander (*Teucrium scordium*), which Ray knew 'in many ditches … and osier holts about Ely city', has now become exceedingly rare, though John found it in Alfred Fryer's locality beside a ditch between Sutton and Mepal. The fen orchid (*Liparis loeselii*) has long ago disappeared except from a tiny area at Wicken; and there I have only once seen it: it may still survive at Chippenham, but the eligible area is large and the plant is notably difficult to discover: it grows in very wet places, at the roots of great tufts of rushes; its two leaves, though characteristic, are not striking, and its flower-spike is very inconspicuous.

The losses on the chalk have been hardly more numerous. One or two of the orchids the musk (*Herminium monorchis*) and the early spider (*Ophrys aranifera*), both of which were first noticed by Ray in the little Appendix to his *Catalogus* that he published in

29 *Muscari racemosum*, grape hyacinth

1663 on the eve of his Continental travellings, seem to have disappeared: the first was always rare and the second probably casual. The spasmodic appearance of the lizard (*Orchis hircina*) since 1920 suggests that even the early spider may some day be seen again. The cat's-ear (*Antennaria dioica*) which Ray knew from various places on Newmarket heath 'in great plenty' has gone altogether; the ling (*Calluna vulgaris*), which he found there and on the Gogmagogs, has gone except from the Suffolk border. And better farming has banished the larkspur (*Delphinium ajacis*) [32] and the violet poppy (*Roemaria hybrida*), and has greatly diminished the number of other

cornfield weeds; the corn cockle (*Lychnis githago*) – still occasionally found near Ely; the field buttercup (*Ranunculus arvensis*); the thorow-wax (*Bupleurum rotundifolium*), which we have only once seen, near Caldecot, and similar denizens.

The area that has suffered most is the patch of heath and bog on the greensand at Gamlingay – a place, thanks to the energies of the Rev. Leonard Jennings, parson there a century ago, well-known to me in my

30 *Malva moschata*, musk mallow 31 *Lathyrus palustris*, marsh pea

entomological days as the haunt of a number of rare insects. Ray himself devoted one of his last days in the University in June 1662 to a fuller exploration of the plants of this neighbourhood, and found at least seven species not included in the substantial local list already printed in his *Catalogus*. His two friends, Peter Dent the Cambridge doctor, and Samuel Dale his neighbour at Braintree, went over there in 1684 and found the bog orchid (*Malaxis paludosa*), which Parkinson had first discovered a generation before in Romney Marsh. Dent also found there the cranberry (*Vaccinium oxycoccos*) and the cross-leaved heath (*Erica tetralix*) and Relhan a century later

32 *Delphinium ajacis*, larkspur
33 *Primula elatior*, oxlip

7. April. '17

added the bell heather (*Erica cinerea*). These, and many others, have long disappeared – though there are still a lot of species found only there in the county, most of them – like wood sage (*Teucrium scorodonia*) or musk mallow (*Malva moschata*) [30] – common enough in other parts of Britain.

Nevertheless, in spite of changes that have transformed the whole landscape in the past three centuries, it is astonishing how much of the wildlife still remains. In the fens, where human interference has been most revolutionary, some few species only survive in the National Trust's reserve at Wicken where the level of the water is artificially maintained and the bushes, which would soon turn the whole area first into a jungle and then into a forest, are systematically destroyed. Here and at Chippenham, where there is an almost finer area of ancient fenland, the flora and fauna can, with care, be preserved. Two plants at least – the marsh pea (*Lathyrus palustris*) [31] at Wicken, and the umbellifer *Selinum carvifolia* at Chippenham – are perhaps comparatively recent arrivals; for the pea though not uncommon in the Broads was noted in Cambridgeshire first by Henslow and the umbellifer, now definitely common if you know where to look for it, was only recorded in 1882: possibly it had been previously mistaken for the rather similar milk parsley (*Peucedanum palustre*) found at Wicken and famous as the usual food-plant of the swallow-tail butterfly. A speciality of the ancient woodlands of Cambridgeshire, such as Overhall Grove and Hardwick Wood, is the oxlip (*Primula elatior*) [33].

Outside these preserves the ordinary ditches of the fens, where they are not too frequently and ruthlessly scoured, maintain a rich and often very gay flora. When we came to Ely in 1932 a first walk down Angel Drove and round the ditches to the west of the railway introduced us to it. John came back with the greater spearwort (*Ranunculus lingua*) a glorious plant which completely eclipsed the very large *Ranunculus flammula* for which I had unnecessarily wallowed in a bog in Kircudbrightshire a few days before. Afterwards that area gave us water violet (*Hottonia palustris*), flowering rush (*Butomus umbellatus*), both the water parsnips (*Sium latifolium* and *S. erectum*), frogbit (*Hydrocharis morsus-ranae*), great horsetail (*Equisetum telmateia*), and a number of other aquatics. Marsh stitchwort (*Stellaria dilleniana*) I found north of the city, and for *Limnanthemum nymphaeoides* one must go south to the Old Ouse between Stretham and the Cam: but these are within easy reach.

In addition there were a sufficient number of cornfield weeds to keep us busy. The yellow-flowered, mauve-lipped hempnettle (*Galeopsis versicolor*) was the commonest and most garish; but on occasion cornflower (*Centaurea cyanus*) [34], broad spurge (*Euphorbia platyphyllos*) and others new to us

rewarded the search. Stubbles are not my favourite hunting-ground; and we have still gaps in our collection of their inhabitants. But, as giving an object for a walk on a bleak autumn afternoon, they are not to be despised.

It was to such a walk on September 7th 1936 that I owe my one definite addition to the county's flora – to such a walk and to the ancient and beloved Aberdeen terrier who was my companion. He had reached a shape and age which could not long sustain the enthusiasm of his setting-out:

34 *Centaurea cyanus*, cornflower

G. spurium Vail
Ely 7 Sep

35 *Galium spurium* var. *vaillantii*

also he had acquired a protective technique of pottering. We had been up through the orchards and out into the fields beyond; he was perhaps tired: but as usual he put up a camouflage of inspecting nuisances, and when we passed along the allotments every potato seemed to demand a visit. There was nothing for it but to wait; and in waiting to 'eye the landscape o'er'. A weed, a goose-grass, at my feet, a large rampant creature but not, surely not, our old enemy cleavers. The flowers were not white but green and tiny; and the seeds were definitely different. It was almost certainly *Galium spurium* var. *vaillantii* [**35**], an alien that is established at Saffron Walden. I rang up Dr Mills that evening: he came over, confirmed my identification, and next day assured me of its accuracy. If it had been a new species I should have felt obliged to name it *Galium canio-aberdoniensis*! As it was we had achieved its first Cambridgeshire record.

Such achievements, in a country where new weeds are constantly establishing themselves, compensate the seeker for many a dull walk round the rubbish-heaps and railway-sidings of the towns. For myself I confess that the *Galium* is my only discovery of any importance, unless the narrow-leaved cress (*Lepidium ruderale*) and the pale willowherb (*Epilobium roseum*), both from my own garden at Christ's College, are worth mention – though this is not for want of effort. But when my son found, and, in spite of the

efforts of a curious sheep succeeded in sending to me in masticated but recognisable condition, a noble specimen of *Madia sativa* from a cornfield in Montgomeryshire in 1941, and when in Cambridge Mr Gilbert-Carter[5] showed me a large patch of *Bunias orientalis* off Brooklands Avenue and some lovely plants of the moth mullein (*Verbascum blattaria*) on the railway behind Sedley Taylor Road in 1942, I felt that it was probably my blindness that was to blame, and for a few weeks searched waste places with renewed enthusiasm. It is not (I may add) a job that I enjoy: I am too self-conscious; and the surroundings are usually too depressing. But I live in hope that it may fall to me to be the first to welcome the Oxford ragwort (*Senecio squalidus*) when at last it finishes its journey from Bletchley, or even to find one of the several casuals which are still on our list of desiderata.

My sight is to blame. So my son maintains when he tries to explain why he is so much better than I am at spotting new species. Perhaps he is right: but his own is (I am pretty confident) quite phenomenal. During his undergraduate days he played golf frequently and not unsuccessfully. He played it, moreover, with a seriousness which he never showed in any other athletic exercise. Yet from the links at Flempton (on the way to Bury St Edmunds) he brought back our first specimens of the knotted clover (*Trifolium striatum*) and shortly afterwards of the subterranean (*Trifolium subterraneum*); from the Gogmagogs after a round played before breakfast on the day of the Silver Jubilee the spring cinquefoil (*Potentilla verna*)[6] – and this, like the other two, is not an easy or specially obvious species; and finally from Worlington, from the bunker guarding the last green, the very rare broomrape *Orobanche picridis*, which somehow he managed to distinguish on the spot from the familiar but very similar *O. minor* which he had previously known at Marlborough. It was a proud moment for us both when we got his identification authoritatively confirmed.

But we must admit that our success with the Cambridgeshire plants is largely due to the friends who have already been mentioned and to the kindness of other members of the university Botany School. Knowing that we did not collect dried specimens, or even gather plants if they were rare or in danger, they showed us many treasured finds and helped us most generously to make our pictures complete. It is due to them that there is now hardly a single species in A.H. Evans's volume, except the few definitely extinct, which we have not seen and painted. They have opened to us fresh beauties in a countryside which otherwise has little but its wide horizons and ever changing light to commend it. They – and their predecessors – and for us especially 'the excellent Mr Ray' – have done much to make more blessed one of the most attractive of earthly dwelling-places.

Cambridge.
6 May '46

CHAPTER FOUR

THE COLLECTION'S PROGRESS
Umbellifers

[C·E·R]

'HOW EVER DO YOU MANAGE TO GET THEM DONE? ALL THESE hundreds – and you so busy!' That is the usual, and not always merely conventional, comment upon our collection. In ten years we have managed to see the vast majority of the flora of the British Isles: we have painted at least two thousand life-size portraits of them: and we are neither of us otherwise unemployed, are indeed two normally hard-working folks. How is it done? To answer that question it might be enough to ask the question how many hours he or she spends on golf or bridge, cinema or concert, light literature, knitting or sleep. The average plant takes perhaps an hour and a half to paint – that is a very liberal allowance. Three thousand hours spread over ten years is less than an hour a day: shared between the two of us it does not amount to a very excessive allowance for recreation.

There is also, of course, the finding of the plants; and that is a different problem, not so much of time spent as of travel and expense. We get about a month's holiday each year, generally in August, a rather dull time for plants, and in places not chosen primarily for their botanical riches. The rest of our collecting is done in our own neighbourhood, or on travels undertaken for another and professional purpose. The number of hours actually devoted to searching is not large – very much less than I used to give to playing or watching cricket. For, after all, most of our plants have been found from the window of a car when we were out on business or without any special time or place being set aside for the search.

We are not proposing in these chapters to go through the British flora and to repeat what Mr Robert Gathorne-Hardy has so excellently done.[1] But to illustrate the gathering of our collection it may be worth while to take one Natural Order or family and see how we have gradually completed it. Any family would serve the purpose. We will choose one which is commonly condemned – the 'umbrella-bearers' as Reginald Farrer called them.[2] He, and Mr Gathorne-Hardy following him, brackets them with the crucifers as objects of dislike; and to most people they stand for all that is

36 *Chaerophyllum sylvestre*, wild chervil

dull and vulgar and weed-like. For us, as has been noted, they were at first ignored: umbellifers, docks and pondweeds went the way of sedges and Cryptogams; we were too busy to be bothered with plants that had no grace of flower to commend them. I have a sneaking feeling that my partner still regards them as uninteresting – that at least he does not share my devotion to them: and this is one reason why I have chosen them as the example of how our collection was made – I shall not be repeating what he is likely to say.[3] For myself the more I regard them the more I admire.

A few – goutweed pre-eminent among them – every gardener must detest. Goutweed is the most invincible of all invaders, but until now I have never had a garden good enough for it to invade! So my hatred is only theoretical. Fools' parsley, from which I suffered at Ely, is a defenceless annual, too easy to be worth resenting. For the rest is there anything more lovely than the spray of filmy foam which the three successful chervils dash against our hedge-rows, or more splendid than the upstanding symmetry of hogweed or wild angelica, or more fascinating than the rarities of the tribe with which we in Cambridge are so favoured? They are not too easy to identify; that is perhaps one of the objections to them: for most of them vary considerably and some are almost as Protean as hawkweeds. But in fact a little care will disentangle all their vagaries.

After all it was with the umbellifers that the first serious attempt at plant-classification in Britain was made; and this gives a sentimental appeal to the study of them. When Robert Morison, first keeper of the Royal Garden of St James, first professor of botany at Oxford, and first road casualty on the site of what is now Trafalgar Square, launched his new system of taxonomy, it was with a monograph of this family that he demonstrated it. And Morison, 'Scotus Aberdoniensis', and with all the qualities of good and bad which those words imply, is an interesting figure. From the day when he was wounded with Montrose at Brig o' Dee, till the day when he was knocked down by the pole of a stage coach on his way from his lodging in Green Street Leicester Fields to Northumberland House and Whitehall, to collect the money which Charles II promised but never paid, his career is full of an awkwardness which destroys its romance and almost spoils its pathos. But he did a great work for botanical gardens and deserves more consideration dead than he received (or deserved) when living. We will choose the umbellifers *in piam memoriam*.

The collection began with one of the few that no one would suspect of kinship with the family – with Peg's masterpiece of the *Eryngium* which we got in 1930 at Goleen; and (I think) with an impressionist rendering, also by her, of hogweed (*Heracleum sphondylium*). But it was not till 1932

37 *Sanicula europaea*, sanicle 38 *Foeniculum vulgare*, common fennel

that we really included them in our objectives; and even then our first would have been ignored had we not found it in January. We had gone to stay for the New Year with friends at Ipswich and on January 6th had driven over to Felixstowe. It was a pleasant day and the mudflats near the fort were drenched in wintry sunshine. On the banks where dredgings had been dumped, as on the sands turned by rabbits in the Breck, bur chervil

(*Chaerophyllum anthriscus*) was abundant; and some of it was in flower. There on the coast it seemed to pay no heed to the seasons. No one who waits impatiently for the first snowdrops and aconites will need to be told how eagerly we fixed upon a plant that was ready for painting in mid-winter.

Having once made a start obviously it must be followed up. In April we had a day trip to Llandudno and found alexanders (*Smyrnium olusatrum*) just coming into flower on Great Orme's Head. A short visit to Marlborough early in May produced wild chervil (*Chaerophyllum sylvestre*) [36] and pignut (*Conopodium denudatum*): a couple of days in Surrey a month later sanicle (*Sanicula europaea*) [37] in a copse on the way from Redhill to Nutfield[4] and goutweed (*Aegopodium podagraria*) outside the station at Merstham; and a clergy school at Gloucester (when I spent an hour trying to hear a marsh warbler) water dropwrot (*Oenanthe fistulosa*). The bank of the Mersey at Oglett gave us wild carrot (*Daucus carota*) and a marshy hollow in the dunes at Ainsdale *Apium nodiflorum*. An excursion from New Brighton pier along the sand hills to Meols (a deliberate and successful attempt to find Isle of Man cabbage, *Brassica monensis*, and the well-established alien *Cotula coronopifolia*) yielded *Oenanthe lachenalii* and burnet saxifrage (*Pimpinella saxifraga*); and another into North Wales to get the wild columbine produced a flowering specimen of marsh pennywort (*Hydrocotyle vulgaris*).

In August we went down to a locum-tenancy at Lapford in the middle of Devon: the neighbourhood was full of new plants – nothing rare, but a summer in the West Country had not been ours for many years and there were butterflies: so we did not worry about umbellifers. But fool's parsley (*Aethusa cynapium*) in the garden, hedge parsley (*Caucalis anthriscus*) and hemlock (*Conium maculatum*) in the hedgerows, hemlock water dropwort (*Oenanthe crocata*) in the ditches and corn caraway (*Carum segetum*), a single specimen, in a piece of rough roadside; wild angelica (*Angelica sylvestris*), a fine pink form, and samphire (*Crithmum maritimum*) on the coast near Bude, common fennel (*Foeniculum vulgare*) [38] on the marsh outside Bideford and rough chervil (*Chaerophyllum temulum*) on an expedition to Sidmouth were somehow fitted in with more exciting things. The year ended with common parsnip (*Pastinaca sativa*), a plant curiously rare in the fenland, on the roadside between Stretham and Ely in mid-September.

In 1933 we were living at Ely and during my residence in the Cathedral during June and July had plenty of time for exploring the near neighbourhood. The ditches on the Angel Drove (Angel Pavement as we called it in uncomplimentary reference to Mr J.B. Priestley)[5] produced lesser water parsnip (*Sium erectum*), generally abundant and distinguishable by the size of its general involucre from the very variable *Apium nodiflorum* some forms

of which it closely resembles. Water parsnip (*Sium latifolium*) is found in some of the larger ditches; and so is fine-leaved water dropwort (*Oenanthe phellandrium*). Bastard stone parsley (*Sison amomum*) [39] is frequent in the roadsides round the city. Pepper saxifrage (*Silaus pratensis*) is rarer but we found it near to Fordham.

It was not easy for me to get far afield, but Wicken is within a few miles and milk parsley (*Peucedanum palustre*), familiar as the food plant of the swallow-tail butterfly, is conspicuous in flower and common in the sedge-fen. But the other fenland species was a real find. I had gone over to Chippenham Fen in the hope of seeing the fen orchid *Liparis loeselii* and was searching the inner part of the area when I noticed an umbellifer not yet fully flowered whose leaves were very like *Peucedanum*. Being tolerably certain that the milk parsley was not a Chippenham plant, and finding this species pretty common, I searched carefully for a specimen with a well-formed umbel; found it; saw that the involucre so conspicuous in *Peucedanum* was not there; and knew I had found something strange to me. Bentham & Hooker told me that it was *Selinum carvifolia* [40] but spoke of it as very rare and newly discovered. It was not until Dr A.H. Evans' *Flora of Cambridgeshire* was published in 1939 that we learned that Chippenham was one of its original localities: it is in fact reasonably abundant in certain spots there.

Another rarity – perhaps the scarcest of all Cambridgeshire plants – we found in the same month in its chief habitat near Cherryhinton. *Seseli libanotis* has been known from this locality for at least 150 years – since Relhan recorded it in 1783 in the first edition of his *Flora* – or more probably for 250: for John Ray, under the English name of 'Mountain Stone-Parsley or a middle sort of Burnet Saxifrage', recorded it 'from the Gogmagog Hills in Cambridgeshire' in his *Synopsis* of 1690.[6] It is not a plant that the inexperienced would easily notice: but for those who admire umbellifers it will always seem to have a peculiar air of distinction.

Our August holiday in Galloway gave us two further species: whorled caraway (*Carum verticillatum*) which is abundant among the heather all over the low moors; and a belated specimen of Scotch lovage (*Ligusticum scoticum*) [42] found after quite a climb on the top of a detached rock on the coast at Dunure. We had done thirty-four species by the end of a year's collecting – rather more than half of those found in Britain; and this proportion was by then probably true of the flora as a whole – except that we had not yet begun the sedges and grasses.

This omission was corrected in 1934, making a start during our holiday in Galloway. This, and an official visit to Finland in July, made it a poor

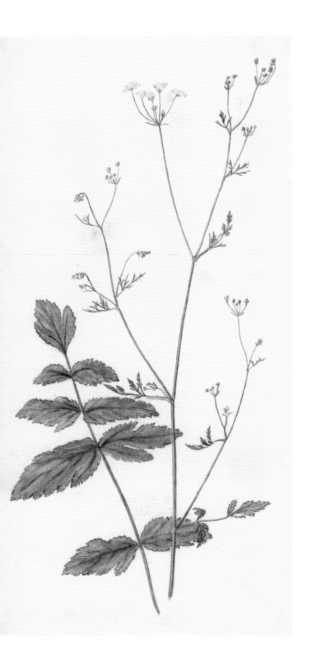

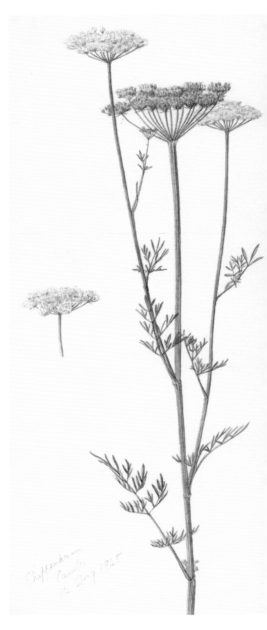

39 *Sison amomum*, bastard stone parsley

40 *Selinum carvifolia*.

41 *Peucedanum officinale*, sulphur weed

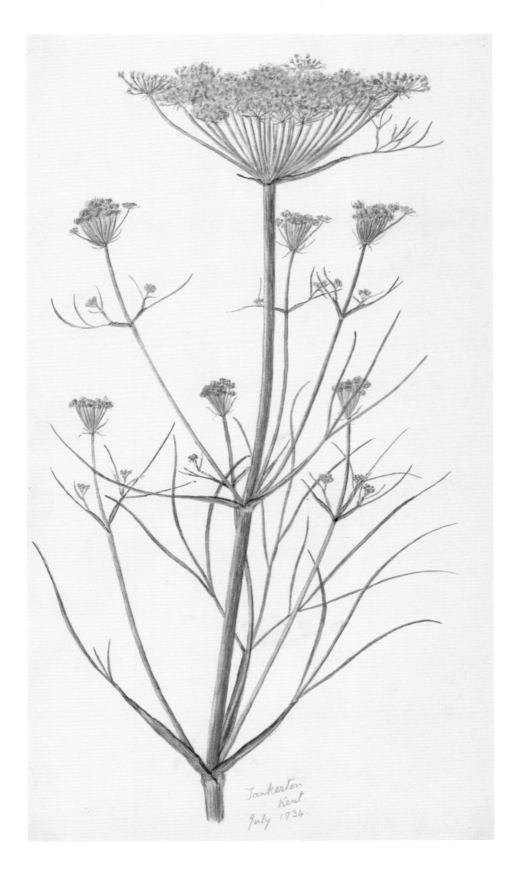

Tankerton
Kent
July 1934.

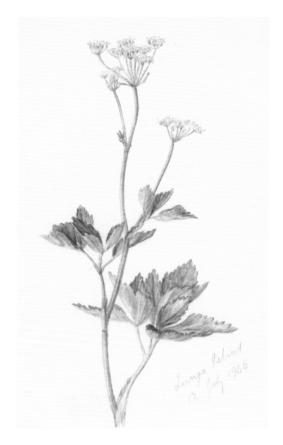

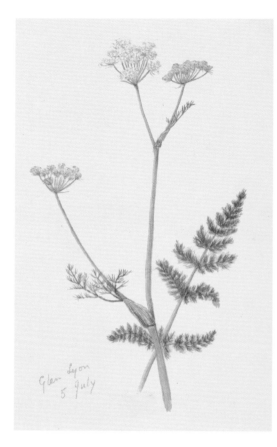

42 *Ligusticum scoticum*, Scotch lovage 43 *Meum athamanticum*, meu, spignel, baldmoney

season for other plants; and we only added one new umbellifer, sulphur weed (*Peucedanum officinale*) [41], brought to us by a cousin's sister from Tankerton on the north coast of Kent. From this lady we received a number of Kentish species many of them new to us: after some hesitation we decided that the collection could not be rigidly limited to plants that we had actually seen growing ourselves, though we have never exchanged plants or gone outside the circle of our friends for help in obtaining them. In the autumn of the next year we had slender hare's-ear (*Bupleurum tenuissimum*) from the same lady, from Whitstable.

In 1935 our expedition to Teesdale gave us two umbellifers, each of them within a few yards of the inn at Langdon Beck. On the bank of the stream near its crossing of the road was a flourishing colony of sweet cicely (*Myrrhis odorata*) [44], which we had noticed driving down from Scotland in the previous September when it was in seed. Further down, and nearer to

Widdybank Fell, was a plant of *Peucedanum ostruthium*, possibly an escape from cottage premises – though who nowadays grows the masterwort or is in the least likely to have imported it? Later on, when we were staying on Loch Tay, we got much interest out of the search for *Meum athamanti-cum* [43] – largely because of its fantastic bevy of names. When the usually sedate, not to say pedantic, Bentham & Hooker so far forgets its propriety as to label a plant 'Meu, Spignel, Baldmoney', the rich nonsense of those syllables introduce a new note into botanical research. We had no reason to suppose that this was more beautiful or desirable than any other unfound species, but its names gave it a distinction. We resolved not to leave Scotland without it; and on the last of our days, July 5th, at the top of Glen Lyon we found it – a fine patch looking curiously moss-like and submarine in the texture and colour and its leaves. In June that year we had

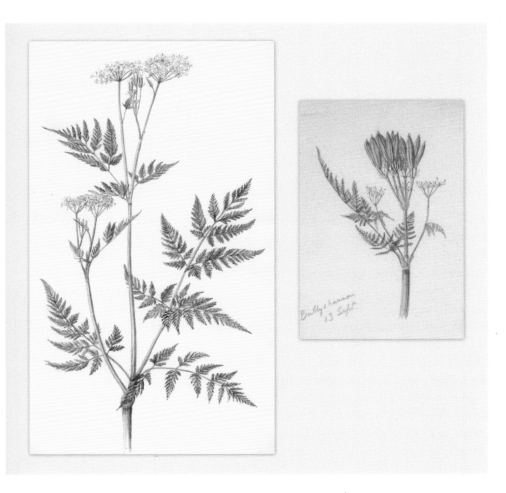

44 *Myrrhis odorata*, sweet cicely

Bupleurum opacum sent us by a friend with other plants from Jersey; in our August Galloway holiday we found *Apium inundatum* in the shallow edge of a backwater of the Minnoch just above the bridge that leads from High Minniewick to Holm farm; and in September John, who had gone to stay at Marazion in Cornwall and painted Cornish heath (*Erica vagans*), autumnal squill (*Scilla autumnalis*) and several other rarities, brought back for me a specimen of *Caucalis arvensis*.

In 1936 engagements took me in June to Portsmouth and Weymouth, and gave us some days at Branscombe. On the way we had a few hours at Bosham and in the harbour found what we had searched for unsuccessfully at Ely, *Apium graveolens*. Why the wild celery, which has been known at Cambridge since the seventeenth century, when nobody in England thought of growing or eating it, has nowadays become scarce, is not very clear. We have in fact found it since 1936 near Sutton in the Isle, but it is no longer common even in districts where the cultivated plant is extensively grown. On the South Devon cliffs we found *Daucus gummifer* in abundance, and in a rough field on the top of High Peak west of Sidmouth, *Oenanthe silaifolia* [45].

Calling in at Teesdale on the way back from our summer holiday I found greater burnet saxifrage (*Pimpinella major*) on a rocky islet in the river and secured it after hazardous gymnastics on rounded stones of uncertain stability and invariable slipperiness. At Ely on our return we searched stubble-fields and found, among other weeds, shepherd's needle (*Scandix pecten-veneris*) and *Caucalis nodosa*. Why these two, for which we had traversed the same fields each autumn, should have turned up together, is perhaps worth asking: but the only answer must be that the ways of casuals are peculiar, and that a field which is infected with (say) striated catchfly (*Silene conica*) or flixweed (*Sisymbrium sophia*) one year may not show a single specimen for many seasons before and after.

Next year was not very exciting. We got a few days at Burnham Overy between examinations and examiners' meetings, and found garden chervil (*Chaerophyllum cerefolium*) – apparently established but evidently a garden escape. Caraway (*Carum carvi*) from Fiskney in Lincolnshire in June and parsley (*Carum petroselinum*) from the Crumbles near Eastbourne in September belong to the same category. *Oenanthe fluviatilis* from a dyke near Mepal in July was more interesting: but its specific distinctness is not, to me, very certain: between it and *Oenanthe phellandrium* the difference seems to depend upon the depth and movement of the water – as it does in the case of some of the water-buttercups.

In 1938 we added two of the rarer Cambridgeshire species. Thorow-wax

45 *Oenanthe silaifolia*

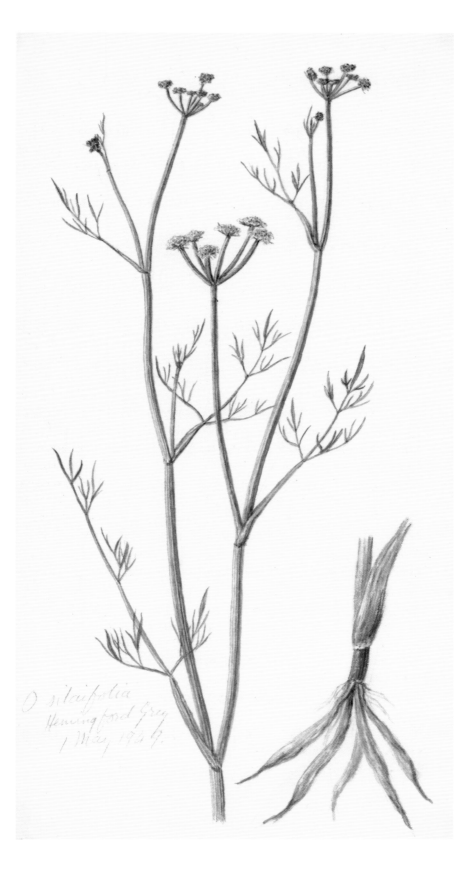

O silaifolia
Hemingford Grey
1 May 1954.

(*Bupleurum rotundifolium*), like many of the annual cornfield weeds, has become scarce with the introduction of machinery and the more drastic cleaning of the fields. In the seventeenth century Ray knew it 'on the left hand of the foot-path leading to Teversham' in the early eighteenth century Dr Covel, Master of Christ's College, had it growing in the garden of the Lodge: in the nineteenth Babington reported it from a number of localities from Upware to Odsey and from Hildersham to Gamlingay. Now, though it can still be found to the west of Cambridge, it is very uncertain in its appearances. John was shown it by our friend Dr W.H. Mills whose knowledge of the Cambridgeshire flora is quite unrivalled. The other find, *Carum bulbocastanum*, shares with *Seseli libanotis*, the distinction of being the county's rarest resident umbellifer; and shares with it too its most familiar locality. There it is the rarer of the two species, an ordinary-looking plant growing usually among a clutter of wild carrot and chervils, and, except for its involucre, almost inseparable from the pignut. But it has a wider range than *Seseli*, growing all along the chalk towards and beyond the Hertfordshire border. We had known its haunt for some time, but each year had failed to find it. Now on July 8th, ten days before he added the thorow-wax, John discovered it in the exact spot where we had previously searched.

A similar discovery fell to me in the following June. My son-in-law,[7] who had just begun to search for plants, had driven me out for a breath of air to Linton. We had found a few plants, corn bedstraw (*Galium tricorne*) among them, in a rough patch just outside the village, and had worked up a field-path onto the chalk. In a derelict bit of ploughed land on the crest of the hill, on the right hand side of the path, we found several plants of an introduced species not found for thirty years in the county and supposedly extinct, small chervil (*Caucalis daucoides*). There was no mistaking the small, but bright pink, flowers and the large prickly seeds standing out in bunches of three or four on their long stiff pedicels. It is a low-growing weed with fine-cut fern like leaves, not unlike *Caucalis nodosa*, and found in exactly the same habitat. I went back in the following season to see if it had survived, but though the field did not seem to have been cleaned, the plant had disappeared. Possibly the bitter weather early in 1940 had killed it. [Ten years later John was to find the other introduced member of the genus, the broad chervil (*Caucalis latifolia*) [46] at Lakenheath in Suffolk].

The last umbellifers to be added have been two very local species in 1940. The first, *Trinia glauca*, I had hunted over the slopes of Swallow Point north of Weston-super-Mare several years before. How I missed it on that occasion (if the book on which I was relying was not wholly mistaken) I could not, and cannot, imagine. I found a lot of other things, including very tiny

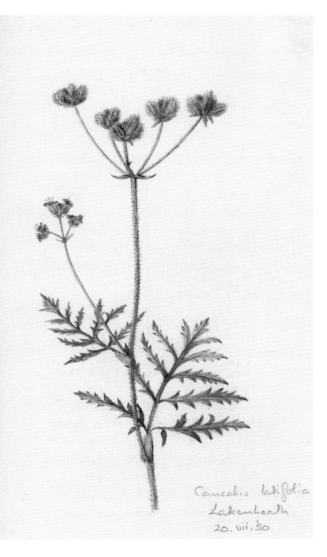

Caucalis latifolia
Lakenheath
20. vii. 50.

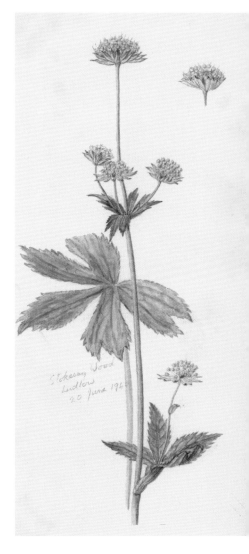

Stokesay Wood
Ludlow
20 June 194

46 *Caucalis latifolia*, broad chervil **47** *Astrantia major*

specimens of *Ranunculus parviflorus* and *Erodium maritimum* and a fine, early, colony of *Orobanche hederae*: so it cannot have been only my blindness. But now at Bristol, in the gully from the Avon gorge to the top of Derdham Downs beyond the tennis courts, *Trinia* was obvious. In that gully, three years before, I had got the diminutive crucifer *Hutchinsia petraea*; and from it had watched the ravens that were nesting that spring on the precipitous cliff above the courts. Now, clambering higher up among the tumbled

limestone at the top of the ascent, the plants were frequent, branching from the roots, low tufted spears of flower stems, mostly dioecious, but with an occasional specimen throwing mixed male and female blossoms. It is a quite charming little species with a few fine-cut grey-green radical leaves; and it is testimony to the citizens of Bristol that they have left it, and so many of the rare treasures of the gorge, unexterminated.

The final species was *Astrantia major* [**47**]. We knew, as all the world knows, that it is to be found in Stokesay Wood near Ludlow. We had planned in the previous season that in June, when term was over, we would go across to see it and then on to Craig Breidden and the last of the British potentillas. But June brought the threat of invasion; the certainty that, if so, East Anglia and Cambridge would suffer; and the plain obligation to stay at home and care for the College. An introduction to a naturalist in the neighbourhood of the wood had been given us: it seemed to be permissible under the circumstances to ask him if he could supply a specimen. On June 20th I sat me down to paint the daintiest, and perhaps the most local, of all our umbellifers.

In 1943 a still rarer species came along. Early in August I was visited by a schoolmaster-friend who had begun his holiday with a botanical tour on a bicycle up from Kent through Essex and Cambridge. He called upon me for information as to Wicken and the Breck; and he gave better than he got. For he reported that crossing the Thames from Gravesend he had found, beside a ditch just outside Tilbury, a patch of the almost extinct hartwort (*Tordylium maximum*). More in faith than in hope (for I knew little of his skill and much of the misnaming of umbellifers) I secured exact details of the place; rang up John in Bethnal Green; and suggested that a run down from Fenchurch Street might not be unpleasant. When, a day later, a magnificent specimen of *Tordylium* arrived, along with the assurance that it was abundant and well-established in this one spot, I confess to a thrill of excited satisfaction. As my visitor during his few hours in Cambridge went out to the Gogs and there, besides *Seseli* and others, found a specimen of the yellow star-thistle (*Centaurea solstitialis*), I conclude that he was not only skilful, but favoured of fortune.

This is indeed the peculiar fascination of botanical studies as compared with any other aspect of natural history. You may live in a city and never see any birds except sparrows and an occasional pigeon and black-headed gull, or any insects except clothes moths and white butterflies: but you cannot get away from vegetation, and the casuals round docks and warehouses and rubbish-heaps are a perpetual excitement. Even in the country, where you can see birds or insects by the dozen, you can see plants by the hundred.

Comparisons are detestable; and to have added a new interest to one's life is not necessarily to condemn other loves. Bird-study will always have a peculiar attraction arising out of the vitality and varied behaviour of its objects: so seemingly human at one moment, so utterly non-human at another – how is one to interpret their actions or enter into their capacities? Moth-collecting will always be to me the most exciting, and the most cathartic, of all such pursuits: there are few sports that require a finer combination of hand and eye than the netting of bulrush wainscot moths (*Nonagria typhae*) as they leave the cover of the bulrushes at deep dusk, or a nicer discrimination than the boxing of the figure-of-eighty moth (*Palimpsestis octogesima*) from among the swarming denizens of a fen-land sugar-patch;[8] and the entry into the little world of the lamp, the darkness, the solitude, the stillness, have an unrivalled power to soothe and refresh. But for an interest that is always available, which takes you out into the loveliest scenery and yet can be satisfied in any backyard, and that continually offers fresh insight into the beauty and worth of nature, the study of wild plants stands high. Its drawback to many of us is that nothing is more depressing or distorted than a herbarium; that these caricatures of the living plant are aesthetically repulsive and scientifically unimportant: and that, beyond the noting of localities or perhaps the growing of a few choicer specimens from seed, there is not much to be done. We, with our paint-boxes, others with camera and colour-film, have got over this difficulty: and rendered our pursuit at once harmless to the plant – did I not lie prone on the summit of Ben Lawers in a driving mist with my sketch-block tucked under my jacket in order to avoid gathering the flowering specimen of *Saxifraga cernua* which we had been told never occurred – and richly rewarding in stored up memorials of its triumphs. And if we, who are neither trained nor gifted as artists, can produce results that satisfy us and seem to please our friends, then here is an outlet which very many may find acceptable.

Winch Bridge
25 June '35

C. heterophyllus
V.h.fi
21 July '34

VISITS TO TEESDALE & THE LAKES

Alston, Langdale and Walney Island, 1935

[J·E·R]

THERE COMES A TIME IN THE COURSE OF ANY COLLECTION OF THE British flora when the collector can no longer walk but a mile from his home to return with a new flower. He has then to consider whither he shall go in search of the many rarer plants that remain; and the choice which faces him is difficult indeed. The Cornish coast, the Breckland of Suffolk, the West Riding of Yorkshire, Teesdale, Glen Clova beneath Lochnagar, Lochs Tay and Rannoch with Ben Lawers between – each of these places, with many others besides, has its own especial rarities; and each of them, surely, is alluring enough even without its own particular botanical treasures. This unanswerable argument is a useful tool to the plant-hunter: when the other members of my family are unduly acrimonious, as they often are, about our passion, my father and I have occasionally succeeded in silencing them with the gentle reminder that to this very passion they owe many of their best holidays.

Our collection had reached just such a stage by the end of 1934; and it was in June 1935 that we first took a holiday that was designed primarily to secure us the maximum number of new flowers. After long consultations over many maps we eventually decided upon our itinerary: we should take the car, travel as rapidly as possible from Cambridge to Teesdale, pause there for two nights, move on to Langdale in the Lake District, thence visit Walney Island, and finally dash northward for a few days among the hills and lochs of Perthshire. We had only a meagre fortnight for the entire trip: but at that point in our collection we were willing to endure excessive haste as the inevitable price of a good crop of new plants; and in the end, though in Teesdale in particular, we would all have gladly stayed for the rest of our fortnight, the outcome justified our choice.

We left Cambridge early on the morning of June 24th, and made all possible speed as far as Boroughbridge. There we bought a picnic lunch; and there we were favoured with an unexpected augury of successes to come. Beside the river that flows just to the north of the town we had

48 *Carduus heterophyllus*, melancholy thistle

paused to eat our lunch; and immediately our eyes fell upon an unfamiliar flower. There on the bank were growing a number of bulbs of the sand leek, *Allium scorodoprasum*, which had hitherto eluded us. It is not an attractive flower, but it greatly cheered us nevertheless. We had, as usual, made a preliminary estimate of the number of additions that we should make to the collection; and I, as usual, had been far more optimistic than my father. But even I, in all my calculations, had given no thought to this leek, which thus, by its modest entry, had enabled us to open our score with an unexpected single.

The approach to Upper Teesdale, from the moment when you pass Greta Bridge, provides a gradual crescendo of excitement. The views spread wider, the hills loom higher, and, above all, the meadows blaze with an ever richer blend of colours. Such meadows, you might think until you have seen Teesdale on a sunny day in June, cannot exist in England; they are reserved for the valleys in the Alps or the Himalayas. Stop, as stop you eventually must, where a little winding path leads down to Winch Bridge. You may open the door of the car, as we did that day, to reveal *Carduus heterophyllus*, the melancholy thistle [48], standing nobly before you. You will drop down, through fields splashed with the purple of wood crane's-bill (*Geranium sylvaticum*) [49], to a little cluster of trees by the old stone bridge. The river is narrow here, and on the far side, just above the bridge, it is flanked by a miniature, broken cliff. Here is a real rock-garden such as only nature could fashion. Here, growing together in the crevices and on the grassy slopes between the rocks, you will find an abundance of three of the loveliest of British plants; and all will, if you choose a day at the end of June, be simultaneously at the height of their flowering season. *Trollius europaeus*, the yellow globe-flower [50], combines as few other plants do the qualities of robustness and of grace, the stiffness of its stalk exquisitely counterbalanced by the delicate tracery of its leaves. The shrubby cinquefoil, *Potentilla fruticosa* [51], is, as many horticulturists recognize, a shrub worthy of a place of honour in any garden, a dense wiry creature, of small, fingered leaves, which covers itself from head to foot in great golden flowers. It is a rarity too; outside Teesdale, where there is a long narrow belt of it down both sides of the river, I know of nowhere else in the British Isles where it is to be found save the limestone area near Lough Corrib in Western Ireland.

opposite, clockwise from top left

49 *Geranium sylvaticum*, wood crane's-bill

50 *Trollius europaeus*, globe-flower

51 *Potentilla fruticosa*, shrubby cinquefoil

52 *Primula farinosa*, bird's-eye primrose

aug '34

W. Slaggyford.

Northumberla.

Langton Beck

17 June.

Teesdale

19 June '47.

High Force

R. Tees

17 June 1941

Finally there is *Primula farinosa*, the bird's-eye primrose [**52**], whose tiny rosette of grey-green leaves throws up a six-inch stalk topped by an umbel of the fairest magenta gems. It too is often grown in gardens – an acknowledgement, which, like the potentilla, it most richly deserves.

Nowhere in Britain – unless again we include Ireland – can there be a richer sight to greet the plant-hunter than on that bank of the Tees. Yet that is only the beginning of the tale. You need walk but a few yards down the stream to come upon another sight that will live with you all your days. There, in a flat meadow beside the river, you will find in its true glory a flower that you will already have seen, apparently beyond number, in the fields above the road – the mountain pansy, *Viola lutea*. In this one field it passes imagination: purple and yellow and particoloured, it spreads its large flowers in an even carpet of colour; and here and there among its masses it grudgingly makes room again for the magenta of *Primula farinosa*. I cherish a suspicion that the treasure of all Teesdale's treasures, spring gentian (*Gentiana verna*) [**53**], inhabits that meadow too; it certainly inhabits a similar site further up the river. But on this and on a later and even shorter visit to Teesdale I have been too late to find it in flower; and I had not the heart to trample the pansies, as I could not have avoided trampling them, in search of a plant that I knew I could find elsewhere.

Such is my memory of Winch Bridge. The dates and localities entered in our collection remind me that at Winch Bridge we found also *Polygonum viviparum* [**54**] and *Juncus alpinus*; but there my memory fails me. I can only remember the *Polygonum* growing in abundance on Widdybank Fell, further up the valley: the rush I remember not at all. But who could be blamed, with such a feast of loveliness to recall, for forgetting two such poor wretches as these? I at least place the polygonums next to the chenopodiums at the bottom of all the botanical families with which I consent to be concerned.

53 *Gentiana verna*, spring gentian.

The sedges and rushes I had persistently excluded from that list altogether, until the day when *Carex alpina* … – but that is another story!

We had spent a memorable half-day. In the course of travelling half the length of England we had found time to add eight new plants to our collection. But the process of addition was not as yet complete; eight portraits waited to be painted. We accordingly drove on the few remaining miles to the Langdon Beck Hotel in a mood of jubilation, tinged with the sense of much toil impending; and no sooner had we set foot in that simple but charming inn than my father whipped out his paint-box, filled the wash-basin with his specimens and the tooth-glass with his paint-water, and started in. That night we shared a room. I remember that my ablutions were somewhat incommoded by the ubiquitous herbage, and that I awoke at a normal hour – eight o'clock or thereabouts – to find that my father, having been painting for nearly three hours, had almost finished immortalising our finds of the previous day. Such are the rigours of the plant-hunter's, or, to be more precise, of the flower-painter's life: and such is one of several excellent reasons why, as a rule, I prefer the role of hunter to that of painter.

A little beck bubbles up by the inn, a rough cart-track running beside it till it merges with the Tees. On either side the track stretch the true Teesdale meadows, sloping hayfields for the most part, less blazing perhaps than the fields lower down the valley, but richer yet in the number of colours that stipple them. We had no need on that evening of our arrival for great exertion. Wandering down towards the river we soon found just beside the beck, a new umbellifer, masterwort (*Peucedanum ostruthium*); and indeed later in the day, again by the beck, but this time not a stone's throw from the inn, we added to it another of the same family, sweet cicely (*Myrrhis odorata*). When we reached the Tees we turned upstream, roaming slowly through the meadows or scrambling over the steep earthy banks, which, in many places hereabouts, fall abruptly into the river. Along the other bank especially the belt of *Potentilla fruticosa* kept us constant company. The meadows yielded us two new treasures, *Orchis pupurella*, differing from all its cousins in its brownish-crimson colour, and alpine bartsia (*Bartsia alpina*) [55], whose colour also, this time a dark thundery purple, gives it a distinction above the rest of its tribe. The muddy bank, too, had its contribution to make, which, if of lesser beauty and lesser distinction, was yet a welcome stranger to us – *Sedum villosum*. Finally, the dates in our collection once more remind me of a lapse of memory. Somewhere in our rambles next morning we found bistort (*Polygonum bistorta*). It may indeed be that it was ramping everywhere; if so, my total forgetfulness will serve as a final indication of the measure of my disrespect for the family Polygonaceae.

54 *Polygonum viviparum*

55 *Bartsia alpina*, alpine bartsia

56 *Vaccinium vitis-idaea*, cowberry

There was one notable absentee that morning – the rarest of all the Teesdale flowers, the inconspicuous bog sandwort (*Arenaria uliginosa*). It is no closely guarded secret that it grows upon Widdybank Fell: you need but turn to your Bentham & Hooker to learn it. But unlike most of Teesdale's treasures it seems to be well hidden; for a careful search of a large part of the fell – the wrong part, I hope and believe – failed to reveal it. Nor was the *Arenaria* to be the only failure of the day: there was another to follow, more bitter in proportion as the flower was more beautiful. *Dryas octopetala*, the mountain avens, is reputed on the most reliable authority, to grow upon the limestone cliff called Cronkley Scar. If you are wise enough to stay at the Langdon Beck Hotel, you need but drop down to the Tees, wade it, and climb the slope on the other side, and you will soon be standing at the foot of the said cliff. That, after a hasty lunch, is exactly what I did; and as I stood beneath one end of the cliff I was elated by the hope that I should soon be finding what is, on the whole, the most lovable of all our native flowers. The exploration of cliffs falls often to the lot of the plant-hunter. Some cliff plants, notably the Snowdon lily *Lloydia serotina*, call for more exploration than I personally am prepared to give them. But *Dryas* is not usually such; it grows often in places accessible to the least adventurous of men. And since I, for one, have a marked preference for the bottom rather than the top of anything that approaches the vertical, I accordingly started to work my way along the bottom of the scar. It was a laborious process. Loth to omit a single yard of so promising a locality, I scrambled painfully over scree and boulders, pausing every few yards to turn and gaze upwards in search of those tiny, dark, glossy leaves and those large, white, golden-stamened flowers. Hours later I was still so scrambling and gazing; and for once, thinking of my father sitting comfortably in the inn, I wondered whether, after all, the lot of the hunter is preferable to that of the painter.

I eventually returned unsuccessful, weary and disconsolate. I felt, as I have felt since, that just as there are few joys to equal that of a successful flower-hunt, so there are few disappointments keener than that of an unsuccessful one: and it is the more irritating when, as on this occasion, you know that the flower was there all the time, toiling not neither spinning, while you grew weary of both. I had not, however, wasted my time altogether. I returned with specimens of two charming cousins of the heather, cowberry (*Vaccinium vitis-idaea*) [56] and common bearberry (*Arctostaphylos uva-ursi*), which at that time were both new to us. And I have since succeeded in eradicating the bitter recollections of that afternoon's failure. Above Loch Assynt, where the road to Kylesku leaves the road to Lochinver, I have seen the sloping outcrop of limestone densely matted

with the *Dryas*; and having seen I shall not soon forget. There too, to show that this time fortune favoured me, I picked and despatched to my father a fat white bud which later belied the plant's name by revealing a full dozen petals.

Such was our day in Teesdale and the miracle of Winch Bridge had somehow been repeated. We had again added eight new plants to the collection. On the morrow, alas, we must leave for Langdale; but to secure ourselves a few more hours in so profitable and lovely a hunting-ground, we unanimously postponed our departure till the afternoon. I wonder still whether I spent those few hours as they should have been spent; for *Arenaria uliginosa* – and *Dryas* also for that matter – were more than ever enticing after our initial failure. In the end, however, I turned my back upon them, and took a path instead into the hills to the northward. It is surprising how quickly, walking in that direction, you desert the limestone and find yourself amid the deep heather that indicates a limeless soil. It was what I sought; for on those heathery slopes and bogs were said to grow the cranberry (*Vaccinium oxycoccus*) [57] and the cloudberry (*Rubus chamaemorus*). This time my search was brief. Within a few minutes I had found them both, and, time being precious, paused not to discover whether chance had led me to their only site. I doubt it. They are neither, unlike *Arenaria uliginosa*, very rare plants; I have seen them both several times since, especially the cranberry, which trails its slender stems over every bog in the hills of Montgomeryshire.[1] But they were both at that time new to us, and that was what mattered most.

Langdon Beck
25 June

57 *Vaccinium oxycoccus*, cranberry

And thinking again of those days, it occurs to me that I really did do best to turn my back upon the *Arenaria*; for now it remains as a permanent entice-ment to draw us back, as soon as may be, to the beauties of Teesdale.

After lunch we bade a sorrowful farewell to the Langdon Beck and took the road for Alston. The road winds uphill, not quite all the way, it is true, but for several glorious miles. Here and there it runs through little woods of fir; and if, as we had, you have heard tales of the common wintergreen (*Pyrola minor*) growing in the woods of Teesdale, and if again you long as passionately as we did for the sight of any *Pyrola*, then you will hardly resist the temptation to stop and search. We eventually yielded at a point where, below the road, a steep slope of scree cuts a grey gash from the dark green to the wood. Scrambling eagerly down this slope we found that fortune had bestowed a final blessing upon us; for there upon the scree we made two last and unexpected discoveries. Alpine pennycress (*Thlaspi alpestre*), like most of the crucifers, is a plant of little charm, though it is at least less repugnant than many of its extensive tribe. But spring sandwort (*Arenaria verna*) is, to my mind, a real beauty – quiet maybe, but a beauty all the same. It is far commoner, no doubt, than its cousin which we had sought in vain upon Widdybank, but unless I am much mistaken it is by far the fairer of the two. The *Pyrola*, for the moment eluded us; but since it was to it that we owed the *Thlaspi* and the *Arenaria*, it would have been churlish to complain. We at least were far from so disposed; indeed when, a few minutes later, we reached the watershed and paused to cast a last look upon the valley, its green meadows ribbed with white cliffs and dotted with white farmsteads, we were in the mood (though I am glad to say it did not happen) to descant with passion on 'this other Eden, demi-Paradise'.[2] And so, for the last six years, Teesdale has remained one of the most sweetly nostalgic of all my treasured memories.

As we deserted Teesdale for the Lake District, we simultaneously, though only temporarily, deserted botany in favour of entomology. We spent three days in Langdale for the sole purpose of catching a butterfly that we had never caught before. The mountain ringlet is to be found, in one of its few English haunts, on the high saddle that separates the twin summits of the Langdale Pikes. That saddle was our objective; and if we were to have any chance of success the sun must be shining. We arrived too late that evening to contemplate an attempt. The next morning it was raining; and it contin-ued to rain all day with a persistence apparently reserved for that region of England. The following morning brought no change, and it began to look as if we were doomed to waste two whole days of our precious fortnight. We were sitting gloomily eating our lunch (and had luckily already consumed

the major part) when through the window we espied a slight rift in the hitherto unbroken pall of cloud. That was enough for my father and me. Casting down our spoons and forks we were away upon a frenzied race. My father has still a pretty turn of speed, but that day at least he finished a poor second. Perhaps he had contrived to eat more than me before the interruption. I am still proud of my time from the village of Langdale to the top of the said saddle took me exactly fifty-five minutes. My father was some five minutes behind. But to my intense annoyance he lost nothing by his defeat; for the weather had not moved as fast as either of us. When at last we had recovered sufficient breath to allow of renewed movement, we parted company and began to hunt in opposite directions. For several minutes nothing happened; but all the time the sun was filtering more brightly through the mist. Then suddenly I espied what we sought, a single specimen, still too sleepy, praise Heaven, to necessitate a run. I imagine that the same thing happened simultaneously to my father, for five minutes later we met where we had parted with the light of triumph in the eyes of each. I have often wondered since whether my father, despite his profession, was as uncharitable as I was and that we both felt a slight twinge of regret that the other also had succeeded. Be that as it may, we met triumphant, and thereafter had no need to part again. The sun had won its battle, and the mountain ringlet was not slow to hail the victory. When eventually, our victims selected, we left that grassy upland, it seemed ridiculous to remember that, but an hour or two before, the sight of a single mountain ringlet had brought the light of triumph into my father's eyes.

Our mission in Langdale accomplished, we spent the next day slavishly (but none the less, as it proved, inaccurately) following the instructions of Reginald Farrer. We went to Walney Island, that strange sandy spit of land linked only by a causeway to Barrow in Furness. My memories of Walney Island are neither sweet nor nostalgic: indeed I am glad that there is no particular incentive to draw me thither a second time. It is, but for its slithery sand-dunes, completely flat, desolate, and (though here my memory contradicts the testimony of a map) of an endless length. I walked northwards for miles along the outer shore; and I did, it is true, find sea bindweed (*Convolvulus soldanella*), a new plant in those days, and, what was less desirable for the collection, but none the less interesting for that, an abundance of the bee orchid, growing surprisingly upon a flat sandy plain very few feet, if any, above sea level. But of the two plants that had brought us to this desolation, *Mertensia maritima* and the unique *Geranium lancastriense*, I saw never a sign.[3] What few geraniums I found were as virulently magenta as their name – *sanguineum* – signally fails to imply that they are. I

returned to the car dejected to find that my father too had had little success. But we would not yet admit defeat. There is a road running southward from the causeway, passing at one point within a hundred yards or so of the sea to the west. This road we took in the car; intending, as we often do, to stop and search any eligible site: but despite Farrer's description of its local abundance, my hopes of finding *Geranium lancastriense* had, I confess, persistently waned. Farrer, of course, proved right, and further search was needless. We soon found ourselves driving along beside a strip of natural lawn which lies between the road and the western sea; and the lawn was a blazing mass of the ordinary magenta bloody crane's-bill *Geranium sanguineum* [**58**], the extraordinary pale pink-veined *Geranium lancastriense* [**59**], and every colour of geranium between these two extremes. Such is one of nature's occasional freaks – a plant confined to one diminutive locality and there as abundant as the buttercups in a water-meadow. We had found it, thanks to Farrer, in its solitary haunt; and beside that success it mattered little that we had failed to find *Mertensia*, which is after all (though still having never seen it I am hardly in a position to speak), comparatively common. And when eventually we returned home and read again Farrer's chapter on our native Alpines,[4] we concluded that we had never been near the spot where *Mertensia* 'trails twinkling azure eyes over the sand'.

 Geranium lancastriense was our last find in England. Next day we took the road for Scotland, and paused not till we drew near to Loch Tay. And now that we are leaving England, I shall leave this chapter too: for our exploration of Ben Lawers and the district that it dominates deserves, if indeed any of our expeditions do, a chapter to itself.

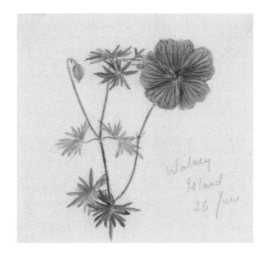

58 *Geranium sanguineum*, bloody crane's-bill **59** *Geranium lancastriense*

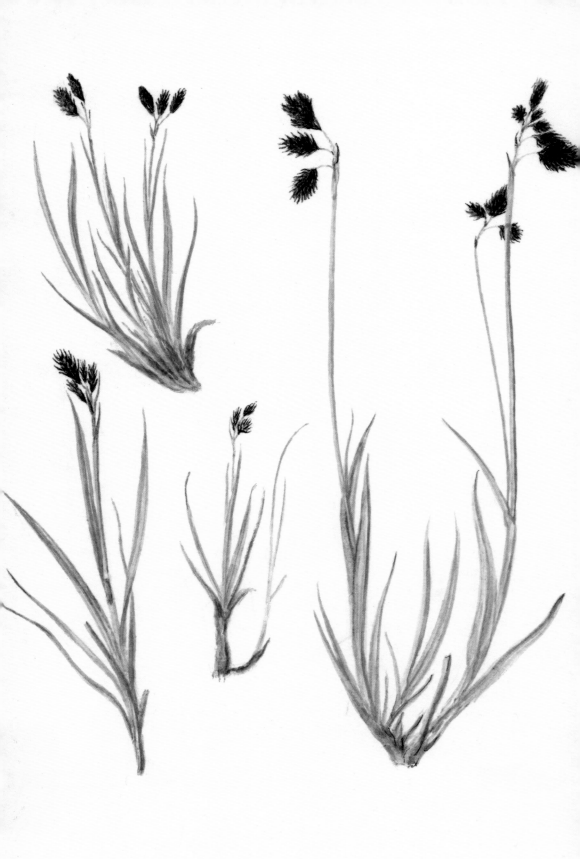

THE BOTANIST'S PARADISE

Ben Lawers, 1935 and 1937

[C·E·R]

IF THE STUDENT OF OUR FLORA COULD ONLY VISIT ONE PLACE OF pilgrimage, there can be little doubt that the summit of Ben Lawers would be his choice. Not only does it have a saxifrage of its own, and one or possibly two sedges, and a vast series of sufficiently distinct hawkweeds, but practically all the alpine species to be found in these islands are obtainable within a few hundred yards of the summit or around and above the lochan that is held in the arm that stretches out to Meall Garbh.

So as the climax of our first great plant-hunting tour, when my wife and I celebrated our silver wedding by taking Mary and John to Teesdale and the Lakes,[1] Walney Island and St Mary's Loch, we visited Tayside and stayed a few days in a charming cottage up the road from Fearnan. It was new country to us all. I had seen the loch and its guardian mountain on a memorable night when, on the hill above Lochearnhead, I had watched a hen curlew and her baby brood in the twilight of mid-June, and almost stepped on a sitting golden plover under a rock at the edge of the descent. And years later two of us had driven from Killin along this very road to Strathappin and the north on our way to Scourie. But of its detail we knew nothing.

That first evening, when we worked a bit of the Loch Tay shore and then paid a short visit to Glen Lyon, and went far enough up the hills to find yellow mountain saxifrage (*Saxifraga aizoides*) and alpine lady's-mantle (*Alchemilla alpina*), we got no idea of the richness of the mountain. Nor did we next morning until we had toiled up the long steep dullness of the ascent from the Lawers Hotel and reached the 3000 foot level. By that time (I confess) my temper was execrable; my legs ached; my painting-kit weighed tons; and my expectation was of much rain and no plants. The lower slopes of Ben Lawers are grass and bracken and heather and again grass; and the gradient is just sufficient to be exhausting but not exciting. For the first time in my life I felt thoroughly senile – until the marvel of the upper zone was discovered.

Alpine plants were new to us then. Apart from a day in March under Cwm

60 *Carex ustulata*

Glas neither of us had botanized on anything higher than Loughrigg. I shall not forget the thrill when John, who had suffered my grumbles heroically but had eventually decided to leave me behind, called out that he had made a find. He had, in fact, surmounted the great green shoulder that screens the summit from view; and on the top of it were the alpine mouse-ear (*Cerastium alpinum*) [**61**] and great cushions of moss campion (*Silene acaulis*) [**62**] both in profusion. I was then thankful to have an excuse for a rest. Paints were got out, and both plants were in my sketch-book before I went further. It was a blessed relief after the depression of the journey to it: it was a pleasant prelude to one of the greatest moments of our plant-hunting.

We had, of course, been dreaming, as every visitor to Ben Lawers surely dreams, of the drooping saxifrage, which has its only British station on the summit. We read that it was horribly rare and that when found it never flowered. We knew that, year by year, collectors (not perhaps too scrupulous in their rapacity) sought for it. We hoped – but our hopes were dim. But, as I put away my paints, John came down to join me. Once or twice on other occasions I have seen him deeply moved. This time he was white and almost speechless. 'I believe I've found it: it's just up there by those rocks:

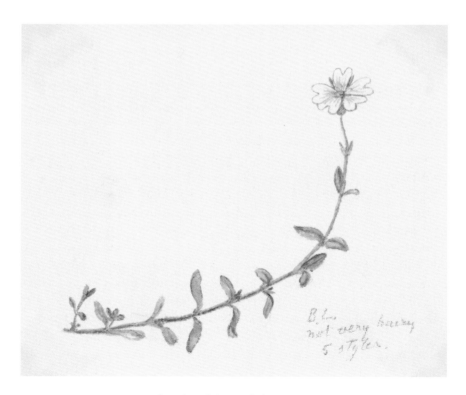

61 *Cerastium alpinum*, alpine mouse-ear

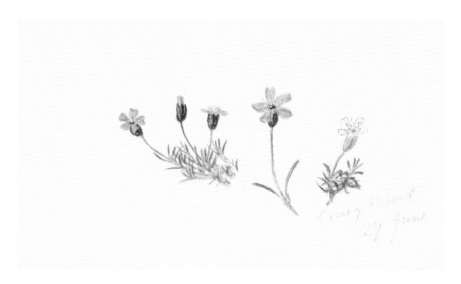

62 *Silene acaulis*, moss campion

come and have a look'. I came; and in the crevices and moist ledges of great boulders were the unmistakable leaves of drooping saxifrage (*Saxifraga cernua*) [**63**] and among them, with brilliant scarlet bulbils in the axils of the bracts up the stem, two or three flower-heads in full bloom. To congratulate my son on his discovery, to sit down in a state of beatitude, to draw and colour the precious thing as it grew, and to know that our day, whatever else might happen, was marked with the white stone of what my Dutch friend calls 'fool success' – even the mist which made me crouch close over my paper and threatened to put an end to painting could not dim the splendour of it. We had found the rarest of Lawers plants literally on our way to the top of the mountain.

After that I had hardly a moment's rest. Before *cernua* was finished John had found the alpine forget-me-not (*Myosotis alpestris*) [**64**] on a difficult ledge not far from the saxifrage. Then we strolled to the cairn, noting a few sprays of purple saxifrage (*Saxifraga oppositifolia*) still in flower, a lot of scurvy-grass (*Cochlearia micacea*) and of mossy saxifrage (*Saxifraga hypnoides* or probably *S. platypetala*) and big moss-like tussocks of the tiny cyphel (*Arenaria sedoides*) so utterly unlike its Bentham & Hooker picture. Then I sat down on the north side of the summit looking towards the lochan; found that I was sitting on patches of dwarf cudweed (*Gnaphalium supinum*) [**65**]; and in the intervals between passing showers made portraits of our finds. Meanwhile John started a methodical survey of the steep, almost sheer, sides of the horse-shoe of cliff around the lochan.

63 *Saxifraga cernua*, drooping saxifrage 64 *Myosotis alpestris*, alpine forget-me-not

His next find, high up and quite close to the summit, was the rock whitlow-grass (*Draba rupestris*) a tiny and inconspicuous creature, but partly on that account perhaps one of the rarest of our day's discoveries. Then, close to it, the alpine saxifrage (*Saxifraga nivalis*) [**66**], a rather stunted specimen. And then on ledges lower down and to the east the two dwarf willows *Salix herbacea* and *S. reticulata*. With them he also secured alpine meadow-rue (*Thalictrum alpinum*) and sibbaldia (*Potentilla sibbaldii*) [**67**], both of which are definitely common, and the mountain form of thyme-leaved speedwell (*Veronica serpyllifolia*), the large flowered, cluster-headed subspecies *humifusa*.

Then we moved down a bit, nearer on my part to the lochan. He explored the more northern cliff-face. I found a patch of Scottish pearlwort (*Sagina scotica*): and continued to paint with persistence. He found two more novelties, the rock speedwell (*Veronica fruticans*) [**68**] with its shrubby stems and brilliant sapphire flowers, and the hoary whitlow-grass (*Draba incana*) a large leafy form of it, very unlike Fitch's picture in Bentham & Hooker. This, and one or two of our other finds, (we took back a few sedges, *Carex rigida* among them), we could not at once identify; and we were both getting tired. We had been out since early morning, and it was now tea-time or

65 *Gnaphalium supinum*, dwarf cudweed 66 *Saxifraga nivalis*, alpine saxifrage

more. We decided to call it a day; and set off by way of the lochan. And as
we did so I made my one real addition to the bag. A friend had told us that
near the lochan we should look out for the chestnut rush (*Juncus castaneus*);
and suddenly I saw it. Judging by subsequent explorations it is definitely
rare; at any rate neither of us has ever seen it since. When we got home and
counted up our new species, we discovered that we had got at least sixteen.
Considering that several of them were painted in the rain, it seemed to us
that we had made good use of our opportunity. But the need for further
pictures gave us an excuse for an easy day on the morrow.

 A single day, even if it be long and fortunate and at midsummer, cannot
exhaust any locality. We had done well on our first visit: but there were
several plants of first-rate interest that we had not seen, and a few others for
which we were too early. Moreover, in 1935, sedges and grasses were hardly
within our range. A second visit was essential. In 1936 this was impossible.
I did a short expedition to the coast of Devon and Dorset, finding the blue
gromwell (*Lithospermum purpureocaeruleum*) at Salcombe Regis and Weston-
mouth, east of Sidmouth, and an early specimen of the Dorset heath (*Erica
ciliaris*) near Corfe – and incidentally getting a fine series of the Lulworth
skipper butterfly. But in 1937 a plan was made. My son and daughter who

were already in Galloway should drive across to Fearnan and collect me off the train at Ballinluig, so that we could spend a couple of days under the mountain.

I was kept at home by residence, but thanks to the loan of a car and expert driver managed to get from cathedral evensong at Ely to York in time to catch the night express, and to arrive sleepy and unshaven but full of hope. We ran out of petrol some miles before Aberfeldy and had to push the Austin Seven into the town: we went on after breakfast to the Black Wood of Rannoch to a certain locality (as we believed) for the bog orchid (*Malaxis paludosa*) – a plant on which we have wasted more time than on any other; and it wasn't to be found: we searched steadily and got caught in a deluge: we took refuge on chance with some friends,[2] and found a large shooting-party and (as it seemed to me wet, dirty, and still unshaven), all the titled magnates of North Britain. And when after a welcome and refreshment, which we neither expected nor deserved, we went round to the Lawers Hotel to take the omens, the master of the house cocked his eye at the mist and said that we should not see the top of Lawers for a week. Hope began to get a trifle subdued. The plan was plainly doomed. John

67 *Potentilla sibbaldia*, sibbaldia

and I shared an attic under the roof in the Clachan: a skylight was our only window. At intervals during the night – very infrequent intervals – I consoled myself with the knowledge that it was at least not raining noisily. But when I woke at 6 and turned an eye upwards it was in the mood that expects nothing. 'It's a miracle – a pukka miracle' the exclamation was almost a shout; for the window was cloudlessly blue. We gloated over it – and agreed to get off as soon as breakfast was over.

This time we went up from Glen Lyon, crossing the old stone bridge and making over Craig Dhu to the eastern end of the high ground. It was a long and heavy ascent but much less dull than the other side; and along the ridge with the loch to our left and the crests of the mountain in a succession of rocky turrets stretching before us the going was delightful. Our first find was the alpine willowherb (*Epilobium alpinum*) hanging its head over a tiny runnel; and then on a boggy patch the three-flowered rush (*Juncus triglumis*); and then a mountain grass (*Poa alpina*). By this time we had separated, John and his sister going on to the summit, and I pottering along at leisure, and inspecting the bare patches on the Glen Lyon side of the top in the hope of *Carex microglochin*. So doing I found a single specimen of the much rarer two-flowered rush *Juncus biglumis* [**69**], and what I took to be the rare scurvy grass *Cochlearia scotica*, a much smaller, neater and less straggling plant than the abundant *C. micacea*. [On a later visit, in July

68 *Veronica fruticans*, rock speedwell
69 *Juncus biglumis*, two-flowered rush

1945, it was on this Glen Lyon side that *Carex ustulata* [**60**] was found and painted].

So I worked my way over the shoulder between Lawers and Meall Garbh above the lochan; and there had my best moment. On a ledge on which two years before I had found one of the alpine hawkweeds in bud it was now a galaxy of golden flower, and, among them, one of the two treasures that we specially wanted, the alpine fleabane (*Erigeron borealis*) [**70**]. Reginald Farrer, whom in general I revere and enjoy both as field botanist and as writer, is so contemptuous of this small plant that I had expected to despise it.[3] In fact my specimen, large, upstanding, exquisitely fluffy in the involucre, exquisitely fringed in the flower, seemed to me one of the most delightful that I had ever seen; and I still unashamedly admire it. I painted it there and then and after it started to descend. Near the lochan I found some abundance of the russet sedge (*Carex saxatilis*), and a good tuft of the grass *Deschampsia alpina*; and a ripe fruit of the cloudberry.

John, meanwhile, had sent his sister back to the car after reaching the cairn, and had begun a grand exploration of the western and southern escarpment of the summit. He also found the *Erigeron* – I fancy in some plenty. But the other rarity, the small gentian (*Gentiana nivalis*) [**71**], was elusive. This was, I fear, mainly my fault: for with a rather faded memory of having seen it at Arolla in the Swiss Alps I had told him that it grew among turf; and so had set him searching flat uplands. In fact he found it eventually on a cliff-ledge so sheer, and so high, that if he had not

been six-foot-three he could not have reached it. On this spot, and higher up, it was not solitary, the specimens varying from single-flowered stems an inch or two high to the giant that we have painted. Before finding it he had covered a large area, and in addition having all the lunch with him, was conscience-stricken at my absence and wasted much energy in leaving messages for me. But when finally we met on the way down to the Lawers Hotel where the car was to meet us, my hunger and his fatigue were forgotten in the excitement of sharing our experience.

Botanically my own record was not too good: I had failed with *Carex microglochin*, and though my fleabane was (as I maintained) the finest specimen, John had seen too much of it to be much impressed. But there were other memories. A ptarmigan had run round me within a few yards while I was painting the two-flowered rush; and, until its tameness made me long for a camera, the sight of it at such close quarters was a thrilling experience. I had nearly fallen over a mountain hare crouching under a boulder and had a grand view of him as he bounded down the hill. And I had seen my son when we met on the way home and he had tried to conceal from me the splendid fact of the gentian until I had told him all my lesser achievements – concealed in intention at least; for his elaborate coolness made it plain the something exciting had happened.

Sequels are usually disappointing. Our first visit to Ben Lawers had been so successful that we could hardly expect not to find a second an anticlimax. It was in fact as notable as its predecessor. We, two very amateurish plant-lovers, had spent two days without a guide or much preliminary advice on the mountain. And we had found the vast majority, indeed almost all, of the notable alpine species which make it a botanist's paradise.

70 *Erigeron borealis*, alpine fleabane

71 *Gentiana nivalis*, small gentian

THE HIGHLANDS O' THE LOWLANDS
Dumfries and Galloway

[C·E·R]

THERE ARE FEW PLACES MORE ROMANTIC IN SCENERY AND STORY, and few less known, in our island than the 'highlands o' the lowlands', the 'Bruce country', the tangle of mountains and lakes which lies in the centre of Galloway north and east of Newton Stewart. S.R. Crockett in *The Raiders*,[1] and John Buchan in one of his best short stories,[2] have exploited the solitude and 'grue' of the land, the gulleys and lochs which bar the way to the Merrick, the great flows that lie between one range of hills and another, the precipices of Black Gairey and Mulwharchar, the desolation of Buckhill o' Bush or Gala Lane; and if imaginative licence has magnified the horrors of the Murder Hole or peopled the Nick o' the Dungeon with cavemen, at least the country lends itself to such use. Yet while everyone knows the similar district to the south of the Solway and most of us have visited the Trossachs, you can walk all day between the Bruce memorial on Loch Trool,[3] and the power station on Loch Doon, and see nothing but a shepherd except it be the golden eagle that has returned to the Hill of the Star and the peregrine whose eyrie looks over the Silver Flow onto Kirriereoch. There will be nothing more startling than the whirr and chuckle of a rising grouse, or more terrible than a gaunt hill fox stalking rabbits through the bracken. But neither in the Lakes nor in Perthshire is there a walk more wild and beautiful than that which leads past the falls of the Buchan over the Shepherd's Path to the Gairland; up its ravine to Loch Valley; over the ridge to Loch Neldricken; round the queer circular pool at its western end and up the hillside to Loch Arran; and so over the watershed to Loch Enoch with its islet and the 'loch in loch' and with the east shoulder of the Merrick rising sheer from its surface. If you have the energy, starting from the head of Loch Trool to take the Glenhead Lochs and the Rig o' the Jarkness on the way to Loch Valley; and if you come home by way of the Broad o' the Merrick and Benyellary and Bennan; you will have had as good a day as Britain can offer.

Is this extravagant? The hills are not 3000 feet in height: there are not

72 *Convolvulus sepium*, larger bindweed

many places on them where you could fall dangerously, the scale of the land is small. It may well be that there is nothing in Galloway to compare with the summit of Helvellyn or the view from the Great Gable; nothing so impressive as Tryffan rising stark from the shore of Llyn Ogwen or Schiehallion as you first see it from Strathappin. Comparisons in which Galloway fares ill are easy to find – and profitless. But for me at least a clear day on Lamachan when all the Cumbrian mountains, the Isle of Man, the coast and hills of Northern Ireland beyond the Mull of Galloway, Kintyre and Arran, the top of Ailsa, Bute and the Kyles and so away past the Merrick to the dim plain of the Clyde are spread out in panorama, stands out peerless in memory; and the nearer scenery – Cairnsmore of Fleet, the Wigtown promontory, the Bay of Luce to the south; the Wood of Caldons, the Hags o' the Borgan and the valley of the Cree to the west; to the north Loch Trool, glimpsed beyond the rugged top of Muldonoch, the Glenhead lochs and the ascent to the Merrick and eastward Loch Dee and Curley Wee and the tumble of hills towards New Galloway – has a beauty strangely haunting in its varied charm.

But whatever be its status in public esteem (and probably more folks know it as the scene of the most ingenious of Miss Dorothy Sayers' detective stories than for any other reason)[4] Galloway has never had much attention paid to its flora. There is, or was, a list of plants privately printed which gave some information for Wigtownshire;[5] there are references in several guide-books and descriptions of the country to a few of its mountain flowers. But when we first went to it in 1931 we had to discover its botanical resources for ourselves. There are memories, fewer probably as one grows older, which remain for ever; and the first arrival at Glen Trool was one of them. I had come up by the night train from the burial of my best friend and arrived at Newton Stewart in the cold dawn of mid-August. The little town was still asleep, but a car was available and in it we set out for a fifteen-mile drive. The road starts north-westward through fields and woods, along the right bank of the Cree and that morning the river, half-veiled in swirls of mist, was running full; for the tide was high: and behind it Cairnsmore to the south and Larg to the north rose dark against the risen sun. Crossing the bridge at Bargrennan we swung eastward into the light, across a mile of moorland to the rocky ravine of the Minnoch, and so into Glen Trool. There is a copse of tangled birch where the Rig of Stroan sinks to the Trool and the road rises over it – a birch-wood thick in moss and lichen and fern, and lovely as fairyland: from there one sees the glen; first a stretch of moorland grass and heather with a twisted thorn beside the track, then a peat-moss, heather and bog-myrtle and a few stunted sallows; then gleaming through

73 *Lythrum salicaria*, purple loosestrife

a pine-wood the loch, around and beyond it a circle of hills. Seen in the early morning when the low sun is refracted by miles of dew-drenched gossamer, and the whole scene, sunlight and shadow, is opalescent, and yet every fold and crease of the hillsides stands out clear; seen so, as I then saw it, the beauty of it is a possession for ever. When we came through the trees to the Lodge, nestled under the steeps of Eschoncan, sheltered by its own woodland of oak and pine, and open to the sparkle of the water, only the midges prevented it from being an entry into paradise.

74 *Drosera anglica*, English sundew 75 *Hypericum elodes*, marsh St John's-wort

In those days everything was new to us; and the three weeks passed before we had finished painting the plants that confronted us every where, including larger bindweed (*Convolvulus sepium*) [72] and purple loosestrife (*Lythrum salicaria*) [73]. The bog-land and hill-sides near the Lodge where we were staying; the river meadows by the Cree between Newton Stewart and Bargrennan and lochs large and small from Loch Moan and Loch Ochiltree to the Glenhead lochs and the pool on the top of Bennan; the summits of Lamachan and the Merrick; the coast from Ballantrae to Dunure and from Glenluce to the Mull of Galloway; all of them were visited and each had its characteristic plants. In the years that followed we got to know the district well enough to make the discovery of anything new a notable event. There was nothing very rare – it is not a

rich neighbourhood: but some of our finds are perhaps worth chronicling.

Round the house and in the bogs at each end of Loch Trool we found at various times all three sundews: *Drosera rotundifolia* often so abundant that on sunny mornings its tiny white flowers starred the ground for hundreds of yards; *D. longifolia* very local, but found in small colonies so that a few yards of a tiny burn on the slope south of the Loch or a bit of bog near Borgan bridge were crowded with it; *D. anglica* [74] rarer but widely scattered and among the bog plants and heather rather than in stream-sides or

76 *Rubus saxatilis*, stone bramble

Newton Stewart
Banks of R. Cree
28 Aug

77 *Mentha longifolia*, horse mint

moss; marsh St John's-wort (*Hypericum elodes*) [**75**] in a rill at the head of the loch; pale butterwort (*Pinguicula lusitanica*) on the track towards the Round Loch of Glenhead; wood cudweed (*Gnaphalium sylvaticum*) near Glenhead farm; stone bramble (*Rubus saxatilis*) [**76**] and marsh violet (*Viola palustris*) on the edge of Loch Trool; these were the best of our finds.

In the Cree valley gipsywort (*Lycopus europaeus*) on the west side of the river was perhaps a new record for Wigtownshire. Common loosestrife (*Lysimachia vulgaris*) occurred in a single place; *Crepis paludosa* was not uncommon; but very thorough search both of Cree and of Minnoch did not yield anything rarer than *Sparganium minimum*, far up beyond Loch Kirriereoch, and horse mint (*Mentha longifolia*) [**77**] near Newton Stewart. The lochs were more productive. Trool and others were full of water lobelia (*Lobelia dortmanna*); Kirriemore and the Lilies Loch under Craignell had *Nymphaea occidentalis*; Kirriereoch *Sparganium simplex* var. *natans*; the pool on Bennan *S. angustifolium*; that by Cairnsmore House has the water-milfoil *Myriophyllum alterniflorum*; and a larger pool near Bargaly *Potamogeton alpinus* [**78**]. After a search of many hours, and several years, we found

78 *Potamogeton alpinus*

Littorella uniflora on the shore of Loch Maberry out beyond Bargrennan and still more exciting awlwort (*Subularia aquatica*) on the edge and under water, flowering or setting seed in both situations, on Loch Moan. Water purslane (*Peplis portula*) we found in a swampy hollow of the sandhills of Glenluce; and two or three of the species or subspecies of water starwort (*Callitriche*) were locally abundant. There is much interest to be gained from this shore; shallow-hunting for the number of plants that make their home there is considerable, and they are mostly small, inconspicuous and very much alike. We are still looking for *Limosella aquatica* and creeping pillwort (*Pilularia globulifera*). But the epic of his successful search for *Elatine hydropiper* in Connemara will be recounted by my son; and I have lately found the quillworts *Isoetes lacustris* and *I. echinospora* in two lakes under Moel Siabod. The trouble about such a search in Galloway is that two of the most Protean and abundant species, lesser spearwort (*Ranunculus flammula*) and *Juncus bulbosus*, are always disguising themselves as something else. The hunt is happier and less exacting when, as in Western Ireland, these two and the callitriches are relatively scarce.

For mountain plants in the strict sense Galloway is not well qualified. Acid soil, granitic rock and not so great altitude produce heather and bilberrry, crowberry and dwarf juniper and lycopodiums, but little in the way of flowers. The Lamachan is singularly bare, the dotterel which occasionally visit it are far more interesting than any of its plants; and apart from the pool on Bennan and Benyellary, the Broads of the Merrick have little but a few plants of autumnal hawkbit (*Leontodon autumnalis* var. *pratensis*) and a *Cerastium* of whose identity I have never been very certain. Cowberry (*Vaccinium vitis-idaea*) and heath rush (*Juncus squarrosus*) were tolerably abundant, as well as the ubiquitous *J. bulbosus*: but the only treasure was curved woodrush (*Luzula arcuata*) [fig.14],[6] and this we only found once.

The one really attractive place was the precipitous rocks and screes of the north face of the Merrick. If coming up from Benyellary you follow the wall that runs across the saddle from it to the Merrick and do not strike off to the east towards the cairn, you will come to the point at which the wall plunges over the cliff down into the valley of the Kirshinnoch Burn, one tributary of which springs from the rock face at this very spot. Here there is an admirable gulley – moist and shaded, sheer in its upper reaches but broken with good ledges and pockets. An active climber would go up or down it without a rope: but he would have to plot out his course and move carefully. Here almost alone in the whole area is an outcrop of real Alpines. Looking over from the crow's nest at the end of the wall there were fine

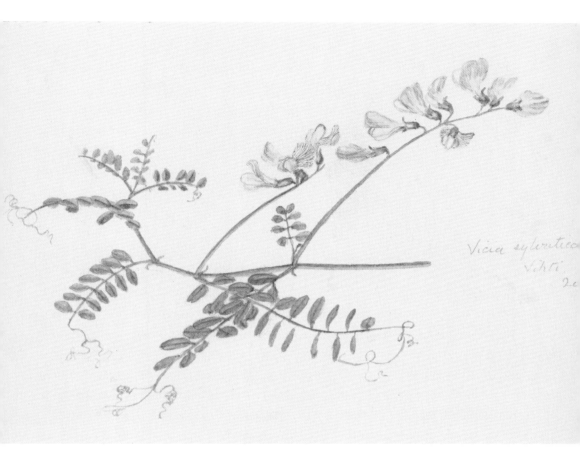

Vicia sylvatica
Vihti
2c

79 *Vicia sylvatica*, wood vetch

upstanding shoots of roseroot (*Sedum rhodiola*), plenty of rounded leaves of kidney sorrel (*Oxyria digyna*) and in the runnels the gold-specked stars of *Saxifraga stellaris* [80] and the tiny fern-like leaves of *Thalictrum alpinum*. Among them there is one real rarity *Saussurea alpina*, showing when we saw it first only dry seed-heads, but a year later its clustered thistle-like flowers. It is not, I think, a common plant anywhere; certainly we have not found it either in North Wales or in Perthshire: here in Galloway there was a pleasant little colony of it.

The other find must be mentioned with hesitation. It was secured on one of the many expeditions when, instead of approaching the cliff from the Merrick, we walked up the valley from Loch Kirriereoch and approached it from below. This way suited me; for one could scan the steep much more easily from below than from above; if it were necessary to climb I would

80 *Saxifraga stellaris*, star saxifrage
81 *Limonium recurvum* subsp. *humile*
82 *Erodium neglectum*

far sooner go up than down. Working along above the screes with their curtain of bilberry and parsley fern and at the foot of the sheer rock among the *Oxyria* was a single specimen which I could not happily accept as the common sorrel (*Rumex acetosa*). At least it must be gathered and examined: on examination it conformed in every respect to *Rumex arifolius* [fig.14]. Unfortunately it was found on the last day of our visit: there was no opportunity for a return and a fuller search: and in the rush of packing the plant was painted but not preserved for expert verdicts.

There was one other plant that we found both on the Lamachan and high up on the ridge that links the Merrick with Kirriereoch, a small hairy form of common speedwell (*Veronica officinalis*) with pale blue or, in one case, brilliant shell-pink flowers. It was very uncommon; we only found two patches of it: and it seemed very distinct from any other examples of the species that we had seen and is not in fact usually a plant of the hills. Whether it can claim connection with the *Veronica hirsuta* recorded in several books as from Ayrshire,[7] is a question which we asked but did not see our way to answer.

The coast, as a glance at the map will show, is fantastically varied. Our acquaintance with it began at Ravenshall Point on the way to Fleet Bay, where there are some pleasantly wooded cliffs that end in a succession of coves and inlets sharply fenced by bare rock. *Spergularia rupicola* which we had formerly found in similar places on the coast of Co. Cork, samphire (*Crithmum maritimum*) and common rockrose (*Helianthemum chamaecistus*) were its principal inhabitants. Then the mud-flats of the Cree estuary produced sea aster (*Aster tripolium*) and its rayless variety, *Atriplex littoralis*, sea arrow-grass *Triglochin maritimum* and other saltmarsh species. On the opposite side of the bay beyond Wigtown, where there is a similar stretch of saltings at Garliestown, we found *Spergularia salina* and the sea lavender *Limonium humile*, the latter much more obviously distinct than I had supposed from the common sea lavender. Burrow Head we have never explored; and the shore from Port William to Glenluce we have not properly searched. Sea radish (*Raphanus maritimus*) is common on the fringe of shingle and herbage that separates the road from the sea; and careful inspection might well reveal other treasures.

The most remarkable feature of the coastline is the Sands of Luce at the head of the great bay that separates the Wigtown peninsula from the Mull of Galloway. Here on Torrs Warren is a grouse-moor, complete with birds and butts, among sand-dunes, where heather and marram grow side by side. It is an area that would repay very full investigation: we found a wonderful series of colour varieties of *Viola curtisii*, and the lilac-flowered *Erodium neglectum* [**82**], but (as is usual with us) not *Mertensia*.

Beyond Sandhead the coast again resembles that on the eastern side of the bay – sand, shingle, and a belt of mixed vegetation. By Drumantrae, a favourite bathing-place of ours, there was a colony of crow garlic (*Allium vineale*) and nearer the sea on the edge of pebbles tufts of creeping wood vetch (*Vicia sylvatica*) [**79**]. We had seen it at Marlborough in a wood, and clambering over bushes in Finland, but the small stunted form, with its characteristically veined pea-flowers, rambling over bare stones was a complete surprise.

83 *Inula crithmoides*, golden samphire

84 *Potentilla anserina*, silverweed

There was a somewhat similar surprise further on in the East Tarbert, the cove which with its western namesake nearly makes an island of the Mull of Galloway. There right on high water mark for a hundred yards of beach is a dense growth of skullcap (*Scutellaria galericulata*), a few inches high but apparently healthy and permanent. The rocks on this side produce a goodly growth of *Geranium sanguineum* (the white form which is said to have come from here is no longer in evidence), a small sea lavender [**81**],[8] some golden samphire (*Inula crithmoides*) [**83**], brilliant in leaf and flower, *Scirpus cernuus*, and, as we discovered in 1940, the fern, sea spleenwort (*Asplenium marinum*). On the western side the rocks are even more attractive: gannets, oystercatchers and seals make the little bay very interesting; and there

ought to be rare plants in it. In fact sea pearlwort (*Sagina maritima*), and two rushes (sea and toad, *Juncus maritimus* and *J. bufonius*) are the only species that I have ever painted from it; and that not for want of searching. Meadow crane's-bill, *Geranium pratense*, not a common plant in the area, occurs on the road-side near the Mull and marsh watercress *Nasturtium palustre* is on the mud of a large pond full of coots south of Sandhead.

The coast from Ballantrae past Lendalfoot and the Kennedy Pass to Girvan and thence by Turnberry to Dunure is attractive but not botanically exciting. Some of the hollows in the low cliffs show a fine growth of Grass of Parnassus and the sandhills have silverweed (*Potentilla anserina*) [84], the knotgrass *Polygonum raii*,[9] and the orache *Atriplex sabulosa*. At Dunure we found dwarf grass-wrack (*Zostera nana*) in seed in pools between the shore and outlying rocks; and on these rocks by precarious scrambling a belated specimen of Scotch lovage (*Ligusticum scoticum*). For this, as for *Mertensia* which is reliably reported from the mouth of the Stinchar, we were a month or more too late.[10]

It is not a notable record. Perhaps if the salmon of the Minnoch and the trout of Loch Kirriereoch had been less exciting we should have searched more widely and been rewarded. But in fact we made much of our collection in those summer months; and each extension of our range is associated with it. At Glen Trool we first investigated the rushes and a year later plunged valiantly into the vast labyrinth of *Carex*. There too, later still, we attacked the grasses, and, on our last visit, the ferns. If rarities in the more brilliant families had been available, we might never have enlarged our borders. As it is we owe to Kirkcudbrightshire a large proportion of our pictures.

Fittleworth
23 Aug '43

AN IDYLL OF SUOMI

Finland, July 1934

[C·E·R]

WE HAD BEEN IN SOLEMN CONFERENCE, DEBATING THE STATUS of our respective churches, the possibilities of expanding Christian charity so as to permit of eventual inter-communion. In our own eyes, and perhaps in those of our Finnish hosts, we were an important delegation – two bishops, a dean, an archdeacon and three others of us to represent the trousered clergy. Photographers had done their best with us: interviewers had wrestled with our inarticulateness: we had been received in audience by the President,[1] and at dinner by our country's minister. The inevitable formulae had been drafted, discussed, amended and finally, with all the ceremony of a treaty of alliance, signed, amid expressions of mutual esteem and satisfaction. The whole business reeked of insincerity, or rather of that peculiarly ecclesiastical enthusiasm for unrealities which thinks the exact mode of appointing bishops far more important than the religious quality of their flocks – as if the style and pedigree of its hierarchy determined the spiritual worth of a church, or brought its members into a different relationship with God. Enough of it – especially as our results had been more satisfying than our procedure. We had made history of the sort that is supposed to count, and could go home with a glow of complacency.

For me, at least, the real history of our visit only began when its official purpose was over. Our Finnish hosts had indeed already relieved our labours by quartering us in a hotel on a wooded island,[2] where arctic terns wheeled and plunged in a reedy lagoon under our windows, and a tangle of unexpected wild-flowers – rose-bay (*Epilobium angustifolium*) [**85**], tansy (*Tanacetum vulgare*) [**86**], goldenrod (*Solidago virgaurea*), chives (*Allium schoenoprasum*) [**87**], orpine (*Sedum telephium*) [**88**], maiden pink (*Dianthus deltoides*) and three sorts of *Campanula* – clothed the rocks and invaded the precinct. But when the last meeting had been endured we were promised a day's rest in our chairman's country home at Vihti.[3] Its surroundings of lake and hill and forest should be full of delights.

85 *Epilobium angustifolium*, rosebay

Cars provided by the Finnish army were waiting for us after luncheon. We were to inspect two of the ancient churches, at Esbo[4] and Lohja, where a sprawl of mediaeval paintings, saints and devils, scenes from scripture and legend and the life of the peasants cover walls and vaulting with colour. The curious can find full accounts of them in any guide-book: for all their quaint interest they only reinforced my already obstinate modernism. But the journey was a compensation. The structure of the land is exactly like that strange corner of Scotland that lies to the west of Ben Arcuil and Foinaven and to the north of the mountains of Assynt. A honeycomb of ancient rock without perceptible eminences or water-shed encloses a multitude of lakes

86 *Tanacetum vulgare*, tansy

87 *Allium schoenoprasum*, chives

88 *Sedum telephium*, orpine

and, between tree-clad hill and fretted waters, fields of rye and barley, hay-cocks piled high round wooden stakes, droves of Ayrshire cattle, and scat-tered farmsteads, timbered and red-roofed. Multiply twenty-fold the scale of the landscape around Scourie, increase the number of its pines, remove the glimpses of distant peaks, and southern Finland will be familiar to you.

So at least I had concluded when, midway between Esbo and Lohja, the parallel was shaken and reinforced. Over a stretch of hay-field from the farm-land on our left to the forest on our right came a huge dark beast at speed. Our car slackened to let him pass. Twenty yards away a young bull moose, long-nosed, heavy-horned, high-shouldered and pathetically weak behind, careered across the road. A moose in broad daylight and open

89 *Impatiens noli-me-tangere*, yellow balsam

country: the largest wild thing I shall ever see; the strangest combination of awkwardness and power; this indeed was foreign – a thing undreamed. Yet just so had a stag, smaller, more graceful, but equally unexpected, bounded across our path when we passed from Loch Stack on the road to Scourie, and revealed in a flash the novelty of the land.

That night we spent at Lohja and the bishop, finding me painting yellow balsam (*Impatiens noli-me-tangere*) [**89**], discovered my passion for the wild-flowers of his country. Very diffidently he (or his wife) suggested that, instead of a few hours with him and then a long journey to the tourist centres and beauty spots of East Finland, we should stay for two nights at Vihti and then give ourselves a couple of days to see Helsinki. There was a lake, a forest and hill; his boys were interested in plants; it would be very simple; and we could have a Finnish bath. To escape two nights in a train; to stay with friends instead of in hotels; to see the folk, the land not as a passer-by but more intimately; these were more attractive than Olavin-linna or Valamo, the rapids at Imatra or the isthmus of Punkaharju.⁵ Once or twice, as she drove us from Lohja, I could see my hostess wondering whether her country home and its primitive ways would be grand enough for these strange rich Englishmen with their luxurious homes and ancient civilisation; once or twice the struggle between her hospitality and her anxieties found sweetly sensitive speech. She could not foresee that she was offering me one of the few perfect experiences of a life-time.

Perfect is a word that should be used only for those moments when a quality of unselfconscious joy develops out of harmonious surround-ings, trustful comradeship and shared activity, when life becomes natural and wholesome and satisfying, when the soul regains its paradise. In our normal days the world is too much with us: we cannot and should not escape the fret of duty, the tension of conflicting claims, the discipline of suffering or the ache of deserved failure. But sometimes, when a spell of work has been finished, or an illness has interrupted one's course, there comes a season of refreshing; and then, if place and people and pursuits are congenial, the perfect may be realised. So it was in those days at Vihti. The house stood on a bluff above a lake, small for Finland, very large to an Englishman. Across it rose a ridge of low hill and forest. Round the house were fields of hay and rye, and beds of summer flowers. On the shore were my host's study, the bathing chamber, and a little pier. Other build-ings completed the farm. The whole was peaceful and welcoming: even a stranger knew that here he was at home.

But it was the boys who made this certain, the boys who sealed the promise of perfection. Much of my life has been spent with youngsters, my

own and other people's: its happiest work was as a schoolmaster. I am not foolish enough to think that I understand the human boy, nor immodest enough to imagine that he likes me; but at least I can admire and enjoy. These three were perhaps the best specimens I have ever known and the eldest was very near my ideal. His parents, dear and godly folk, had called him Samuel; and their faith had been fully justified. Slim and straight of body, serious and sensitive but with jolly wrinkles round the eyes, thoughtful for others but wholly free from selfconsciousness or priggishness, the child was a joy to behold and a delight to accompany. Within ten minutes of our arrival I was carried off into a sanctum under the roof, and shown sheet by sheet his herbarium. I knew neither Finnish nor Swedish; he had no English – he was only thirteen – but plants have names in Latin and we could both string together school-boy sentences in the speech of ancient Rome.

'Habes Ledum palustre: ubi invenisti?'
'In monte trans lacum' – and a wave of the hand in the appropriate direction.
'Ubi Carum carvi inventum est'
'In horto – sed non in horto' – could anything be more tersely expressive?

So began a friendship, of which (I think) we were both immediately aware. The inspection of the collection was its proof and sacrament. Every page was to be examined with ritual solemnity: every rarity must be noted: appropriate, if linguistically restricted, comparisons between the flora of Finlandia and what I fear we called Englandia must be discussed. There was neither haste nor impatience. We were both entirely absorbed – he in the satisfaction of finding a fellow enthusiast and the fun of circumventing the curse of Babel – I in the interest of seeing unfamiliar species, in the revival of days when my own chief pleasure was this same showing of my treasures, and in admiration for the competence and the ingenuity of my colleague.

He must have been admirably taught. On my last day in Helsinki I got an introduction to a member of the Botanical Institute of the University, was shown their great series of Finnish plants with its specimens of each species from the several provinces of the country, and discovered how keenly their teachers had developed the study of nature in the schools. But no teacher save his Maker had given this lad his power of observation, of discrimination and of memory. For three years he had been collecting, and in them he had found, pressed and mounted some four hundred different species – no bad achievement in view of the total number of Finnish plants and of the difficulty of identifying sedges and grasses or even Compositae

and Umbelliferae. One plant was wrongly named – *Triglochin maritimum* (sea arrow-grass) appearing as *Plantago maritima* (sea plantain): one, the sanicle (*Sanicula europaea*), was offered to me for identification: there may have been a few others unknown or misplaced: but on the whole sheet after sheet was correct – names, localities, dates and other particulars duly entered upon it. The list was to my surprise not very unlike my own. Southern Finland was the only area represented, and its flora is very close to that of Northern Britain. But there were enough specimens not found with us, or not known to me, to promise me a busy time. If I was to see and paint as many as possible we must waste no moment of the visit. Four novelties were in fact waiting to be depicted within an hour of my arrival: for we found, as he had said, the caraway (*Carum carvi*) as a weed, the crucifers *Berteroa incana* and *Bunias orientalis*, and soon after the yellow chamomile (*Anthemis tinctoria*) [90].

My initiation into the family circle was to be completed that afternoon by partaking in the national rite of the bath. For an Englishman, accustomed to regard his bath as a private affair and to shrink from undressing in company, the Finnish bath sounds something of an ordeal. He does not easily connect sociability with nakedness; indeed he regards the human form divine as only decent when concealed. He is in this matter a puritan if not a prude. For myself my physique is definitely C3; my body serves its purpose but can give no aesthetic satisfaction to its owner or to anyone else. I can only reflect that it would be still uglier if it were fat instead of lean. Into the ethics of Nudism this is not the place to enter. I might appreciate the cult if I did not so cordially distrust its exponents. I can only confess that I should have escaped the Finnish bath if there had been any reasonable excuse. To do so would have been a tragic mistake. When once any flush of shyness had passed, the experience was wholly delightful. We were as unselfconscious as children, full of the humour of a novel adventure and yet aware that we were neophytes assisting at a sacred mystery. A naked and perspiring professor being first parboiled and then drenched with a bucketful of cold water by a similarly naked bishop – the memory of it washes out all the pomposities of our Conference and creates a spiritual kinship that years of talk could hardly achieve. If only I believed in hell, I should be sure that this same Lazarus would minister to my torments. Here was a veritable catharsis, a baptism of friendship.

So next day to the forest. Over the lake where a family of great-crested grebes and, I think, a couple of red-necks kept us at a safe distance, through lowland fields bordered with hemlock water dropwort (*Oenanthe crocata*) and melancholy thistle (*Carduus heterophyllus*), past a small farm on a bluff

90 *Anthemis tinctoria*, yellow chamomile

91 *Campanula patula*, spreading campanula

above a stream, and so into the wild. The hill was a long ridge of gneiss, fall-
ing steeply to another lake and enclosing what we should call a tarn. The
lower slopes were thickly covered with pine and spruce, birch and alder
with a thick undergrowth of raspberry and red currant, bilberry and ling.
Campanula persicifolia, common along with its cousins *patula* [**91**], *rotundi-
folia* and a magnificent form of *C. glomerata*, sprays of mezereon (*Daphne
mezereum*) laden with scarlet berries. Meadowsweet and goldenrod broke
through the ferns and brambles. Twinflower (*Linnaea* borealis) [**92**] crept

among the mosses. Seed-heads of one or other of the pyrolas rose amid patches of cow-wheat and wild strawberries. Higher up the bare granite became more evident; firs were the only trees, and the plants were restricted to those of a definitely northern type. We found a fine patch of *Ledum palustre* above the tarn, specimens of *Lychnis viscaria* [93], one still in flower, of may lily (*Maianthemum bifolium*) [94] and *Trientalis europaea* [95]. The summit was a long succession of rounded hummocks of rock, cushioned with deep grey-green lichen. Between the boulders was a dense growth of bog whortleberry (*Vaccinium uliginosum*) and occasional spotted orchids. Upon them *Silene rupestris* was almost the only plant, except a few flowering shoots of cowberry (*Vaccinium vitis-idaea*).

For some hours we tramped the hills. It was a grey day and the distant view was seldom clearly seen. One could get little idea of the lie of the land, but much of its detailed character. We feasted off a basket of bilberries bought from a lad who was gathering them with his grandmother; explored the shore of the tarn where I found the milk parsley, *Peucedanum palustre*, new to my young colleague but familiar to me from days with the swallow-tail butterflies at Wicken; descended steeply in Indian file to the second lake; and finally followed a long and muddy ride back to the farm and so to our boat. My host setting a merciful pace and keeping a sense of direction which I was constantly losing; the two boys skirmishing to and fro and with eyes for birds and insects as well as flowers; myself snatching a few minutes rest to draw a novelty, including wood vetch (*Vicia sylvatica*) [79], before its

92 *Linnaea borealis*, twinflower

93 *Lychnis viscaria*, viscid campion

94 *Maianthemum bifolium*, may lily

leaves wilted or to colour a blossom that might fade before it could be put
into water; and around us the granite and the lichen and the pines and the
soft sweet silence: it was an unforgettable experience.

When we got home it was to find a great family gathering beginning to
assemble. It was our hostess's name-day, and the festival of her patron-
saint, Margaret, an occasion honoured as regularly as a birthday by all good
Finns. While the relatives were arriving, I realised how generous had been
the hospitality which could welcome a stranger at such a time. Tact and
botanical ardour suggested that the guest make himself scarce.

Samuel, unfatigued by his exploration of the hill, had made a pact to
show me one or two of his choicest rarities; they grew, so far as I could
discover, some three kilometres away. Now was our opportunity. We set
off, saw a quite new bit of country, found our plants, improved our means
of communication, and cemented our mutual esteem. Just so, six years

earlier, my son and I had explored the coast of western Cork on the day when we found *Helianthemum guttatum* on Three Castles Head. Is there anything more fascinating in the world than a youngster's unspoiled enthusiasm for the wild life of the earth? So long as we can keep our power to share His keenness the gates of Eden are still open to us.

After such admission to fellowship the name-day party was an appropriate climax. As a sort of brevet uncle I could manage to feel at home – could at least hope that my presence would not be wholly an intrusion. It was in fact one of the simplest and happiest of evenings, full of the little intimate jests of kinsfolk, of good racy talk, traceable in outline though unintelligible in detail, and of that underlying *gravitas* which the Finns have in common with the northern Scots. How some thirty people were all seated and fed and served will always remain a miracle. The house had four rooms available, opening out of one another, but none of them large. We sat down by companies, a well-selected group in each apartment. The food, abundant and admirably cooked, was laid out upon a table between the doors. There seemed an unlimited supply of plates and cutlery. The Finnish maids, one of them a superb blond Amazon, six-foot tall and muscled

95 *Trientalis europaea*

like an athlete, must have performed wonders of washing up. But there was no sign of flurry or of any hitch in the arrangements. It was like a vast and leisurely picnic.

We were a cosmopolitan gathering. One sister had married a Swede, a charming man who spoke excellent English and had a large young family. Another's husband was French. A German girl; a Norwegian engineer; a Finnish dean; and one or two unidentified Swedish-speaking visitors completed the party. German, which I can manage to follow but cannot speak, was the highest common factor of our intercourse: the dean and I tried conclusions in Latin but without much satisfaction; it is not a tongue adapted for contemporary small talk: my hosts kept me in touch with the proceedings by frequent and condensed reports. No ordinary Englishman could help feeling ashamed of his education in such company; but it was difficult to be self-conscious with people so welcoming and sympathetic. When at last, after immense bowls of strawberries and cream, we rose and in the pleasant Finnish fashion shook hands with the lady of the house and offered our thanks for her entertainment of us, the gratitude was wholly genuine – and extended to far more than the food.

For me the day could not end when midnight brought the festivities to a close. My room, which I shared with a substantial organ on which one of the relatives had been playing Mozart, was full of the spoils of our expeditions. I was to leave next morning. To get the plants painted would mean long and steady labour. Fortunately the nights even in July are hardly ever dark and it would be bright enough to see colour clearly by four. They were all drawn before I went to sleep; they were painted – enough to be easily finished afterwards – before we breakfasted. Our collection has never had so many good additions in a single day.

Leaving was a sorry business. I could only beg that, as soon as he was old enough to travel, Samuel should learn English with us on a long summer visit and that his parents would regard our house as theirs if ever they could find reason to come to England. But when, just as my baggage was being put into the car, the boys brought me the two plants that we had hoped and failed to find – two plants on pages torn out of their herbarium – and insisted that I must pack them up as a parting gift, the sweet sorrow almost unmanned me. Knowing to the full a collector's passion no present to me could have been more precious or more costly. We shook hands; and I managed to murmur 'pignora amicitiae'; Finland could give me no more abiding memory.

There is the contrast that will live with me from my visit to Suomi. On the one side, the great world of Church and State, of solemn debate and

formal procedure, of receptions and orations and occasions and the nego-
tiation of terms of alliance; a council chamber full of anxious delegates
bargaining over their faith. On the other, the small world of trust and
intimacy, of common interests and unquestioning generosities, where the
reckoning of claims and counter-claims is unknown and one lives simply
and spontaneously without mask or muzzle: Samuel and his home and his
gift of flowers. 'Of such is the Kingdom of Heaven' was said not of an eccle-
siastic but of a child – and said by One who knew.

Bradley Lane
Newton Abbot
26 Aug 46

CHAPTER NINE

IRELAND REVISITED
Connemara, August 1939

[C·E·R]

SOMETHING LESS THAN A YEAR AFTER OUR RUN AROUND IRELAND we crossed the Irish Sea again – this time from Liverpool to Dublin en route to Roundstone in Connemara. Eventually we were to be a large party, overflowing the rectory and parked out in rooms in the village: but my son, my wife and I were an advance-guard and foregathered at the Pier-head on the afternoon of August 7th, intending to drive next day quickly to Loch Derg, search for the fleabane *Inula salicina*, then to go on to Woodford for the blue-eyed grass, *Sisyrinchium angustifolium*, and so through Galway to the west. We had booked berths long before – which was fortunate as it was the eve of the Dublin horse-show; and having plenty of time were persuaded to send our car ahead of us by a smaller boat so that arriving early it would be waiting for us at North Wall.

There are few experiences that give me a more authentic thrill than the start of a passage to Ireland. Partly no doubt the excitement is due to the peculiar effect that Dublin has always had upon me; though far more obviously than Edinburgh or Amsterdam a capital city of a foreign country to go there is always for me to go home. Partly it is the memory of the many years when the family set off for its summer holiday by cattle-boat from Liverpool to Cork. But the chief reason is certainly because my first invasion of John Bull's other island was the strangest and maddest Odyssey of my life. It was in the winter of 1916–17, just before my departure to France. By the kindness (as I afterwards discovered) of Bishop Boyd Carpenter,[1] I had been invited by the Provost to preach in Trinity College Chapel. On a cold and dreary Saturday I left Holyhead and in due time found myself at Westland Row. It was raining: there was no one to meet me: and when an ancient cab at last deposited me before the Georgian splendour of Provost's House I felt empty, diminutive and horribly afraid.

'No sir' said the sardonic Irish butler when at last I rang the bell 'the Provost is not expecting you: indade he's just goin' out'.

96 *Sisymbrium irio*, London rocket

'But I've come from England; I've come to preach; I've come and I can't get back to-night'.

So pleading at last I softened him and was admitted to his master's study. To me then entered the great Dr Mahaffy[2] – more like a stage-Irishman than anyone could be in real life, and on this occasion with scarlet braces hanging loose over a dress-shirt.

'My dear sir, why did you tell me that you'd fallen down from a ladder in your library and broken your leg ... But indeed you did: here's your letter that I got on Thursday'.

And there it was, but sent from a Manchester vicarage and signed with my surname but other initials: so it was not a leg-pull by my undergraduates, but a genuine document. I pointed out the discrepancies; and light broke upon the great man.

'My dear Mr Raven I see what's happened. I asked you to preach: that's sure. I sent your name to the Dean who makes out the Chapel-card. He'll have looked you up in Crockford and found this namesake, one of our own Trinity College men; and he'll have asked him to preach.'

It was my opportunity:

'Well, Mr Provost, it's fortunate for you that you're not in the position of Elijah with two ravens to feed you. Should we have preached in duet?'

And all was well. Irish hospitality rose to the occasion; guest-room with fire ablaze and clothes unpacked, and an eight-course dinner for one, improvised by magic. But next morning saw the climax of the incident. Marching across at 9.15 (straight from the breakfast table) to the chapel with pokers and much pomp the Provost suddenly announced:

'Mr Raven when I thought you weren't coming I asked our Mr Roberts to preach; and I won't be able to stop him ... What'll I do? I've got the Viceroy coming and must be in attendance ... I can't see Mr Roberts ... I have it. There's a hymn before the sermon. When the hymn begins you make a bolt for the pulpit!'

In due course the hymn arrived: I was (I confess) shattered by the whole business. I knelt down as my habit is, and in hope of recovering quietness and vision. A large hand plucked at my surplice; a stentorian whisper rang round the chapel

'Man you'd better be starting or he'll get there first'.

Poor little Englishman. And yet I love Dublin better than any city in the world.

So on that August morning when my son and I came on deck in time to see Howth loom out of the grey sky and to catch a glimpse of Ireland's Eye (my dream island) over the neck that links the Head to the Liffey banks,

we were both eagerly expectant. The small boat was moored ahead of us as we made the quay-side. The weather was cloudy but not bad. Our luck was in. It was not. The car had totally disappeared. The boat on which it had crossed was empty save for a steward offensively alcoholic: no one knew, and no one cared, where the car had gone. In a bit – when our own boat was emptied – there would be someone to help us. Meanwhile …

I am hopeless on such occasions. For patience is a virtue totally unfamiliar to me: I have a quick temper and on occasion violence of speech. I had the sense to realise that my wife and son would deal more wisely with the business. I also remembered that the London rocket (*Sisymbrium irio*) [**96**] was said to occur at North Wall. So to a patch of rough and weed-grown bank by a lock-gate. It was fenced and my son is taller and more active. I summoned him and in three or four minutes *S. irio* had been gathered. I retired to a dump of packing cases, a puddle for paint-water and a place to tie up the dog, sat me down, unpacked my paint-box and proceeded to forget cars and boats and plans. Far more rapidly than I expected the car was found (in the fore part of the small boat), and removed from its hiding-place: and I was summoned. My family were the only people who thought it funny that I was painting a weed, alongside a warehouse, and throned upon an open crate of lavatory pans! We had wasted invaluable hours; but had at least redeemed the time, and collected a plant and a memory.

The plant, though in appearance the dullest of casual weeds, has a history which gives it distinction. After the Great Fire of London it sprang up everywhere on all the devastated areas of the City and outside it – on the dykes of the marshes and graveyards of the plague. Robert Morison, afterwards first Professor of Botany at Oxford, and then in charge of the Royal Gardens of St James's, was confident that only spontaneous generation could account for so sudden and general a growth. But Ray drew a parallel from the appearance of charlock on the newly raised dams and banks of the fenland and insisted that the case did not prove what was, on other grounds, unproven and improbable. Why *Sisymbrium irio* has disappeared in London and now survives only in Berwick and Dublin is one more mystery attaching to it: but plant distribution is a matter on which the last word has not yet been said.

The crossing of Ireland by road is not an affair of much interest. As if to compensate for the varied beauty of its coast the inland is monotonous and only not ugly to those who like a wide horizon. Making good speed we struck the shore of Lough Derg some miles south of Portumna, and at a place very near one of the localities at which we learnt later the fleabane is to be found. We covered a big stretch of lough-side both here and afterwards

[159]

on the west side of Portumna: but the shore is a wide belt of gravel, of large stones, and of scrub, difficult country to search quickly, and *Inula salicina* is a shy flowerer.[3] John found the water germander, *Teucrium scordium*, which we had discovered some weeks earlier, but not in flower, in a ditch near Mepal on the edge of the Isle of Ely, but the rarer plant escaped us. We like to think that if there had been no delay in Dublin … but I hae ma doots. An *Irio* in the collection is better than an extra hour's search for the *Inula*. Woodford was more successful. We stopped at a stream close to the road, a stream small and shallow and running fast over a pebbly bottom; and there in tussocks, taller and more lush than one sees it in English rock-gardens, was the blue-eyed grass. John found it; and a few of its flowers were open: knowing their habits I thought it wise to sketch them there and then.

Not till after Galway did the road become beautiful. Then every mile westward brought the mountains nearer. Connemara from Lough Corrib to Clifden and Renvyle is too lovely and too beloved to deserve description from me. Suffice it that the Twelve Pins always look like mountains, and form a group that is from all sides strikingly beautiful: we had our own reasons for driving round them – and we knew their excellence. The

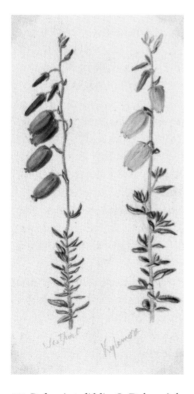

97 *Daboecia polifolia*, St Dabeoc's heath **98** *Daboecia polifolia* (white form)

99 *Erica mediterranea*, Mediterranean heath 100 *Eriocaulon septangulare*, pipewort

coast, if less grand than that of Kerry, is full of gloriously coloured bays and
inlets, and the view from Renvyle on its northern edge with the panorama
of islands seawards, and the great mass of Mickle Rea hanging over the
narrow fiord of Killary Bay to the east, is as fine as anything in the coun-
try. Indeed my son, who came to it fresh from the Peloponnese and Sicily,
declares that the drive from Renvyle to Leenane and thence to Roundstone
surpassed anything that he had seen both for form and for colour.

Roundstone itself, a straggling row of cottages set on a steep slope and
facing eastward over the little harbour and the bay, with its ever-changing
tides, and the mountains looking down from its head, has a charm appro-
priate to its setting. The plant characteristic of it is of course St Dabeoc's
heath (*Dabeocia polifolia*) [97, 98], the lovely thing that Edward Lhwyd
first sent to John Ray in 1699. Here its short, straight sprays, carrying
the big lantern-shaped blooms break out through the cushions of low
growing gorse, and clothe the banks and roadsides with purple and gold.
Behind the village rises the lonely hill of Urrisbeg where the Mediter-
ranean heath (*Erica mediterranea*) [99] fills a ravine and the Siberian juni-
per (*Juniperus nana*) clings tightly to the rocks. To the south, a short mile
from the rectory, is the lough of Craig Duff, home of *Naias flexilis* and of

101 *Arabis ciliata*, fringed rock-cress

the elusive eight-stamened waterpepper (*Elatine hydropiper*), its edges matted with a dense growth of pipewort (*Eriocaulon septangulare*) [**100**]; and further on the double inlets of Dog's Bay, formed by a long island of sandhills linked to the mainland by a narrow causeway of dune and offering sheltered bathing in any wind or weather – Dog's Bay where we were too late to find the dense spiked orchid *Habenaria intacta* and failed to find the fringed rock-cress, *Arabis ciliata* [**101**], but where the Salzburg eyebright (*Euphrasia salisburgensis*) makes tiny tufts, red-brown and white starred, on every crevice of the northern rocks. To the north and along the main road to Clifden lies Craigga More where Mackay's heath (*Erica mackaii*) [**102**] takes the place of the cross-leaved, and where all three sundews grow together and (I suspect) hybridise in the bogs. To the west, between Urrisbeg and the Atlantic, is a stretch of moor, part loughs, part heather, infinitely diverse but a trifle monotonous; there are a few good sedges – we found mud sedge (*Carex limosa*) [**103**] – and several bladderworts *Utricularia minor* very abundant, and *U. ochroleuca* – but never in flower, and *U. intermedia* similarly sterile. Beyond this lies the isolated hill of Bunowen and its lough; the coral strand on Mannin Bay near Ballyconneely – a strange by-product of the Gulf Stream; the promontory of Errislannan where we picnicked and found a fine white specimen of St Dabeoc's heath [**98**]; and the lovely road northward through Clifden and Letterfrack to Renvyle and the lough where *Hydrilla verticillata* has its only Irish home.

102 *Erica mackaii*, Mackay's heath
103 *Carex limosa*, mud sedge

At Roundstone we had spent a couple of days in the previous year and had found the three local heaths, and in Craig Duff the pipewort and *Naias*. We now set ourselves, with the aid of Dr Lloyd Praeger's admirable *Tourist's Flora of the West of Ireland*, to make up the gaps. One of them was easy. Babington's leek (*Allium babingtonii*) [**104**], whatever its status,

104 *Allium babingtonii*, Babington's leek

is a prominent object, along with wild turnip (*Brassica napus*), stinking mayweed (*Anthemis cotula*) and polypody, on the rough stones of the embankment that flanks the harbour. Another was exceedingly difficult. *Elatine hydropiper* was said to grow in Craig Duff in the shallow water and mud of the margin. The lough was low during our visit. *Lobelia dortmanna* and *Eriocaulon* were abundant: but a thorough search, John taking the eastern and I the western side, yielded no sign of any other rarity. A stroll to Craig Duff became a usual evening's employment: for we knew that *Elatine* was tiny and the lough, though not large, had a much indented outline. It was a huge excitement when John at last returned with an exceedingly diminutive, and very richly coloured specimen, found well above low-water-mark and on my side of the lake; and scarcely less when next day I retrieved my credit by finding a much larger specimen in his water.

The *Hydrilla* [105] at Renvyle was hardly less exciting. We had no boat, and fully expected to be turned out for trespassing (as in fact we were on a subsequent visit); and *Hydrilla*, like *Naias flexilis* at Craig Duff, and both of them in their only other station, Esthwaite Water in the English Lakes, grows deep and is invisible from the land. Fortunately both are comparatively brittle; fish or snails break off pieces; and a visit to the lee shore had produced *Naias* in some quantity. John spotted *Hydrilla*, but there was only the one piece of it: I painted it as it lay in the water there and then.

That day gave us our first search for the rarest of Irish pondweeds, *Potamogeton kirkii* of Maam Bridge.[4] To get to it we had to complete the circuit of the Pins and come back by a road across the moor under the Maam Turk range which finally cut the main road from Galway. That first visit yielded nothing. There was peppermint (*Mentha piperita*) [106] established near the cottages at the bridge-head, and a new sedge, brown beak-sedge (*Rhynchospora fusca*), on the bog near the river: but in the stream I could only see *Potamogeton natans* (broad pondweed) and a trailing thing too far out to identify – which might well be nothing but a *Sparganium*. Nevertheless the plant was guaranteed by Praeger: it was eminently desirable: the drive though long was exceedingly lovely; and what was the use of having a body of accomplished swimmers if they could not explore a river? So a week later the expedition was repeated. Derek and Michael retired under the bridge and came out decently covered; John and I had meanwhile located what we felt sure was *kirkii*; encouraged by our excitement they plunged in – did so in fact with simultaneous and most undignified speed. Rounded stones under water, as I know to my cost from attempts to wade the Tees, can give points to ice for sheer slipperiness. Neither of them seemed much hurt: they persisted and soon were able to swim to the weed: but it was a

relief that their bruises were not in vain. It was unmistakably *kirkii*, a noble creature – whatever its pedigree. The upper leaves tend to become paddle-shaped, and to lie on the top of the water; the lower are a foot long or more, and nearly an inch wide, great ribands of transparent green. Presumably the plant sometimes set seeds: Fryer and Bennett in their *Potamogetons of the British Isles* have, I think, a picture of a spike: but our bathers inspected every likely patch of it and could see no trace, though *P. natans*, which is

105 *Hydrilla verticillata*

106 *Mentha piperita*, peppermint

presumably one of its parents, was flowering freely. We made some rather pleasant pictures of it, but they are too large to reproduce.

This expedition, and its success, were responsible for my son's conversion to an enthusiasm for pondweeds. These, with sedges, grasses and chenopodiums, he had previously regarded as fit only for my more catholic and degraded taste – a pity, for he has power of discrimination definitely more alert than mine. Now he woke to the fascination of these aquatics;

and a marked increase in our collection resulted. I had already found a rather nice specimen of *Potamogeton friesii* in Craig Duff: but the lough at Bunowen was credited by Praeger with two other species; and when next we went westward we resolved to go prepared for bathing.

As it turned out that day was the last and to me the most poignant of our Irish botanisings. On August 24th I had been taking a Quiet Day for clergy at Tuam on the further side of Lough Corrib at the palace of my old friend Jack Crozier, once of St Ann's Dublin and now bishop of the diocese.[5] There we had heard of the German agreement with Russia and ultimatum to Poland; and had realised that war was almost inevitable. Fortunately, having the bishop at hand, I was able to use his authority in terminating my locum-tenency at Roundstone and booking passages back to England for our party and cars. But it was with profound misery that we made our last excursion two days later to Bunowen.

It was a perfect day. John and I dropped off at the lough with jars for water and towels in case of bathing. Very soon we spotted some pondweed spikes some distance out: he waded and brought to me *Potamogeton nitens*. Further on we noted a larger-leaved, redder species semi-transparent and exquisitely netted: he waded again and it was *P. coloratus*. With *Ranunculus baudotii* a bit further on the lake deserved our praise: we took to the hill (which we had already explored without result) and while he searched it inch by inch, I went on to the dunes to report to the others at the little quay. My success came first. Along the edge of the shore, on a natural bank covered with rough grass, was a colony of the fringed rock-cress, *Arabis ciliata*, one of the rarities of Connemara and superficially very distinct in its brilliant green and shining leaves from its cousin the hairy rock-cress, *A. hirsuta*. John's, however, was more deserving. We had known that Bunowen was a locality for the rarest of the bugles *Ajuga pyramidalis*, but had satisfied ourselves that if there at all it was very well concealed. Now, just as I was painting the *Arabis*, John came to fetch me to a plant so juvenile and so low-growing that I had to have it touched before I registered it, a rosette of leaves, which, when we checked it, became almost certainly our rarity. Of course it would not flower for another season: and in fact there were only three specimens of it discoverable: but we know the spot; and when next we can get over to Ireland shall look forward to a meeting with its descendants.

And so to lunch and to one of the few unforgettable moments of my life. We picnicked by the jetty, a concrete wall with its foot on the shore. Below was a stretch of golden sand and the glory of the sunlit sea. Eastwards was the bay looking up to the mountains: westwards the Arans and the Atlantic. There were eight of us, my wife and I, and six youngsters; and after lunch

and a bathe they picked up sides and began a cricket match at the water's edge. We two elders had seen one war when the children were babies; and had found comfort like a million others in the belief that at least such pain could not recur. And now for me, sitting in the sun and painting a pond-weed, came horror. These lovely young limbs, the joy, the gaiety, the careless zest of life – here once again was the end of it. The dreams and hopes, the future opening up before them, the causes we had served, the ideals we had proclaimed – the sun was turned into darkness and the sea into blood. It was as well, perhaps, to have seen the calamity clear-eyed before it came; for all that has happened since has been less poignant, more endurable, in consequence. But of all the pictures I have ever made *Potamogeton coloratus* [**107**], drawn in a large jam-jar on the quay wall at Bunowen – a bad picture, I fear, but better than might be expected – is the one that has the most power to move me. I had seen death many times before, but never more plainly or with such dread.

107 *Potamogeton coloratus*
108 *Osmunda regalis*, royal fern

This experience, as vivid as anything that I have known, did not over-shadow the rest of the party; nor, even for me, did it spoil the last days of our holiday. Those days were botanically important for us; for they saw the beginning of our picturing of ferns. Hitherto we had drawn the line at grasses: now the abundance of the royal fern, *Osmunda regalis* [108], tempted us further. I spent the last hours, while the more useful members of the party were packing, in starting us off with portraits of the six or seven small species that grew in the rectory precincts. During the following weeks most of the larger commoners followed; and by 1942 only *Woodsia* and *Trichomanes* remained unpainted – which considering that Cambridge has only two good ones within reach is not bad going.

H. alpinum
Little Craigindal
17. vii. 51.

var. insigne
Glen Einich
25 vii. 51

THE INN AT THE END OF THE GLEN
Glen Clova, 1942

[C · E · R]

FAIRYLAND IS THE PERQUISITE OF CHILDHOOD AND THE PANTO-
mime; and in spite of Shakespeare and spirit photographs the middle-
aged cannot be expected to take it seriously. But the legends of the nymph-
holepts and of mortals kidnapped by the little people, have nevertheless
their support in an experience which even the most prosaic can, on occa-
sion, share – the experience of falling out of the world of geography and
common sense into an elfin country that quite evidently belongs elsewhere.
For many Englishmen a visit to Ireland has this quality about it. We know,
of course, that we are stepping ashore onto a coast with a position on the
map, a history and a character no more inscrutable than those of Belgium
or Canada. We like (or dislike) the Irish people, enjoying their humour
and making allowances for their temperament. Theoretically their island
should be as unromantic as it is, very certainly, slipshod, and ill-organised,
poverty-stricken. Actually it is faery; it has a time-scale of its own; its own
values of beauty and truth and goodness; and, in the south at least, a very
evident detachment from the world of our English habits and conventions.
It welcomes, but never surrenders, intrigues but always eludes. We love, but
can never possess; are at home, but always as strangers; enjoy, but only if
we can slip out of our complacency and leave behind our ambitions and our
cares. We too become fey.

But it is from particular cases rather than a general example that the
vindication of fairyland is to be drawn. Three times now there has come to
me this sensation of stepping out of normal existence into a place, familiar
indeed and most friendly, but manifestly not of this earth – a place with a
frontier invisible but sharply drawn, which, as you cross it, admits you to
the elemental joy of a life released from fretfulness and transiency. Three
times; and the last of these was at Glen Clova. For years Glen Clova had
been to me, as to every field botanist, a household word. Not only was it
the one locality for yellow oxytropis (*Oxytropis campestris*) and alpine lettuce,
Mulgedium alpinum, but for all highland species, especially for the willows

109 *Hieracium alpinum*

and the sedges, its name constantly figured in the textbooks. As such it had acquired in my imagination a status like that which the Black Wood of Rannoch had held in my entomological period. Rannoch, long before I had crossed the border, stood for everything that the moth-collector could desire. I pictured it in the springtime – its heather crowded with *Nyssia lapponaria* (the Rannoch brindled beauty),[1] its birch-trunks alive with *Brachionycha nubeculosa* (the Rannoch sprawler) – or in summer when *Anarta melanopa* (the broad-bordered white underwing) and *A. cordigera* (the small dark yellow underwing) and half a dozen others were adance over its moorland. So with Clova. The White Water took the place of the Black Wood; plants replaced insects; but the glamour and the mythologising were the same.

If anyone suggests that it is this long dwelling upon an unknown Eden that gives to it when at last it is visited its faery quality, then it is enough to answer that Rannoch once seen lost its mystery and became part of the common earth – and that despite its prelude, the witchery of Strathappin and the splendid outline of Schiehallion, loch and woodland burns and birches, kept their beauty: but the elfin touch was lacking; and no dreams came true. Clova was different. We arrived – and at once felt that we had come back to a place intimately familiar. We left – and could hardly believe that we who detrained at Euston were the same people who, on the evening before, had been watching the sun setting behind Craig Mellon. The fortnight of our stay was an event complete in itself, independent of what preceded and followed. For it, we had dropped out of the world. Indeed, if it were not for the pictures of the plants that we found there, and a row of new butterflies in my cabinet, I could believe that it was all a dream.

Botanically indeed, the record of that fortnight was so remarkable that we can still hardly believe in it. We had made very full enquiries and received a mass of detailed information both from previous visitors and from the data in herbaria. There were in the neighbourhood, if every possible species was included, some twenty new to us; and so far as we could, we had found out particulars of their localities and worked them out on an Ordnance Survey map. Nevertheless our most sanguine expectations were satisfied with the hope of a dozen; and when we realised how large was the area, and how intensely local the rarities, even that number seemed excessive.

Our first day gave us a clear idea of our difficulties. The hotel at Milton is some four miles from Braedownie, the point at which Glen Doll and the White Water join the South Esk on its western bank. From Braedownie there is half an hour's walk along Jock's Path up Glen Doll before one reaches the little bridge that gives access to Glen Fee, with Craig Rennet

at its western corner and the Fee waterfall at its head, and the south corrie high up on the side opposite to the Craig. These, with Craig Maud, a similar bastion of the mountain a mile further up Glen Doll, and the ravine just beyond it, form the best known hunting ground. Nearly all the rarest plants – *Oxytropis campestris*, *Astragalus alpinus*, *Mulgedium alpinum*, *Linnaea borealis*, and the sedges *Carex alpina* and *C. grahami* – and many others – are to be found there. On the map it looked as if half a day's exploring would give us all that we could expect.

So having left Euston at 7.30 p.m. on the 24th June and arrived at Kirriemuir fifteen hours later, we set out after lunch from the hotel on bicycles to explore Craig Rennet. My own share in the adventure was cut short by a puncture some three miles down the road: I found the Scotch brown argus, *Lycaena artaxerxes*, (the last new British butterfly that I am likely to see alive),[2] walked up the Esk and then along Jock's Path to the Fee bridge, caught a glimpse of my son and his friend Peter high up on Craig Rennet,[3] and then tramped back with my derelict machine. At least it taught me how large, how steep and rough were the stretches of scree and precipice to be searched. When the others returned having seen no plants except serrated wintergreen (*Pyrola secunda*) [**110**] and an abundance of holly fern, *Aspidium lonchitis* (although they had visited the exact spot given us as the locality for

110 *Pyrola secunda*, serrated wintergreen

[173]

111 *Lychnis alpina*, alpine campion 112 *Oxytropis campestris*, yellow oxytropis

Astragalus), we realised that our hopes of finding all the treasures in a single afternoon were wildly illusory. The place was glorious; the weather was ideal; we were splendidly fit; the hotel was welcoming and very comfortable. But we should have to work hard for our plants.

Next day, the 26th, saw our first and longest expedition. *Lychnis alpina* [111], as everyone knows, occurs rarely on Hobcarton Fell beside the Whinlatter Pass in Cumberland and on Little Kilrannoch, the mountain to the west of the head of Glen Doll and separating the Clova watershed from the Isla. We had been advised to work up the Feula, Fialzioch, or vulgarly Filthy Burn, which falls into the White Water beyond the ravine, to follow its tributary round to the back of Kilrannoch and there to expect the *Lychnis*. On the way up Jock's Path, and at the top of Glen Doll, we found dwarf cornel (*Cornus suecica*) in some abundance and big patches of interrupted clubmoss (*Lycopodium annotinum*); a single belated flower of purple

saxifrage (*Saxifraga oppositifolia*), fine specimens of the *humifusa* form of *Veronica serpyllifolia*, and plenty of alpine willowherb (*Epilobium alpinum*) up the burn. But the *Lychnis* was not on view. We worked the slope from the brink of the little stream to the upper levels of Kilrannoch, paying special attention to outcrops of bare rock and peat: then John set off to explore its summit. I sat down to paint and Peter went off on his own: all of us were a bit discouraged, for we were on the appointed place; the plant was said to be there in hundreds and we saw no trace of it.

Peter had gone up beyond the stream to the flat tableland at its source. He returned in some excitement with a pink flower of about the right size, colour and foliage. It was thrift – the mountain form of *Armeria maritima*; and with it he had also got a scurvy-grass presumably *Cochlearia scotica*. Both were plants that we had not seen that day: obviously their locality was worth a visit: I went back with him. There, on bare patches covered with small chips of stone looking white against the black of the peat, was the *Lychnis*. Its leaves and growth were strikingly like the thrift: its colour was the same blue-green and crimson: its flowers were in bud and hardly yet risen from the rosette: but it was unmistakable; and in one patch at least it was abundant. The area of its occurrence is very small: it seems wholly confined to places devoid of any other vegetation except isolated plants of thrift and scurvy-grass and tussocks of cyphel (*Arenaria sedoides*) looking very like the rock-gardener's moraine beds: but there it thrives. I brought back samples of the stones among which it lives and my colleague Dr R.H. Rastall[4] tells me that they are a decomposed serpentine that usually occurs in the Highlands only in very small areas, and is liable to poison the ground through the excess of magnesia resulting from its decomposition. Here is a problem for the ecologist.

June 27th gave us a similar experience. *Oxytropis campestris* [**112**] was said to be on Craig Rennett and we had only worked the Glen Doll side of the rocks. To carry on the search along the whole northern escarpment of Glen Fee should be our next task. We began almost at the corner, clambering up the boulder-strewn lower slopes and over the screes above them to the foot of the cliffs. It was heavy going – steep enough to be almost unpleasant, and too high to be easily surmounted. The first gullies and terraces were uninteresting: there was very little, except holly fern, that was at all unfamiliar. I was beginning to wilt when we passed a low buttress of rock and came into a long shoot of lighter stone: John got to the ledges above it, and at once rushed back to me 'there it is, all over the rocks: can you manage it?' I did so, with paint-box, water and paper; sat me down under the cliff with clumps of *Oxytropis* above and around; and spent the rest of the morning

picturing it – the grey feathery leaves, the woolly buds and stems, the great clover-head of whitish flowers with the yellow flash on the standards and the purplish shade at the keel. It is absolutely restricted to the one strip of rock, not twenty yards wide: most of the tufts are inaccessible except to the climber: some few are within hand-reach from the top of the scree; and seedlings can be found down it.

Carrying on to the head of the glen where the Fee cascades down in a pleasant series of falls, John and Peter found no more *Oxytropis* nor anything of special interest except patches of *Loiseleuria procumbens* and some curious willows. The district is credited with all the British alpine willows: on various occasions we found all the chief species and some others: but their identification is specialist work – and highly complicated at that. I sent two pieces to Kew, one which looked like a longer-catkined and rather wider leaved *Salix lapponum*, which they pronounced to be the hybrid between *lapponum* and *myrsinites*, *S.* × *phaeophylla*; and another, too small to be *S. phylicifolia* and too shiny-leaved for *S. nigricans*, which they named *S. arbuscula* × *nigricans*. I regretted afterwards, especially when I got Mr A.D. Cotton's very kind reply,[5] that we did not enclose several others: for the head of Glen Fee seems to be a meeting place of many species. *Salix caprea*, *S. lanata*, *S. lapponum*, *S. andersoniana*, *S. aurita*, *S. myrsinites*, *S. arbuscula*, *S. reticulata* and *S. herbacea* are all within reach – and they interbreed promiscuously. We saw nothing else new to us and completely failed to find *Linnaea* which we had heard was a neighbour of *Oxytropis*.

Next day, being the Sabbath, we rested. As a friend had sent us *Lychnis viscaria* from Arthur's Seat in Edinburgh and Professor Graham had sent purple oxytropis, *Oxytropis uralensis* from Ben Vrackie,[6] I was pretty busy.

Monday June 29th we planned to devote to *Linnaea* in the birch-wood on the west side of Glen Doll under Craig Maud, where it was said to be abundant. So we started off up Jock's Path, crossed the White Water, and spent some hours scrambling among huge boulders, moss-covered and densely overgrown with heather and bilberry under the few straggling sallows, rowans and birches that form the wood. It is a fascinating place: an army could hide itself among the pits and crannies, the broken rocks and fallen trunks: and there are plenty of plants including the pink bells of cowberry. But *Linnaea* was not there – or at least we failed to see a trace of it. So John and Peter went off to the ravine intending to explore it and then go over the cliffs and screes of Craig Maud. I stuck to the wood; for having seen *Linnaea* in Finland I knew that the place was exactly suited to it, and it seemed a better task for me to concentrate on a workable area than to try to scale the heights. The result was disappointing

Athyrium alpestre
var. flexile(?)
Head of Glen Doll
29 June 1942

113 *Athyrium alpestre*, alpine lady fern

114 *Salix myrsinites*, whortle willow

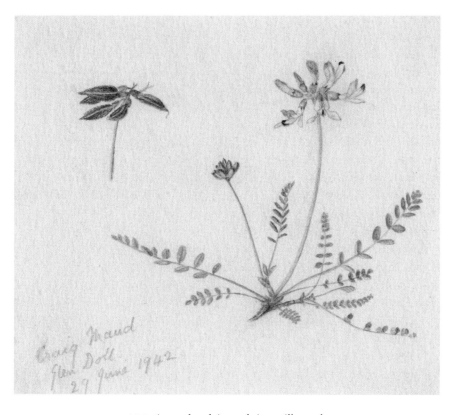

115 *Astragalus alpinus*, alpine milk-vetch

and in the afternoon I strolled down to the White Water considerably peeved. When the climbers overtook me after working to the near end of Craig Maud, the outlook cleared: 'sit down out of the wind and I'll show you something' were my instructions: and the tin contained a wonderful selection. In the ravine they had found both the alpine veronicas – *V. fruiticans* making the rock look sapphire-spangled for several yards, and *V. alpina* the one species which we had never seen, smaller in the flower but almost equally blue. Alpine fleabane, *Erigeron borealis*, had been abundant; and there was a fern frond that seemed to be alpine lady fern (*Athyrium alpestre*) [113]. But the treasures were from Craig Maud. Whortle willow (*Salix myrsinites*) [114] was the least of them – this time pure-blooded, and frequent along the cliffs. But there had been one gully to the south of the main crags where a small strip of rock was free from heather and bilberry, tussocked with moss campion, *Silene acaulis*, including the white-flowered form, overhung with masses of *Dryas octopetala* small-leaved and large-flowered, and at its base carpeted for a few feet with *Astragalus alpinus* [115] just beginning to throw up its flower-heads. For myself I felt that *Linnaea* had been well lost if this was the alternative.

On June 30th I was busy with pictures – willows being dioecious (with male and female plants) have to be done twice, and we were anxious to do justice to the novelties. But in the afternoon John and Peter went up the hills at the back of the hotel to Loch Wharral and Loch Brandy; and I joined them there and went on to the Corrie of Clova. They were specially looking for alpine grasses and willows and got alpine foxtail, *Alopecurus alpinus*, above Loch Wharral, a fine specimen of woolly willow (*Salix lanata*) with enormous catkins, samples of a queer little creeping willow that lives in the stones on the very edge of Loch Brandy and is probably the *herbacea–lapponum* hybrid called *S. caesia*, and some fine chickweed willowherb, *Epilobium alsinifolium* [116], much larger-flowered than *E. alpinum*. In the Corrie John spotted lesser twayblade, *Listera cordata*, among the heather, and once having seen it proceeded to find it all over the area.

After this easy day, he and Peter went off on July 1st to Loch Esk, up Jock's Path, then to the north, and so over to Bachnagairn. They were in search of the dwarf birch, *Betula nana* [117], which we had hitherto failed to find; and came back with some charming specimens of it and of a plant which we, and the party of botanical students from St Andrews, who were in the research hut at Braedownie agreed was the hybrid *B. nana × pubescens*.

On July 2nd we planned to work the stretch of cliff from Craig Maud to Craig Rennet with special attention to the watercourses along which the alpine lettuce, *Mulgedium*, was said to have been found until they were

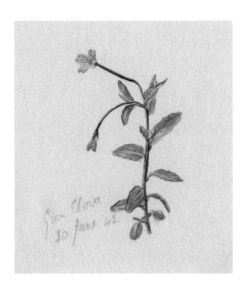
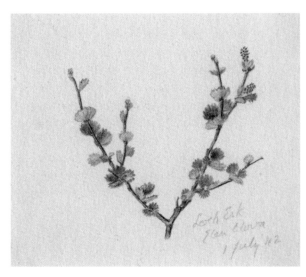

116 *Epilobium alsinifolium*, chickweed willowherb

117 *Betula nana*, dwarf birch

scoured some years ago by a heavy spate. This would complete our explo-
ration of the rocks from the head of Glen Doll to the head of Glen Fee,
and might disclose some fresh stations for the local treasures. In fact the
day proved heavy and unremunerative. The torrent beds were very steep
– the climb up to the fall on the northern one exhausted me; *Mulgedium*
was nowhere in evidence; the only plants of interest were *Sagina scotica* in
masses, *Salix reticulata* clothing one small section of cliff, and a nice speci-
men of the fern moonwort (*Botrychium lunaria*).

The following day was very wet – the sort of weather on which only very
plain news of a treasure would have made a search practicable: we were
well up on our timetable; and I had arrears of painting to overtake. We did
very little.

On the 4th – my birthday – it was decided by the two young men to
have another search for *Linnaea*. Age was the pretext, and fatigue the
real reason, for my failure to accompany them – though I felt sure that in
the birch-wood I could only repeat my former uselessness. Looking for
anything so frail and lowly, so exactly similar in leaf to the bilberries and
veronicas among which it lived, so like in flower to the bells of the cowberry,
seemed a task only tolerable if the evidence that the plant was there was
much stronger than it appeared. Accident might of course disclose it:
John's flair for discriminating rarities would do so if it still existed there:

I should merely waste my own and others' time. We had an easy day in the glen watching sandpipers, photographing lapwings and a nesting yellowhammer, and looking rather idly for intermediate wintergreen (*Pyrola media*) and the ever elusive bog orchid (*Malaxis paludosa*). Before tea the two returned evidently triumphant. Peter had found *Linnaea*, not indeed in the wood, but a hundred yards or so beyond it where for a few yards it was literally abundant, trailing everywhere over the moss and just beginning to lift and expand its delicate twin belfries from the joints of the paired leaflets. In addition they had received the grass alpine cat's-tail, *Phleum alpinum*, and a fine large *Lychnis alpina*, from the St Andrews party who had gone on up

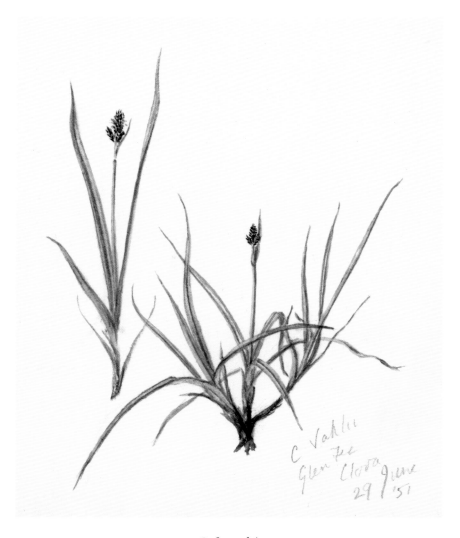

118 *Carex alpina*

the Fialzioch burn to Kilrannoch. With the exception of *Mulgedium* and the sedges we had now found practically all the local rarities.

Next day the party rested, the two doing a leisurely stroll up the Bassies on the opposite side of the glen and coming back with tufts of the rush *Juncus trifidus* which we had somehow failed hitherto to collect.

Our time was drawing to an end. July 6th could see a full expedition, but it would probably be our last; for the weather was uncertain, and we had to pack on the 8th. We went to the last unworked locality in which there were said to be novelties, to the South Corrie of Glen Fee, famous as the home of *Carex grahami* and reputed to contain other rare sedges. It was in this corrie that Mr R.H. Corstorphine,[7] who knew this country intimately and whose death a few months before had thrown us onto our own resources, had spent a whole day with another famous botanist searching for *Carex alpina* [**118**]. We had not yet seen *C. atrata*; and this at least ought to be obtainable. In any case the distance was not great and I could count on interesting places within my reach to explore.

After crossing the Fee bridge we struck across the lower slopes south of the burn, making for a point on the skyline slightly above the floor of the corrie so that we could look down into it and make a survey of its likeliest places. On the way a few hinds and calves drifted across the hillside in front of us. They did not prepare us for what we saw when at last we looked over into the hollow. It is a big amphitheatre, half a mile perhaps from cliff top to cliff top, and with a flat floor as big as a cricket ground. And it was packed with red deer; a few young stags, but in the main hinds and calves of various sizes, beautifully spotted and brilliantly coloured. A rough count made it clear that there were at least two hundred: but when they moved this seemed too small an estimate. It was a sight recalling the films of African nature-reserves, a sight which none of us will forget. The noise of the herd was as remarkable as its size – at least to folks as ignorant as ourselves. Peter described it as like a pack of hungry gulls: pigs seemed to me a much closer resemblance. At least the cries were varied and continual, especially when the beasts saw us and began to move away. There was no fear or stampede. Leisurely and in single file they started up the near side of the corrie, swung right-handed, crossed the screes at its head, and appeared in silhouette opposite us on the skyline. It must have taken some ten minutes before the last of the column disappeared; and even then a bunch of fawns were left, which kept us company for the morning.

Prospecting the corrie we failed to see the 'boggy ground, five yards by twenty approached by steep grassy ridges and overhung by a boulder-like rock on the right side of the corrie', which was our landmark for *Carex*

grahami – or rather the whole face of the escarpment was littered with boulder-like rocks, consisted of steep grassy ridges and no doubt contained eligible patches of bog. But in fact we did not find any one so large as that recorded; nor, after long scrutiny of every possible locality, did we find anything that looked much like *C. grahami*. So far as that particular treasure of the place is concerned we failed.

This only appeared some hours later. We set to work systematically to explore the whole half-circle from the point on the left where the hillside steepened into cliff and scree to the big gully overgrown with stunted trees where the corrie merges into the main circuit of Glen Fee. I stayed on the floor and the lower reaches: John and Peter worked it all over, level by level, visiting practically every accessible ledge and slope. We met for lunch about half way round the rocks. 'I want you to look at this little chap', said John 'I believe he's *Carex alpina*'. So far as I could judge he was: three very small heads, the upper one with stamens at its base, black glumes and green nuts, short stemmed (but the season was early), and totally distinct both from *C. rigida*, which was of course immensely common, and from *C. atrata* of which he had got several characteristic specimens. I had meanwhile got a queer *C. panicea* which turned out to be *C. vaginata*. So we had three new species to our credit; and *C. alpina* – well, I suppose it was the greatest rarity of our whole tour. It had been found solitary – perhaps a precocious arrival high up, and nearly opposite the middle of the entrance to the corrie. Near it was an abundance of the dwarf willow, *Salix herbacea*.

The right hand side of the corrie, though it gave us nothing new, was very rich in alpines and its exploration filled our afternoon. *Veronica alpina*, alpine saxifrage (*Saxifraga nivalis*) in very fine condition, *Saussurea alpina* just coming into bud, *Hieracium alpinum* [109] very woolly and single-flowered, the yellow-rattle *Rhinanthus drummond-hayi* [119] hairy and short and not yet flowering, and finally *Draba incana*, great big specimens like those on Ben Lawers, looking vastly different from the neat dwarfs that we had found the year before on Widdybank Fell. Our search here confirmed our previous rough-and-ready maxim: if the rocks are covered with heather and bilberry, don't bother to explore them: where there is moss campion (*Silene acaulis*), there is likely to be good stuff. But the further question remains, is it simply that the heather-bilberry combination crowds out the more varied flora or are there factors of geology, moisture or exposure that help to determine the range of the rarer species? Plainly all the characteristic rarities of the neighbourhood are confined to very limited areas: and most of them in those areas are abundant. Are they the last strongholds of species that were formerly widespread? Or incipient colonies, which centuries

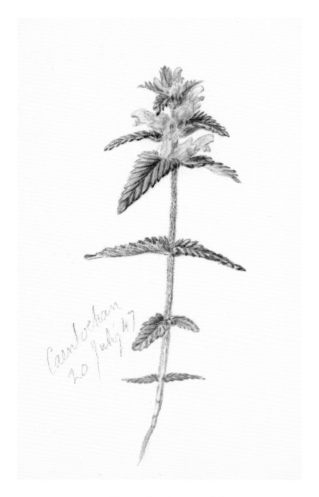

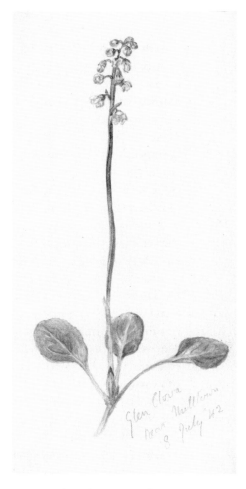

119 *Rhinanthus drummond-hayi*

120 *Pyrola media*, intermediate wintergreen

hence will occupy large tracts? Is their present distribution accidental or conditioned by geological or ecological factors? It would be worthwhile to encourage definite research into the botany of the area; for whereas on Ben Lawers the alpine species are all huddled together in a relatively small and homogenous locality, near or on the summit of a very high hill, here they are scattered in isolated patches over a large and seemingly somewhat diverse stretch of ledges and rock-face, not at, or even near, the top of the cliffs, nor as a rule, far from the 2000 foot contour line.

On July 7th, feeling that serious collecting was finished, we took the ladies of the party up the Esk as far as a car could travel and then along it to the derelict farmstead and wooded cataracts of Bachnagairn. The place

is remote but incredibly beautiful. The Esk, split into three strong streams plunges down a thousand feet of mountain-side, through channels cut deep into the rock. On the main river there is one considerable fall, and for a mile or more its course is fierce and broken. The tributaries splash down, one on each side of it, gleaming white through the trees and filling the air with sound. We got only one plant from our expedition, the common bearberry, *Arctostaphylos uva-ursi*, abundant as a trailing shrub, but scarcely ever flowering. But the slopes all up the riverside looked rich in promise and would plainly have deserved a search. We came back from our last expedition with the knowledge that some day, and in spite of our successes, a sequel would be fully justified. With plants so strictly confined to tiny areas close and careful scrutiny is obviously necessary; and here up the Esk valley, in these gulleys which scar the hillsides on each bank and the rock-faces that repeat the structure of Craig Maud, there must surely be almost infinite possibilities. We will return.

Indeed, apart from its botanical riches, Glen Clova will always hold us. Its enchantment is not dependent upon *Oxytropis* or *Linnaea*. The hotel with the house martins at work under its eaves and a burn dancing beside it between banks glorious with broom; the water wheel-where the grey wagtails are nesting; the bridge over the river which the sunset turns to flame; the water-meadows with their herds of black cattle and flocks of new-shorn sheep, their sandpipers and peewits, sea-pies and curlews; the woods of pine and birch plaintive with a multitude of willow-wrens; the road over the moor where my wife Bee found our one and only intermediate wintergreen (*Pyrola media*) [120] raising its pink bells among the heather; our host and hostess cheerful, shy, efficient and continually careful of our wants; these and the power to forget war and worry, examinations and proof-sheets, letters and lectures made the place faery. It can be found – I can prove it – upon earth: it exists eternal in the heavens.

LARCH

1. ii. '41.

Letters from John to Charles Raven

The 1942 letter outlining the plan for the present book, was reproduced in part by Duncan Robinson in *John Raven by his Friends*, but is included here in its entirety. 53 letters, telegrams and postcards from John to Charles, concerning the collection of plants for painting by Charles in Cambridge, have survived. Although all but one date from after the chapters of this book were completed, it seems worth including some to give the flavour of the relationship between father and son, and the immense care that John took in planning and executing these trips. The first group of letters, from 1943, refer to a trip through Wales to s w England, but as the related chapter was never written, these are not included here. The second major group, referring to a trip to Scotland in 1945, are in many ways a supplement to the chapter on Ben Lawers. The first of these was partly quoted by Karl Sabbagh in his book on Rum.

THE OXFORD HOUSE, MAPE STREET,
BETHNAL GREEN, LONDON E.2
26. XII. '42

My dear Pa,

Having by the narrowest margin survived Christmas & all the subsequent sweeping & washing up, I revived myself this afternoon by thinking about plants. And the results of my thinking were these: that even if there is not the remotest prospect of its being published until long after the war, it would do us no harm whatsoever to compile a little collection of essays &

illustrations; that to date we could provide some 11 chapters as follows: –

1. The beginnings of the collection – Co. Cork, Ainsdale [CER], [2.] Marlborough [B.] [Ely & Cambridge]. 2. Breckland. 3. Ben Lawers [B.]. 4. Ireland revisited [B.]. 5. Roundstone [CER]. 6. Teesdale [B.]. 7. Ribblehead [CER]. 8. Glen Clova [CER]. 9. Expeditions from London [B.]. 10. Arolla. [Finland . CER]. 11. Glimpses of Greece [B.].

& no doubt the later addition of a chapter on S.W. England would complete the dozen; & finally, that chapters 2, 3, 5, 6, 7 & 8 could all be illustrated as 6 & 5 & perhaps by now one or two others have already been. Of the remaining chapters' illustrations I had a few notions, namely: –

1. *Helianthemum guttatum*, *Bartsia viscosa*, [*Sax. umbrosa*], *Pyrola rotundifolia*, *Epipactis dunensis*, [*Parnassia*], [*Brassica monensis*], *Ophrys Trollii*, *Orchis ustulata*, *Herminium monorchis* & any other nice things from the very early days that you chose to add.

4. *Spiranthes stricta*, *Arenaria ciliata*, *Polygala Bealii* (if that's its name), *Sisyrinchium*, *Diotis*, *Saxifraga umbrosa* & *geum*, *Sibthorpia*, *Arbutus*, *Pinguicula* & *Simethis*.

9. *Lathyrus tuberosus*, *Bupleurum falcatum*, *Leucojum*, *Arabis glabra*, *Ajuga chamaepitys*, *Verbascum lychnitis*. These are nearly all big plants, but I think it might be possible to get a reasonable bit of each onto a page.

11. I have planned in some detail, & I think rather pleasingly, incorporating *Ranunculus*

Winter twig of larch, watercolour by John Raven, 1 February 1941

asiaticus, Tulipa saxatilis, Iris attica & *tuberosa* & 5 of the tiny mountain plants I found on Olympus, including *Sax. thessalica.*

10. would be entirely up to you & would certainly present the greatest problems, both in selecting species & securing specimens.

If you liked this plan, I would gladly cooperate. Chapters 9 & 11 I should obviously have to write, & there are one or two others I might have a shot at. 8 you've already done. 1, 2 & 10 are plainly your province. The remainder we might draw out of a hat. So what about it? It would, as we decided 2 years ago, be an excellent way of occupying our spare time until we can get active again. Let me know what you think about it.

Much love
B[unny]¹

OXFORD HOUSE
17. V. '45

My dear Pa,
 I've been thinking deeply, with the following surprising results:–
 My departure from Oxford House at the end of next month marks the end of an era & the beginning of quite a different one. I shall leave here – as nearly everybody in the world is at present – somewhat jaded, & – unlike most other people – temporarily devoid of conscience. Before starting on the next job, whatever that proves to be, I would like to take a really good holiday, & incidentally make myself really fit. And so I spent half an hour on top of a bus this morning concocting the following scheme.
 When I leave you on Iona – say on July 14th – I propose to remove your bicycle &, using it & such trains as are available, move slowly across central Scotland to the East coast. My proposed itinerary, & its various objectives are as follows:
 14th – 19th at Dalmally, whence I shall explore Ben Laoigh [Lui] for (in particular) *Cystopteris montana*
 19th – 21st, to the Lawers Hotel, whence

I shall go for *Carex microglochin* & *C. ustulata, Polygonatum verticillatum, Woodsia alpina* & perhaps *Calamagrostis stricta* var. *borealis.*
 21st – 24th, to Pitlochry, whence I shall go for *Menziesia, Carex rupestris* & *Schoenus ferrugineus.*
 24th, meet Peter & proceed with him to Braemar, whence we explore Lochnagar &/or the Cairngorms for *Mulgedium, Poa laxa* & *Carex lagopina,* & the coast for *Corallorhiza, Juncus balticus, Carex incurva* & maybe even *Pyrola uniflora.*
 Assuming that I can find a room somewhere in or near the places named, & that it occasionally stops raining, I cannot really see that I should have to be excessively energetic to get almost all these treasures. I should, of course, make careful enquiries in advance. Peter is keen on his share in the exploit, & for my part, though I feel it must be immoral to contemplate anything so exciting, I am not at all sure really that it isn't a pretty brilliant scheme!
 But of course there is one big snag, namely funds. Even though Peter will be paying for himself, my own expenditure, by the time I'm back in the South, can hardly be much under £20;² & as you know, all I possess at present is a few bad debts. I assume that one day – though it may not be for about 2 years – I shall get a job where I shall have a penny or two to spare. The question is whether, until that indefinite date, the family coffers can rise to lending me so substantial a sum. Would you please give me an honest & considered answer to this question? And if by any chance it is yes, then I will get down at once to the problem of booking rooms.
 Two other questions crop up: when are we due to leave Spean Bridge for Iona, & how long have you told George McL[eod] that I shall be staying with him? As Peter will reach Scotland on the 24th, I want to have finished with Perthshire by then – for which purpose I can hardly stay on at Iona much beyond the 14th. Is my departure on that day possible?
 If you think this whole project too absurd, then say so. It's a superb day & the

prison-house of B[ethanl] G[reen] sends my fancy roaming on fantastic expeditions. But all the same, I'd like to do it.

Much love, B.

P.S

1. I desperately need a Bradshaw. Can you possibly get one in Cambridge yet? I'm trying here as well.
2. Could your friend of the Leys find me a modest room in Pitlochry?³

ROYAL HOTEL, TYNDRUM. PERTHSHIRE
13. VII. '45

My dear Pa,

We've arrived safely. [Ben] Lui looked remarkably simple from the train, which actually passes the point at which we shall leave our bicycles & start to walk. But the clouds have now descended & the prospect is not too good. Let us hope.

I found a card from [J.E.] Lousley awaiting me here with a few rather vague directions for *Carex Grahami* on Ben Douran. It must depend on the weather & my leg. He – Lousley – asked for particulars of *Caucalis daucoides* near Cambridge. Though I – & he – know that it has disap-peared again, it would be a kindly act if you would drop him a line directing him to the appropriate field.

Stand by for – I suppose – Tuesday evening.

Much love, Bunny

ROYAL HOTEL, TYNDRUM. PERTHSHIRE
15. VII. '45

My dear Pa,

We've just had breakfast & are waiting for the weather to decide what it's going to do. On the whole the prospects are pretty favourable. Meanwhile here's a report on proceedings to date.

Yesterday we awoke to a fierce gale driving torrents of rain, & the clouds as low as they could be. I decided that the only course was to hang around in the hope of its clearing & then to make at top speed for Lui. But at 11 it was still as bad as ever,

so, abandoning Lui for the day, we set off to explore the local lead-mines & the hill above. Strolling up through the mist we found it surprisingly dry & altogether quite pleasant. So when we turned home for lunch I announced to Peter my intention of setting out immediately afterwards to explore the two lower North-facing cliffs on Lui itself. Returning to the hotel we found Libbey from Ballachulish awaiting us. So we lunched at speed, & by the time we had finished the sky was definitely breaking. Borrowing a bicycle for Libbey we pedalled 7 miles towards Dalmally, waded the stream, &, in bright sunlight, began the climb to the bottom of the middle cliff. It was steep but very simple, & as soon as we reached the rocks *Arabis petraea* – in beautiful, &, I assume, *grandiflorus* form – appeared in masses. That cliff is astounding. Sheets of *Dryas*, all the small sallows, both Drabas, many saxifrages, *Saussurea* etc. make it far more of a rock-garden than even Lawers itself. But as the time for our departure drew on, & I was thinking of sacrificing my dinner in a good cause, there was still no sign of *Cystopteris*. With just 5 minutes to go I came upon it; & once we had entered its zone it was obviously plentiful. Immature, I'm afraid, but very charming – & the devil to paint. So we then turned & made for home, arriving just 10 minutes before dinner time. And I spent the rest of the evening painting a crude but accurate picture of the *Arabis* just in case it doesn't enjoy its travels. A day will spent – & the two plants in the bag of which I was most doubtful of the whole list.

And now, since it's fairly obviously going to be fine, we have to decide whether to return & see more of Lui – we hardly explored a 20th part of the eligible rocks yesterday – or to go up to Bridge of Orchy & try the long chance of *Carex Grahami*. Probably the latter, I think. But Tom Tutin, whom in my haste I entirely forgot yesterday, lies heavy on my conscience, & I wonder whether I shouldn't repair my omission.

Well, the weather did clear & we did

go to Ben Douran – an easy cycle ride & a simple but very steep climb. We lunched on a high shelf with precipices above & below, & afterwards worked slowly & methodically up round the Western end of the cliff to the summit plateau. The only notable find on the way up was a single spike of a sedge that hardly appears to square either with *panicea* or *vaginata*, & two spikes of what I take to be *pilulifera*. On the summit plateau – at about 2,500' – are a marsh & 2 pools. Beside the larger pool was a small but vigorous colony of a sedge which, in everything but the all-important shape of its fruit, appears to be *aquatilis*. In view of the shape of its fruit I cannot place it at all. We then walked along the top of the cliff – & incidentally by this time it had begun to pelt with rain & continued steadily till we reached home – & down a marshy corrie (probably the locality of *Grahami*) to the bottom of the cliff. In this valley I found what at first I thought was *Grahami*, but proves on inspection, I fear, to be only *flava*. And that completed the day's work. We reached home drenched to the skin. The day's bag is, I fear, poor: but all the same, if you have time, I think it might be worth painting *pseudo-vaginata* & *pseudo-aquatilis* & then posting them to [Ernest] Nelmes [at Kew] for identification.

I leave here tomorrow at 1.30, shall look at Killin on my way & pedal on to Lawers in the afternoon. The last thing I shall do in the morning is post the parcel in which this will be enclosed. The post leaves here at 6 p.m. With any luck the stuff should reach you on Tuesday evening. If the weather permits I shall go for the Lawers sedges on Tuesday & *Polygonatum* on Wednesday & post the lot by Wednesday evening's post. But the weather being pretty erratic we must wait & see.

I suspect this hotel – being very smart – will take a disproportionate chunk out of my funds. If you would post me a crossed blank cheque to Scotland's Hotel, Pitlochry, I might never have to use it but it would dispel anxiety.

The holiday's total stands at 12 & the year's at 29. Will reach 50 yet.

Much love, Bunny

P.S I've worked my leg pretty hard these 2 days & for some unknown reason it seems suddenly to have decided to recover. Only about 2 twinges all day today.

Further P.S I am acutely worried about this parcel. The fern is the hardest brute I have had to pack in my life. Would you on this one occasion put me out of my misery by acknowledging safe receipt by wire to Lawers Hotel, Aberfeldy, Perthshire.
 B.

LAWERS
TUESDAY [17 VII 1945]

My dear Pa,
 Just back from the Yellow Corrie, where, for the third day running, I got soaked to the skin. I got soaked yesterday, too, while looking unsuccessfully for *Calamagrostis stricta* at the junction of the Lochay & the Dochart. Our arrival here – in a laundry van, with my bicycle up behind – I heard from two of the most eminent of Scottish [Glaswegian] botanists [J.R.] Lee & [R.] Mackechnie, who are here for a week, that *Calamagrostis* hasn't been seen in that locality by any living man; so I hardly rank that as a failure.

This morning, rather reluctantly but with a feeling that it might pay, I found myself hitched on to Mackechnie's party & bound for the Yellow Corrie. However it soon became evident that their pace was too slow for me; so at an appropriate moment I slipped off & over the saddle alone. By the time they came over the top I had already found plenty of C[arex] *ustulata* in beautiful form & a little fine *Kobresia*, but not a sign of [C.] *microglochin*. So after a pause for lunch a vast combined search began – six of us, well spaced out, descending the corrie by different runnels. Soon after we began, the mist descended, & with it a steady downpour. I dumped my ruck-sack to extract a scarf, & in stooping to pick it up again spotted the most insignificant little blighter I ever set eyes on. I summoned Mackechnie, who passed it as *microglochin*, & near at

hand we found one more spike each. Amid general excitement the search continued in a steady downpour. Never another sign of the plant. It was a much harder search than I had expected: it is clear that the plant is not abundant. But anyhow it's in the bag, & need worry us no further. There may be some competition for the specimens, so I will attempt to paint them all this evening; & at least I can reasonably claim one – the best – to post to you. As it's somewhat immature, I think it will travel all right; & of the other two treasures, *ustulata* & *Kobresia*, I haven't a doubt that they'd stand up to a week in the post without complaint.

Tomorrow Libbey joins me for two days, but I do not propose to let him upset my plans. I shall go to the Keltney Burn in the morning, &, if my energy is sufficient, & the weather adequate, when I've done with that, I shall go on the other way up to Lochan na Lairige & look for *Woodsia alpina* in its best locality on the rocks above. If – as in this weather is not, I fear, very likely – I can do both these things in one day, then I could give Thursday to looking for *Arenaria rubella* in the S.W. corrie & collecting some stuff for Tom Tutin. But sufficient unto the day – I will no doubt write a further report soon. This I will post at lunch time tomorrow an easy job this time.

As – largely thanks to the weather – I haven't done much for Tom lately, would you post on to him anything I send you once you have finished with it.

Thanks for your card. I'm very glad the painting is up to date. Yes, it was a splendid fortnight, which I certainly enjoyed hugely & Peter, I think, likewise. And if only the weather gets no worse the prospects remain good.

And now I must bring my note-book up to date. I shall hope for a wire from you when I get back tomorrow acknowledging the safe receipt of *Arabis* & *Cystopteris*. Till then I remain very worried about the latter, of which, however, I took the promised precaution of pressing a frond.

With much love, B.

P.S *Microglochin* – the best – is in the envelope – perfectly safe, I think. The other 2 have been claimed, but I have painted them before handing them over. The tin also contains 4 *ustulatas*, 2 *Kobriesias* & a *Juncus biglumis*, all from the Yellow Corrie.

LAWERS
18. VII. '45

My dear Pa,

First of all, I've made a blunder over those sedges – though not a serious one. I included I think 3 specimens of *saxatilis* as *atrofusca*. Further investigation leaves no doubt of the error. But there was one beautiful *ustulata* in that tin; & just to make sure that there is no confusion I will enclose another in tomorrow's parcel. I do hope you spotted the error & haven't painted them all together; for if so I fear it means more work.

And now for today. Despite a blustering East wind I stuck to my plans & cycled over to Keltney Burn. There I risked my life to no purpose in the fierce ravine that Lousley told me was the home of *Polygonatum* [*verticillatum*]. In great gloom I gave it up & walked on up the burn above Garth Castle. At last, at the top of another but less savage ravine I came upon a large colony of *Convallaria* [*majalis*] that aroused my hopes. And there, a little further down the steep bank, were about a dozen spikes of *Polygonatum*. Two only bore fruit – & none, alas, flowers.

I then ate a hasty lunch & decided, though with little hope, to cycle up Glen Lyon to Bridge of Balgie & over the mountain road to Lochan na Lairige & the rocks of Creag an Lochan above. By a superhuman feat I reached the head of the lochan at 4 o'clock & at 4.30 was into a fine colony of *Woodsia alpina* – in beautiful form – 500 feet above. There was so much on the small part of the rocks that I had time to explore that I had no qualms about removing a typical plant. But I suppose it is even so a thing of value; so I hope, when you've finished with it, you will send it on to Tom.

Of the ride back, into the teeth of a gale, the less said the better. But I was back by 6.30 & am still alive – just. But unless the weather is unexpectedly fine, I think I may take a fairly idle day tomorrow. But again – tomorrow can wait: today at any rate has been an uncommonly successful day. *Woodsia*, in particular, (though not by my reckoning a new plant) gives me the most intense pleasure. I hope you will enjoy painting it! Its spores are beautiful.

It's now Thursday morning, & pelting with rain. Small hope of much activity today, I fear. So I have been packing up the parcel for today's post. On the whole it seemed wisest to divide the *Polygonatum* into 2 sections. How you will paint it I'm not clear: perhaps that will have to be in 2 sections too. I'm keeping another specimen in reserve in case of need. The greaseproof paper contains *Woodsia*, & the other roll of paper, which looks like padding, *C. ustulata*: don't put it in the waste-paper-basket. The rest is pure padding & not worth searching for rarities. I think the whole should travel well enough.

If it does clear by lunch time, I shall have a last visit to Lawers itself. The gang that went up yesterday got *Arenaria rubella*, *Sagina nivalis* & *Poa glauca* – 3 quite nice things. But all the same I'm glad I did what I did. I prefer my 2 to their 3.

Thanks for your letter & the wire. I'm profoundly relieved about *Cystopteris*: I had grave misgivings about it.

It's beginning to clear, so I shall post this & stand by.

With much love, B.

LAWERS

19. VII. '45

My dear Pa,

You won't be expecting a report on today; but it has been such a remarkable day that I think you'd better have it all the same. So here goes.

At lunch time, after one of the wettest mornings imaginable, it suddenly began to clear, &, with some fear of another soaking, I decided to set out up the South West corrie. I wanted to get *Poa glauca*, *Arenaria rubella* & *Sagina nivalis*. They got all these 3 yesterday, but of the *Arenaria*, despite a search, they had only seen one plant & that they had uprooted; & of the other two, since they were in the mist when they found them, their directions were so vague as to be useless. I moved apace & was into the corrie by 3.30, & before I even reached the good rocks had found *Poa glauca* on an isolated boulder. And as soon as I reached the main cliff I found quantities of *Arenaria rubella* on the fine scree between the sloping slabs. So I walked upwards, seeing masses of *Myosotis*, Gentian, *Erigeron* etc. until I found myself unexpectedly on the summit ridge. And there, just by the cairn, was *Sagina nivalis*. *Poa alpina*, mainly viviparous, was everywhere: that, both viviparous & not, I will send along for interest with the rest.

Being at the summit, which was by now basking in sunshine, & with all my objectives achieved, I decided to drop down to the main rocks by the Lochan, to see whether there was any sign of *Woodsia* there too, & to return home along the Lawers burn. I found 2 fine clumps of *Woodsia* at once, & also a beautiful plant of *Potentilla crantzii*, so I started for home. I arrived in fine form at 6.50 – 10 minutes before supper – just as one of the worst thunderstorms I have ever witnessed broke over the Loch.

So ends another truly remarkable day – almost miraculous really. I don't know what's in store for me, but just at present my luck seems too good to last.

And now there's the question of posting this lot. On the whole I'm not inclined to risk sending them to Iona. They all, fortunately, look pretty tough; so I think it will be best if I take them with me to Pitlochry & post them to you Express either on Saturday or Monday morning. But all the same, as I have spare specimens of each, I may tomorrow morning put at least the *Arenaria* & *Sagina* in a small tin & send them with this. There's probably no harm in trying both ways.

Tomorrow morning by bicycle to

Aberfeldy & on by train to Pitlochry. If it's fine when I arrive there – at 1.12 p.m. – I shall probably climb Ben Vrackie as soon as I've had my lunch.

With much love, B.

SCOTLAND'S HOTEL, PITLOCHRY
22. VII. '45

My dear Pa,
 This is aimed to reach Cambridge on Wednesday. It does not, I am afraid, include the Rescobie plants, because I have regarded them as less urgent than the others & consequently left them until tomorrow or, more probably, Tuesday.

My last report, which I hope reached you before you left Iona, covered my last day at Lawers & the finding of *Arenaria rubella*, *Sagina nivalis* & *Poa glauca*. All these were passed as correct by Lee & Mackechnie. I will enclose further specimens of each & another *Carex microglochin*, in this parcel. There is also another small *Sagina* which Mackechnie thought might be *scotica*. That completes the Lawers stuff.

Well, on Friday morning I cycled into Aberfeldy, caught a train & reached here just in time for lunch. It had been a tolerably fine morning, though all too obviously deteriorating. But having nothing else to do I decided to risk it & made in the afternoon for Ben Vrackie. A heavy thunder shower delayed me in the wood on the way up, & I reached the good rocks – which are, by the way, very good – just as it settled down to rain steadily for the rest of the day. Even so I succeeded in finding masses of both *Astragalus* [*alpinus*] & *Oxytropis* [*uralensis*], some beautiful small Moonwort with ripe seed, & a certain quantity of a small sedge on damp rock-ledges which, from its creeping habit & grass-like leaves with a long fine point, is, I am sure, [*Carex*] *rupestris*, defeated me by having apparently no signs whatever of flower. And so, when I turned for home soaked again to the skin, I swore to return in better conditions & renew the search. It was the first failure on my list, & the necessity to return upset my timetable.

And so, as yesterday at last looked a really promising day. I set off immediately after breakfast for Loch Tummel. There I found *Schoenus ferrugineus* in very great abundance over a small stretch of shore, &, only regretting that I hadn't time to pedal on to the head of the loch & look for *Carex aquatilis*, I rode back to Killiecrankie to catch the only train of the day up to Dalnaspidal. As I waited for the train the weather showed the invariable signs of deterioration, & by the time I arrived an intermittent drizzle had already begun. I found all the detailed instructions I had received merely confusing so rather desperately I began to plod up that abominable face [of the Sow of Atholl] until my altimeter registered 2400'. But just before I reached that height I walked straight into *Menziesia*, still with the relics of magenta flowers upon it. I then searched that particular area pretty thoroughly & disposed, once & for all, of the theory that the plant verges on extinction. I saw not less than 200 plants, nearly all flowering or having flowered freely. I started a count, but soon gave it up: there was too much of the stuff. So without qualms I selected a few specimens – one of which I painted after my return – & descended again to my bicycle, taking careful stock all the way of how to find the plant again. So that it may be preserved in writing, here is the route. Standing on the side road West of the railway you see about 2/3 of the way up the hill, & slightly left of centre, 2 fairly large grey screes with a larger grassy patch between, which stands out from the rest of the heather-clad hill – so: – [thumbnail sketch]
You make for the middle of this grassy patch & go up the left hand of the fingers pointing upwards. When you reach the top of this you see, about 40 yards straight up the hillside, an isolated whitish rock presenting a rectangular face about 3' × 1'6". When you reach this you see again about the same distance ahead 2 sphagnum springs, the left-hand one slightly higher than the other. The trickles from these 2 soon join, but the resulting streamlet quickly disappears.

Menziesia grows in abundance immediately to the right of the right-hand springs – so: [thumbnail sketch]

So that is that: & the flowers, though obviously past their best, are still perfectly paintable, & should, I think, survive 2 days in the post. In any case would you paint a nice piece of greenery, & you can take the flower, if necessary, from my perfectly adequate version. (The secret of the plant, by the way, is that if it were not in flower it would be impossible to distinguish from Crowberry.)

And it's now 10.5 a.m., & I am giving the weather till 10.30 & then, if it still looks reasonable, going back to Ben-y-Vrackie. But by the end of yesterday, having cycled the 25 miles back into steady torrents of rain, I was even wetter than at any other time in the last wet week; & I must admit that I'd like to get through a day without a soaking.

It's now 10.35 & I've decided that Ben-y-Vrackie it shall be. I've also just discovered that there's a letter post out this evening; so this shall go by it, & can serve as a warning that tomorrow morning I shall despatch by express parcel post a tin containing: *Arenaria rubella*, *Sagina nivalis* & *S.* ?*scotica*, *Carex microglochin*, *Juncus biglumis*, *Poa alpina* (viviparous & not) & *P. glauca* – all from Lawers; fruit of *Oxytropis uralensis*, Moonwort, *Astragalus* & non-flowering *Carex* [*rupestris*] from Vrackie; *Schoenus ferrugineus* & *Menziesia*.

My address from Wednesday is c/o Hon. Robert Bruce, Glenerney Lodge, Dunphail, Moray. I would like to hear how things have been arriving so far, thanks to the slowness of Iona posts, I have only heard of the safe arrival of the Lui & Douran things.

And now I'm off – no doubt for another soaking.

Much love, B.

P.S Thanks for the cheque.

SCOTLAND'S HOTEL, PITLOCHRY 22. VII. '45

My dear Pa,

Here is the promised parcel – & it so severely depletes my stock of tins that Heaven knows how I shall ever despatch another. But no doubt a way will be found.

Well, the rain held off till tea-time today & gave me just long enough to explore Ben-y-Vrackie pretty thoroughly. The results confirm my fears. There is one large colony of the mystery sedge, which I am now perfectly certain is [*Carex*] *rupestris*, & it shows no signs whatever f flowering, having flowered or being about to flower. In desperation I grubbed a bit up – there is plenty to spare – in the hope that, like [*C.*] *montana* before it, it might be induced to grow in Cambridge. There are two little bits of it. I suggest that you plant one in a pot as you did *Simethis* & the other in the sink alongside of [*C.*] *capitata*.[4] I do not think lime will do it any harm: the only necessity is that it should not get too parched. We flowered *capitata*: I cannot see why we shouldn't flower *rupestris* – if it is *rupestris*.

I've spent an idle evening writing letters & painting a passable picture of Moonwort: but don't let that dissuade you from doing it again. As for tomorrow, I really don't know, but Rescobie must I fear wait at least until Tuesday. The anticipated disaster – the penalty of too much success – has befallen me. I have begun to sprout an unpleasantly large boil on my behind which makes cycling an intolerable torment. Extremely annoying, especially when I'm just beginning to feel fitter than for many years past. I have a nasty fear that it may be the end of my botanical activities for a while; but I hope for the best, & am still planning for Rescobie on Tuesday.

Much love, B.

PITLOCHRY, 23. VII. '45

[*a post card, addressed to The Rev. the Master, postmarked 25 Jul 45*]

The parcel was duly despatched Express this morning; since when I have been by bus to explore the marshes around the head of Loch Tummel. I suspect that they are very much drier & their contents consequently less luxuriant than they used to be; but all the same they produced a grass that is undoubtedly a *Calamagrostis*, &, as far as I can see,

not at all unlike *stricta*, & a sedge which might or might not be [*Carex*] *aquatilis* but certainly isn't *lasiocarpa*, of which there was also plenty. These – including *lasiocarpa*, because I very much doubt whether either the Rannoch or the Douran plant was it – I will post Wed a.m. with anything I get at Rescobie tomorrow.

Love B.

P.S Both plants need expert vetting. Suggest you send them unnamed to Tom Tutin.

SCOTLAND'S HOTEL, PITLOCHRY
24. VII. '45

My dear Pa,

A hasty report this time, for I've had a very long & pretty uncomfortable day & am longing for a bath & bed.

Rescobie was a wash-out. But fortunately, as I was going so near, I decided to throw in Montrose as well. There – or rather at a place called Mains of Usan 2 miles South – I found, by a miracle when I had almost abandoned hope, a small colony of *Carex incurva*. It is not an impressive plant! Having found it & taken a few specimens I searched the immediate neighbourhood unsuccessfully for more. Then, having not gone more than 25 yards away, I was utterly unable to find the first patch again.

There was a fair quantity of what I take to be *Lysimachia thyrsiflora* over a very limited area at Rescobie. But, blast it, like *Carex rupestris* it has forgotten to flower. I spent most of my time there searching every stem of the colony, but it was a waste of effort. A local fisherman told me the pond had overflowed its banks during the winter & spring: maybe the plant's development has been retarded that way. What little time I gave to looking for *Calamagrostis* secured me nothing but wet feet.

And so this parcel contains only:

1. *Carex ?aquatilis* – from Tummel
2. *?Calamagrostis ?stricta* – from Tummel
3. *Carex incurva* from Usan
4. *?Lysimachia thyrsiflora*

If you can spare the time I beg you (a) to take the identification of No. 2 seriously, for

I think it may be a discovery of some note & (b) if you are satisfied that No. 4 is correct, to paint it, even though it is not in flower, & so do something to fill an irksome gap.

I always await your letters eagerly & was delighted to find on my return this evening the one in which you report the painting of all that mass of stuff.

Congratulations – & love, B.

P.S *Carex incurva* is in the 2 little boxes. Handle with great care as its fruit are liable to drop. I've included also another sedge from Tummel which I thought at first might be *limosa*.

P.P.S I forgot to enclose this in the parcel so they come separately. They are being posted simultaneously.

GLENERNEY LODGE, DUNPHAIL, MORAYSHIRE
26. VII. '45

My dear Pa,

Thank you so much for your wire, which arrived just before I did. I take it that this means that *Menziesia* arrived in a paintable condition. I hope you had time to cope with it, & that not so far behind it the Tummel, Montrose & Rescobie plants will have reached you at any rate by tomorrow morning. As for my 'health', it remains not too good: in fact I had to go & have the wretched thing dealt with in hospital at Forres this morning, & cycling is for the time being right out of the question.

But this is less of a disaster here than it might have been. This place is very nearly perfect, sitting among the fir & birch woods on the banks of a rocky salmon stream. *Goodyera* grows right up to the door, & is indeed super-abundant in every wood all around, & there must be *Pyrola* round about. So tomorrow I shall have a look for *uniflora* in some of the many local larch-woods.

And today Mary [Verney],[5] having a day off & the loan of her aunt's car, drove me down through Forres to within ½ mile of the Culbin sands. Climbing the first ridge of the endless sandhills I spotted only about

300 yards away a large flat 'slack' that had obviously once contained a lochan. The whole area proved to be densely covered in *Juncus balticus* & *Lycopodium inundatum* & – apart from the Western end, where there were a few scattered sallows & birches, – precious little else. And an hour's search in the neighbourhood of these trees revealed, besides some Pyrolas in seed, 6 colonies of *Corallorhiza* – also, alas, well past flowering, but with very characteristic seed &, of course, when I had concluded that it was moral to dig a bit up, beautifully distinctive roots. So that was that as far as the Culbin Sands were concerned & we drove along to Dyke, where a vast extent of fir-woods used to yield *Pyrola uniflora*. The fir-woods were no more – acres of them felled flat. And so we turned for home, exploring various side-roads, & I got some useful hints as to where to spend my spare hours in the next few days. Though I don't for a moment suppose I shall find *uniflora* I shall have a good shot for it before I bid farewell to the North.

And now for my return. I reach London, apparently, about 9.30 on Tuesday morning. I shall then, I think, dump your bicycle at King's Cross & proceed to O[xford] H[ouse] to discover the state of affairs. If – as I hope – there is nothing to keep me there for more than an hour or two I shall come on to Cambridge & be with you in time for supper. If it seems desirable to spend a night there to get *au fait* with recent developments I will ring you up about tea-time to let you know I shan't after all be with you till Wednesday morning.

Which being so, & it now being almost Friday, & this being postally nearly the end of the world, I have decided on the whole to send no more parcels but to bring with me everything that has not already been despatched. None of today's treasures would be too happy in the post: all will survive in water almost ad infinitum.

It will be good to be at home.

Love, Bunny

Endnotes

1. The Rev. Samuel Reynolds Hole (1819–1904); Dean of Rochester from 1887; the National Rose Society's first President, and the first recipient of the Royal Horticultural Society's Victoria Medal of Honour. His sister Sara Hole (1821–1880) married Charles's grandfather the Rev. John Raven in 1847.

2. The Ravens had six holidays in Co. Cork: Crosshaven 1925; Glandore 1926 and 1927, and three at Goleen (1928–30).

3. The 'purple shell' is *Janthina janthina*, the violet sea snail, a gastropod that floats on a raft of mucus bubbles of its own making; the Portuguese Man of War is *Physalia physalis*, a 'jellyfish', or more accurately a siphonophore, a colonial organism that floats by means of a large bladder filled with carbon monoxide. Both are widely distributed drift organisms that are occasionally washed up on the south-west coast of Ireland.

4. The editor is not qualified to comment on the moths and butterflies mentioned in the text, other than to give updated names. The clouded yellow butterfly, then *Colias edusa* (now *C. croceus*) was known as 'Edusa', from the custom of making common names from Latin epithets.

5. The lectures were given at the renowned Union Theological Seminary, which had become a constituent faculty of Columbia in 1928. Dietrich Bonhoeffer had a period of study leave there this same year, 1930–1. This was Charles's second visit to the US; the first to Boston and Harvard was in 1926 when he met John and Ethel Moors of Brookline, pillars of Trinity Church Boston. The rectorship of this church came up while Charles was in New York in 1930, and he was offered but declined the post. In 1954 Charles married the widowed Ethel Moors, but she died on the honeymoon.

6. Richard Berry Harrison (1864–1935), a black actor, the son of fugitive slaves, played 'de Lawd' in Marc Connelly's *The Green Pastures*. This had opened on Broadway on 26 February 1930 and ran for 16 months, winning its author a Pulitzer Prize for drama in 1931.

7. George Herman 'Babe' Ruth junior (1895–1948). A prolific hitter as right fielder for the New York Yankees, to whom he had been sold by the Boston Red Sox in 1919. One of the great sports heroes of American culture, elected to the Baseball Hall of Fame in 1936.

8. Two noctuid moths – the lychnis moth is now called *Hadena bicruris*, and the grey coronet *Hadena caesia*.

9. Edward 'Ted' Earle Raven (1889–1950). Chaplain of St John's College Cambridge (1921–6) and Dean from 1927 until his death.

10. The wainscots are noctuid moths: those mentioned here are all now placed (with the same epithets) in the genus *Mythimna* – the common wainscot *M. pallens*; the smoky wainscot *M. impura* and southern wainscot *M. straminea*. The two Boarmias are geometrid moths: the mottled beauty (*B. repandata*) is now *Alcis repandata*

and the willow beauty (*B. gemmaria*) now *Peribatodes rhomboidaria*.

11. 'Bentham & Hooker' is discussed on page 17–18. If the Ravens had the most up-to-date version, this was the 1924 edition of the text ('Seventh edition revised', but effectively the Ninth) by A.B. Rendle. The 'Illustrations', by W.H. Fitch, W.G. Smith 'and others' would also have been the 1924 edition ('Fifth revised edition', effectively the Ninth).

12. *Flowers of the Field* by Rev. Charles Alexander Johns, first published in 1851, and with 30 editions up to 1902. The 1907 edition (with numerous impressions thereafter), revised by Clarence Elliott, had 92 colour plates by Miss E.N. Gwatkin – in a similar style to that of the Ravens.

13. Edwin Landseer's 'Stag at Bay' was exhibited at the Royal Academy in 1846. It is currently on loan to Dublin Castle by the Guinness family. Benjamin Williams Leader (né Benjamin Leader Williams) (1831–1923) was popular for his English and Welsh landscapes painted in a meticulous style inspired by the Pre-Raphaelites.

14. *Jesus and the Gospel of Love*, published September 1931, regarded by Charles as his 'big book', expressing his 'deepest understanding of and commitment to the Christian faith' in which he used biology, psychology, and critical and historical investigations, 'to demonstrate that the New Testament witness to the nature of Jesus' personality could be accepted wholeheartedly by anyone seeking to interpret his faith in terms of the modern scientific outlook' (Dillistone 1975: 199–200): it was regarded by academics as too populist (cf. the reception of John's *Plato's Thought in the Making*).

15. *Catalogus plantarum circa Catagbrigiam nascentium … ;* printed by John Field, at the expense of William Nealand, in 1660, though Ray's name appears neither on the title-page nor elsewhere in the work. Charles devoted chapter four of his biography of Ray to this work, of which he wrote 'Few books of such compass have contained so great a store of information and learning or exerted so great an influence upon the future'.

16. Charles, in his biography of Ray, translated this as 'the cunning craftsmanship of *nature*', in a recent translation (2011) it has more accurately been rendered by John's pupil Philip Oswald as 'those richly wrought works of the artificer *nature*'.

CHAPTER TWO

This chapter was written at Oxford House in 1943.

1. The new names for many of the orchids are given in the Index. The wasp orchid *Ophrys trollii* is now regarded as an aberrant form of the bee orchid (*O. apifera*), which perpetuates itself (breeds true) by self-pollination.

2. Charles took a locum tenancy at Lapford in August 1932.

3. Bryanston, Norman Shaw's mansion for the second Lord Portman in Dorset, was opened as a progressive public school in 1928 by the Australian schoolmaster J.G. Jeffreys.

4. The wedding was of John's sister Peg, to the physician John Lipscomb, which took place in the Lady Chapel of Ely Cathedral.

5. Wicken Fen had belonged to the National Trust since 1899. For a time before World War II Charles was chairman of the trustees that ran it; an application for the use of its alder buckthorn (*Frangula alnus*) for making charcoal for gunpowder towards the war effort troubled his conscience, though he allowed it (Dillistone 1975: 237).

6. *Spiranthes stricta* is no longer regarded as distinct from *S. romanzoffiana*, an interesting amphiatlantic species, discovered by John in Morvern in 1964.

7. Charles Cardale Babington (1808–1895). Botanist and entomologist, from 1861 Professor of Botany at Cambridge. Author of the *Flora of Cambridgeshire* (1860) and the popular *Manual of British Botany* (ten editions up to 1922). He was interested in critical genera such as *Rubus*, and regarded

by lumpers such as J.D. Hooker as an arch-splitter. John was a much greater user of the Cambridge herbarium than was his father.

CHAPTER THREE

1. Frank Buchman (1878–1961). American Lutheran pastor of Swiss descent, and founder of the 'Oxford Group', renamed 'Moral Rearmament' in 1938. An evangelical movement with emphasis on sin and the possibility of individual access to God through confession. Popular in the 1920s and '30s though dismissed by some as a 'Salvation Army for snobs'; said to have been an inspiration for some of the principles of Alcoholics Anonymous.

2. This chapter shows Charles's keen interest in the history of botany; it was written at the time he was working on his *John Ray* and *English Naturalists from Neckham to Ray*.

3. Arthur Humble Evans (1855–1943), a classicist and ornithologist. Alfred Fryer (1826–1912) lived at Chatteris in the Fens and studied the genus *Potamogeton*. William Hobson Mills (1873–1959), Reader in Stereochemistry at Cambridge University.

4. Charles himself would contribute the foreword to the next *Flora of Cambridgeshire*, that by F.H. Perring, P.D. Sell and S.M. Walters (CUP, 1964).

5. Humphrey Gilbert-Carter (1884–1969). Director of the Cambridge Botanic Garden from 1921 to 1950, and University lecturer in Botany 1930–50. Author of the invaluable *Glossary of the British Flora* (1950); teacher of Clapham, Tutin and Warburg – they dedicated their great 1952 *Flora* to him.

6. The Silver Jubilee of George V and Queen Mary was on 6 May 1935, and as a Royal Chaplain Charles may have taken part in the service of commemoration. With King George Charles is known to have discussed budgerigar breeding, rather than theology.

CHAPTER FOUR

1. The Hon. Robert Gathorne-Hardy (1902–1973), writer, bibliographer and botanist. *Wild Flowers of Britain* is illustrated with photographs, and with line illustrations and chromolithographs by John Nash; published by Batsford as part of their British Nature Library in 1938.

2. Reginald Farrer (1880–1920). Plant collector and prolific author, especially of travel and gardening books: in this context especially *My Rock Garden* (1907) and the *English Rock Garden* (2 vols, 1919).

3. Although Charles refers to John as his 'partner', this was in the matter of collecting specimens rather than in painting.

4. Charles's parents lived at Nutfield in retirement until their deaths in 1940. John received his early lessons in Latin there, from his grandfather.

5. John Boynton Priestley (1894–1984). Popular novelist and playwright. His fourth novel was *Angel Pavement* (1940), a 'social panorama of the city of London', which followed his more famous *Good Companions*. A socialist, and founder member of CND, the reason for the Ravens' evident disapproval is unexplained and somewhat surprising.

6. John Ray. *Synopsis Methodia Stirpium Britannicarum*. 1690.

7. John Milman Lipscomb (1914–1992), Peg's husband, a physician, who was at Marlborough with John Raven. Charles never learned to drive, his main chauffeurs being his wife Bee and daughter Mary.

8. The figure of eighty moth is now called *Tethea ocularis*.

CHAPTER FIVE

In the original 1942 scheme this was originally to have been written by Charles, and to have included the nearby Ribblehead limestone. John later wrote about Teesdale in chapter eight of *Mountain Flowers*.

1. The reference to Montgomeryshire dates from the period when John was looking for accommodation and schools for London evacuees, while working at Oxford House.

2. *Richard II*, Act II, Scene i, from the 'scepter'd isle' speech of John of Gaunt.

3. Philip Miller's *Geranium lancastriense* is now regarded only as a variety of bloody crane's-bill, *G. sanguineum*, and even the epithet is now lost (for this and other name changes see Index entries).

4. Chapter two 'Our English Alpines' of Farrer's *My Rock Garden* (1907).

CHAPTER SIX

1. After the death of her mother, Margaret Ermyntrude ('Bee') Buchanan-Wollaston was brought up by her aunt and uncle, the Rev. & Mrs Ernest Stewart Roberts in the Master's Lodge of Gonville and Caius College. Charles met her as an under-graduate and they became secretly engaged in 1906, the wedding taking place on 22 June 1910.

2. Inverhadden, Kinloch Rannoch, an estate belonging to the parents of Launcelot Fleming (1906–1990), glaciologist, geologist, Arctic and Antarctic traveller and at this point chaplain and fellow of Trinity Hall. Later he became, successively, Bishop of Portsmouth, Bishop of Norwich and Dean of Windsor.

3. Farrer (*My Rock Garden* p. 141) wrote 'our own very rare native *Erigeron alpinus* [sic] is but a poor thing, like an inferior, shabby-flowered *Aster alpinus*, with flowers curiously stodgy and frowsy, by the side of that glorious purple Margaret'.

CHAPTER SEVEN

See p.22 for the background to Lord Tavistock and Glen Trool.

1. Samuel Rutherford Crockett (1859–1914), a popular Scottish historical novelist, especially of works relating to his native Galloway. *The Raiders* (1894) was his first novel, about the gypsy leader John Faa, a character now better known through Philip Pullman's *His Dark Materials*.

2. John Buchan (1875–1940). Prolific author, historian, and latterly Governor General of Canada. This probably refers to the story 'No Man's Land' first published in Blackwood's Magazine in January 1899, and reprinted in his 1902 collection *The Watcher by the Threshold*.

3. An inscribed boulder commemorating the victory of Robert the Bruce over an English army near Loch Trool in March 1307. The memorial was erected in 1929, on the 600th anniversary of the death of Bruce, and was an early symptom of emergent Scottish nationalism.

4. Dorothy L. Sayers (1893–1957). Crime writer, author of theological works, and translator of Dante. *The Five Red Herrings* (1931) is one of the Lord Peter Wimsey tales, about the murder of an artist, set in an artists' community based on those in Gatehouse of Fleet or Kirkcudbright, where she had holidayed from 1928.

5. *A List of Wigtownshire Plants*, by Andrew C. M'Candlish. Galloway Gazette Press, Newton Stewart. 1931 – this work has no localities, so would not have helped them much, even had the Ravens seen a copy.

6. For notes on *Luzula arcuata* and *Rumex arifolius* see pages 23/24. The Ravens' knowledge of the latter species as a possible British native is the only evidence that they looked at the work of G.C. Druce – they seem to have kept aloof from his Botanical Exchange Club, and, in fact (until much later) from other botanists in general. Rather than use such networks to obtain material, the keeping of the project as an activity restricted to family and close friends seems to have been paramount.

7. In fact these all go back to the same source, and show the persistence of certain records through the literature. The plant was described by Thomas Hopkirk in what is the earliest Scottish 'Local Flora' – *Flora Glottiana* (1813), based on a specimen sent to him by 'Mr. Smith, Nurseryman near Ayr': it is probably only a variety of *Veronica officinalis*.

8. *Limonium recurvum* subsp. *humile*. The Ravens did not name or comment on this plant and were unaware of its significance. It was first collected on the Mull of

Galloway in 1834 by George Walker-Arnott, and was known in the nineteenth century as *Statice spathulata*. It was placed as a subspecies of *L. recurvum* only in 1986, its only other British station being St Bees Head, Cumbria (the other subspecies are from Portland, Dorset, and County Clare).

9. In view of Charles's passion for John Ray it is sad that this plant now has to be known as *Polygonum oxyspermum*.

10. Charles did, eventually, see and paint the elusive oysterplant (*Mertensia maritima*) on Lunga, one of the Treshnish Isles, on an excursion from Iona in July 1945. Charles was a great supporter of the Iona Community through his friendship with George Macleod and visited to give lectures again in 1946 and 1948.

CHAPTER EIGHT

For the background to this visit see p.24. The introduction is revealing of Charles's antipathy to ecclesiasticism, though the fact that he was sent on this mission shows the interest he devoted to ecumenism at this time (a devotion he later came to regret). Most of the drawings from this trip were sketchy and not incorporated into the collection, though some survive showing how the original large sheets were dissected.

1. Pehr Evind Svinhufvud, third President of Finland, from 1931 to 1937.

2. Brändö, now Kulosaari.

3. The chairman was Aleksi Lehtonen, Bishop of Tampere.

4. Now Espoo, a suburb of Helsinki.

5. Olavinlinna has a notable fifteenth-century castle; Valamo (Valaam), is an ancient monastery on an island in Lake Ladoga.

CHAPTER NINE

1. William Boyd Carpenter (1841–1918), chaplain to Queen Victoria, Edward VII and George V, and a Canon of Westminster. Interested in eugenics

and, in 1912, President of the Society for Psychical Research.

2. The Rev. Sir John Pentland Mahaffy (1839–1919). Irish classicist, Egyptologist and musician; Provost of Trinity from 1914 to 1919; teacher of Oscar Wilde. 'One of Dublin's great curmudgeons and also one of its greatest wits' (when asked in what way he thought man differed most from woman he replied 'I cannot conceive'). CER's anecdote (repeated in Dillistone 1975: 91, where the telegram referred to is said to have come not from anyone in Crockford but from an eponymous seed merchant) may not have augured well, but Charles's performance led to an invitation to give the Donellan Lectures at TCD, which, due to the First World War, were not delivered until 1919 – these were on the history of Christian Socialism (F.D. Maurice, Charles Kingsley *et al.*), and led, the following year, to one of Raven's most significant books.

3. *Inula salicina* was not finally painted until 18 July 1954 and 16 August 1955 – the last of the collection to be drawn, it may then have been sent to Charles by a correspondent.

4. *Potamogeton kirkii* is now considered to be the hybrid between *P. gramineus* and *P. natans* – in view of Charles's description of the leaves it is appropriate that it is now called *P. × sparganifolius*.

5. John Winthrop Crozier (1879–1966), from 1939 to 1957 the ninth bishop of Tuam, Kilala and Achonry.

CHAPTER TEN

1. The Rannoch brindled beauty is now *Lycia lapponaria*, the Rannoch sprawler *Brachionycha nubeculosa*.

2. The Scotch brown argus is now *Aricia artaxerxes*.

3. Peter Kuenstler (1919–2010), was working with John at Oxford House in Bethnal Green. After the war Peter continued in the field of social work at Bristol University, and later as a consultant in the field of development in Africa; he

contributed a chapter on Oxford House to *John Raven by his Friends*.

4. Robert Heron Rastall (1871–1950). Cambridge geologist who published on sedimentary petrology and stratigraphy, structural and economic geology, and authored several textbooks.

5. Arthur Disbrowe Cotton (1879–1962). Botanist and mycologist; Keeper of the Kew Herbarium from 1922 to 1946.

6. Robert James Douglas Graham (1884–1950). Economic botanist, Professor of Botany at St Andrews from 1934.

7. Robert Henry Corstorphine (1874–1942) with his wife, Margaret Buncle, the doyens of Angus botany, authors of a substantial but never completed county Flora (its related extensive herbarium is in Dundee University). He was managing director of his wife's Arbroath family printing firm T. Buncle & Co., which printed many botanical works of the Druce stable. The couple owned Inchdowrie House, just below the inn in Glen Clova, but Corstorphine had died on 25 March of the year of the Raven visit.

APPENDIX

1. Bunny was the nickname John invented for himself as a child and by which he was known within the family. The text in square brackets in this letter represent additions/ alterations made by Charles.

2. About £500 in today's values.

3. The Leys school of Cambridge was evacuated to Pitlochry during the War.

4. *Carex capitata* is one of the plants allegedly found by J.W. Heslop Harrison in South Uist. The Ravens asked Harrison for a plant, which the Raven's grew and painted in the garden at Christ's.

5. On this excursion John was accompanied by Mary Verney, daughter of Sir Harry and Lady Rachel Verney, who owned an hotel at Wern on Red Wharf Bay, Anglesey. The Raven family holidayed at Wern in the 1940s, and this is where Bee died. The aunt referred to was another Mary (*née* Lindley, great grand-daughter of the orchidologist John Lindley), married to the Hon. Robert Bruce, Lady Rachel Verney's brother; they were children of the 9th Earl of Elgin.

List of Plant Sketches

Fig.7 *Iris pseudacorus*, yellow flag. Grantchester, Cambridgeshire, 12 June 1940 [C·E·R]

Fig.9 *Salix caprea*, great sallow. Madingley, Cambridgeshire, 23 March and 13 August 1953 [C·E·R]

Fig.10 *Carduus arvensis*, creeping thistle. Wern, Anglesey, 25 July 1943 [C·E·R]

Fig.14 *Rumex arifolius*. The Merrick, 28 August 1937 [C·E·R] + *Luzula arcuata*, the Merrick, August 1934 [C·E·R]

Fig.16 *Bromus sterilis*. Fen Drayton, Cambridgeshire, 15 October 1948 [C·E·R]

Fig.17 *Hieracium opsianthum*. Lochailort, 28 August 1952 [J·E·R]

Fig.18 *Hieracium scoticum*. Melvich, 8 July 1951 [C·E·R]

Fig.19 *Artemisia norvegica*. [Wester Ross], 28 August 1953 [J·E·R]

Fig.20 *Koenigia islandica*. The Storr, Isle of Skye, 26 August 1951 [J·E·R]

Fig.21 *Diapensia lapponica*. Near Arisaig, 19 May 1953. [J·E·R]

Fig.22 *Euphorbia stricta*. Wyndcliff, near Tintern, 16 June 1943 [C·E·R]

1 *Helleborus foetidus*, stinking hellebore. College Mound, Marlborough, Wiltshire. 20 March 1932. Probably [J·E·R] and [C·E·R].

2 *Anemone pulsatilla*, pasque flower. Devil's Dyke, Newmarket, Suffolk. 12 April 1932. [C·E·R]

3 *Helianthemum guttatum*, spotted rockrose. Three Castles Head, Co. Cork. August 1929 [C·E·R]

4 *Scabiosa succisa*, devil's-bit scabious. Goleen, Co. Cork. 13 September 1930 [C·E·R]

5 *Eryngium maritimum*, sea holly. Goleen, Co. Cork. September 1930. [Peg Raven].

6 *Glaucium flavum*, horned poppy. Sandhead, Wigtownshire. 6 August 1931 [C·E·R]

7 *Viola curtisii*, seaside pansy. Ladies Lake, Co. Wexford. 31 August 1938 [C·E·R]

8 *Erica tetralix*, cross-leaved heath. Glen Trool. 14 Aug 1938 [C·E·R]

9 *Centaurea scabiosa*, greater knapweed. Mildenhall, Suffolk. July 1933 [C·E·R]

10 *Chrysanthemum segetum*, corn marigold. No locality or date. [C·E·R]

11 *Pyrola rotundifolia*, larger wintergreen. Ainsdale, Lancashire. 25 July 1942. [C·E·R]

12 *Parnassia palustris* var. *condensata*, Grass of Parnassus. Ainsdale, Lancashire. October 1930 [C·E·R] + var. *palustris* Girvan. 15 August [C·E·R].

13 *Orchis hircina*, lizard orchid. Near Hitchin, Hertfordshire. 30 June 1938. [J·E·R]

14 *Orchis morio*, green-winged orchid. Bottisham, Cambridge. 14 May 1950 [c·e·r]

15 *Orchis ustulata*, dwarf orchid. No locality or date [c·e·r]

16 *Orchis mascula*, early purple orchid. Balsham, Cambridgeshire. 1 May 1946 [c·e·r]

17 *Aceras anthropophorum*, man orchid. Chilham, Kent. 24 May 1948 [c·e·r]

18 *Orchis praetermissa*. Chippenham, Cambridgeshire. 4 July 1938 [c·e·r]

19 *Neottia nidus-avis*, bird's-nest orchid. No locality. 14 May 1947 [c·e·r]

20 *Orchis purpurea*, lady orchid. Chilham, Kent. 18 May 1948 [c·e·r]

21 *Orchis laxiflora*. Grand Mare, Guernsey. 7 April 1949 [c·e·r]

22 *Cephalanthera rubra*, red helleborine. Gloucestershire. 22 June 1942 [?j·e·r]

23 *Orchis militaris*, military orchid. No locality. 4 June 1950 [j·e·r]

24 *Listera cordata*, lesser twayblade. Clen Clova, Angus. 30 June 1942 [c·e·r]

25 *Aristolochia clematitis*, birthwort. Whittlesford, Cambridgeshire. 21 May 1943 [c·e·r]

26 *Astragalus danicus*, purple milk-vetch. No locality or date [c·e·r]

27 *Dianthus deltoides*, maiden pink. Hildersham, Cambridgeshire. 29 June 1940. [c·e·r]

28 *Arabis turrita*, tower rock-cress. St John's College, Cambridge. 23 April 1948 [c·e·r]

29 *Muscari racemosum*, grape hyacinth. Gogmagogs, Cambridgeshire. 22 April 1934. [c·e·r]

30 *Malva moschata*, musk mallow. Nutfield, Surrey. August 1932 [c·e·r]

31 *Lathyrus palustris*, marsh pea. Ranworth, Norfolk. June 1932 [c·e·r]

32 *Delphinium ajacis*, larkspur. Horsell, Surrey. July 1932 [c·e·r]

33 *Primula elatior*, oxlip. ?Hardwick Wood, Cambridgeshire. 7 April 1947 [c·e·r]

34 *Centaurea cyanus*, cornflower. Goleen, Co. Cork. September 1930 [j·e·r]

35 *Galium spurium* var. *vaillantii*. Ely, Cambridgeshire. 7 September 1936 [c·e·r]

36 *Chaerophyllum sylvestre*, wild chervil. Cambridge. 6 May 1946 [c·e·r]

37 *Sanicula europaea*, sanicle. Redhill, Surrey. June 1932 [c·e·r]

38 *Foeniculum vulgare*, common fennel. Cambridge. 23 September 1947 [c·e·r]

39 *Sison amomum*, bastard stone parsley. Ely, Cambridgeshire. July 1933 [c·e·r]

40 *Selinum carvifolia*. Chippenham, Cambridgeshire. 12 August 1945 [c·e·r]

41 *Peucedanum officinale*, sulphur weed. Tankerton, Kent. July 1934 [c·e·r]

42 *Ligusticum scoticum*, Scotch lovage. Lunga Island, Argyllshire. 12 July 1945 [c·e·r]

43 *Meum athamanticum*, meu, spignel, bald-money. Glen Lyon. 5 July 1935 [c·e·r]

44 *Myrrhis odorata*, sweet cicely. Langdon Beck, Co. Durham. 24 June 1935 [c·e·r]

45 *Oenanthe silaifolia*. Hemingford Grey, Huntingdonshire. 1 May 1949 [c·e·r]

46 *Caucalis latifolia*, broad chervil. Lakenheath, Suffolk. 20 July 1950 [j·e·r]

47 *Astrantia major*. Stokesay Wood, Ludlow. 20 June 1940 [c·e·r]

48 *Carduus heterophyllus*, melancholy thistle. Winch Bridge, Teesdale. 25 June 1935 [c·e·r]

49 *Geranium sylvaticum*, wood crane's-bill. Slaggyford, Northumberland. August 1934 [c·e·r]

50 *Trollius europaeus*, globe-flower. Langdon Beck, Co. Durham. 17 June 1941 [c·e·r]

51 *Potentilla fruticosa*, shrubby cinquefoil. High Force, Teesdale. 17 June 1941 [c·e·r]

52 *Primula farinosa*, bird's-eye primrose. Teesdale. 19 June 1947 [C·E·R]

53 *Gentiana verna*, spring gentian. Ballyvaughan, Co. Clare. May 1947 [C·E·R]

54 *Polygonum viviparum*. Teesdale. 24 June 1935 [C·E·R]

55 *Bartsia alpina*, alpine bartsia. Widdybank Fell, Co. Durham. 25 June 1935. [C·E·R]

56 *Vaccinium vitis-idaea*, cowberry. Cronkley Scar, Teesdale. 24 June 1935. [C·E·R]

57 *Vaccinium oxycoccus*, cranberry. Langdon Beck, Co. Durham. 25 June 1935. [C·E·R]

58 *Geranium sanguineum*, bloody crane's-bill. Walney Island, Lancashire. 26 June 1935 [C·E·R]

59 *Geranium lancastriense*. Walney Island, Lancashire. 26 June 1935 [C·E·R]

60 *Carex ustulata*. Ben Heasgarnich, Perthshire. 9 July 1948 [C·E·R]

61 *Cerastium alpinum*, alpine mouse-ear. Ben Lawers. 15 Aug 1937 [C·E·R]

62 *Silene acaulis*, moss campion. Craig Maud, Glen Doll, Angus. 29 June 1942 [C·E·R]

63 *Saxifraga cernua*, drooping saxifrage. Ben Lawers. 2 July 1935 [C·E·R]

64 *Myosotis alpestris*, alpine forget-me-not. Ben Lawers. 2 July 1935 [C·E·R]

65 *Gnaphalium supinum*, dwarf cudweed. Ben Lawers. August 1937 [C·E·R]

66 *Saxifraga nivalis*, alpine saxifrage. Ben Lawers. 2 July 1935 [C·E·R]

67 *Potentilla sibbaldia*, sibbaldia. Sgurr na Lappaich, Inverness-shire. 15 July 1947 [C·E·R]

68 *Veronica fruticans*, rock speedwell. Ben Lawers. 2 July 1935. [C·E·R]

69 *Juncus biglumis*, two-flowered rush. Ben Lawers. 18 July 1945 and 8 July 1948 [C·E·R]

70 *Erigeron borealis*, alpine fleabane. Ben Lawers. 15 August 1937 [C·E·R]

71 *Gentiana nivalis*, small gentian. Ben Lawers. 15 August 1937 [C·E·R]

72 *Convolvulus sepium*, larger bindweed. Newton Stewart, Wigtownshire. August 1931. MER [+C·E·R]

73 *Lythrum salicaria*, purple loosestrife. Near Newton Stewart, Wigtownshire. August 1931. MER [+C·E·R]

74 *Drosera anglica*, English sundew. Glen Trool, Kirkcudbrightshire. 25 August 1934 [C·E·R]

75 *Hypericum elodes*, marsh St John's-wort. Iona. 29 August 1948 [C·E·R]

76 *Rubus saxatilis*, stone bramble. Near Newton Stewart, Wigtownshire. August 1934 [C·E·R]

77 *Mentha longifolia*, horse mint. Bank of River Cree, Newton Stewart, Wigtownshire. 28 August 1936 [C·E·R]

78 *Potamogeton alpinus*. Bruntis Loch, near Newton Stewart, Wigtownshire. 14 August 1940 [C·E·R]

79 *Vicia sylvatica*, wood vetch. Vihti, Finland. 20 July 1934 [C·E·R]

80 *Saxifraga stellaris*, star saxifrage. Snowdon. 30 August 1945 [C·E·R]

81 [*Limonium recurvum* subsp. *humile*]. Mull of Galloway, Wigtownshire [C·E·R]

82 *Erodium neglectum*. Near Sandhead, Wigtownshire. 21 August 1938. [C·E·R]

83 *Inula crithmoides*, golden samphire. Mull of Galloway, Wigtownshire. August 1934 [C·E·R]

84 *Potentilla anserina*, silverweed. Iona. 23 August 1946 [C·E·R]

85 *Epilobium angustifolium*, rosebay. Fittleworth, Sussex. 23 August 1943 [C·E·R]

86 *Tanacetum vulgare*, tansy. Watton, Norfolk. 23 July 1941 [C·E·R]

87 *Allium schoenoprasum*, chives. Brändö, Helsinki. 16 July 1934 [C·E·R]

88 *Sedum telephium*, orpine. No locality or date [c·e·r]

89 *Impatiens noli-me-tangere*, yellow balsam. Grasmere, Westmoreland. 31 August 1937 [c·e·r]

90 *Anthemis tinctoria*, yellow chamomile. [Vihti, Finland]. 21 July 1934 [c·e·r]

91 *Campanula patula*, spreading campanula. Trewyn, Monmouthshire. 23 July 1940 [c·e·r]

92 *Linnaea borealis*, twinflower. Glen Dole, Angus. 4 July 1942 [c·e·r]

93 *Lychnis viscaria*, viscid campion. Glenfarg, Kinross-shire. 3 July 1946 [c·e·r]

94 *Maianthemum bifolium*, May lily. Ken Wood, Hampstead. May 1945. [c·e·r]

95 *Trientalis europaea*. Rannoch, Perthshire. 3 July 1935 [c·e·r]

96 *Sisymbrium irio*, London rocket. Newton Abbot, Devon. 26 August 1946 [c·e·r]

97 & 98 *Daboecia polifolia*, St Dabeoc's heath. Near Westport, Co. Mayo. August 1938 + Ennisfallen, Co. Galway. 19 August 1939 [c·e·r]

99 *Erica mediterranea*, Mediterranean heath. Mallaranny, Co. Galway. June 1938 [c·e·r]

100 *Eriocaulon septangulare*, pipewort. Roundstone, Co. Galway. 25 August 1938. [c·e·r]

101 *Arabis ciliata*, fringed rock-cress. Bunowen, Co. Galway. 15 Aug 1939 [c·e·r]

102 *Erica mackaii*, Mackay's heath. Craigga More, Roundstone, Co. Galway. 27 August 1938 [c·e·r]

103 *Carex limosa*, mud sedge. Altnaharra, Sutherland. 16 July 1946 [c·e·r]

104 *Allium babingtonii*, Babington's leek. Roundstone, Co. Galway. 9 August 1939 [c·e·r]

105 *Hydrilla verticillata*. Renvyle, Co. Galway. 12 August 1939 [c·e·r]

106 *Mentha piperita*, peppermint. Maam, Co. Galway. 16 August 1939 [c·e·r]

107 *Potamogeton coloratus*. Bunowen, Co. Galway. 25 August 1939 [c·e·r]

108 *Osmunda regalis*, royal fern. Roundstone, Co. Galway. 28 August 1939 [c·e·r]

109 *Hieracium alpinum*. Little Craigindal, Aberdeenshit, 17 August 1951 [j·e·r] + var. *insigne*. Glen Einich, Inverness-shire, 25 July 1951 [j·e·r]

110 *Pyrola secunda*, serrated wintergreen. Glen Fee, Angus. July 1942 [c·e·r]

111 *Lychnis alpina*, alpine campion. Meikle Kilrannoch, Angus. 4 July 1942 [c·e·r]

112 *Oxytropis campestris*, yellow oxytropis. Glen Fee, Angus. 27 June 1942 [c·e·r]

113 *Athyrium alpestre*, alpine lady fern. Head of Glen Doll, Angus. 29 June 1942 [c·e·r]

114 *Salix myrsinites*, whortle willow. Craig Maud, Glen Doll, Angus. 29 June 1942 [c·e·r]

115 *Astragalus alpinus*, alpine milk-vetch. Craig Maud, Glen Doll, Angus. 29 June 1942 [c·e·r]

116 *Epilobium alsinifolium*, chickweed willowherb. Glen Clova, Angus. 30 June 1942 [c·e·r]

117 *Betula nana*, dwarf birch. Loch Esk, Glen Clova, Angus. 1 July 1942 [c·e·r]

118 *Carex alpina*. Glen Fee, Clova, Angus. 29 June 1951 [c·e·r]

119 *Rhinanthus drummond-hayi*. Caenlochan, Angus. 20 July 1947 [c·e·r]

120 *Pyrola media*, intermediate wintergreen. Near Milton, Glen Clova, Angus. 8 July 1942 [c·e·r]

Acknowledgements

It remains to the editor to thank those who have allowed this book to become a belated reality.

First and foremost, Faith Raven, who has carefully looked after the drawings and manuscripts and has already taken great efforts to bring to light unpublished material of her late husband. Several memorable hours were spent in the dusty Docwra's attic among the archives and collections of Charles and John. From E.M. Forster's copy of Bauhin's *Historia Plantarum*, to the remnants of Charles's oological and osteological collections, his photographs and drawings of birds, the reserve collection of the British plant drawings, evocative family photographs, and even Charles's aunt Eleanor Comber's paintings of plants made as a missionary to the blind in South Africa. Some of these have helped to enrich this book.

Second, John's and Faith's daughter Sarah, and her husband Adam Nicolson. The drawings are now kept at Sissinghurst, and their generosity in allowing me to stay in the South Cottage while cataloguing the collection and making the selection for this book was an unforgettable experience. Sleeping in Vita's bed, working at Harold's desk, and waking at three o'clock one morning to a scene that Charles would have described as 'faery' – a freezing November fog diffusing the light of an almost full moon, and the privilege to wander around a garden peopled by a sinister quartet of inky columnar cypresses that seemed to be being wooed from beyond the pale by a pair of more rangy, feral Lombardy poplars.

I have also greatly benefitted from conversations (or emails) from Caroline Beamish, Mary Raven, John Saumarez Smith and Peter Sell. Clare Brown of Lambeth Palace library kindly provided information on the Helsinki conference, and John Akeroyd on *Rumex arifolius*. Thanks are also due to the late Helen Lamb who made a typescript from the manuscript chapters written by Charles and John.

The Edinburgh Botanic Garden (Sibbald) Trust kindly provided a grant towards the cost of publication.

Lastly, Robert Dalrymple for his work on this, our fifth collaboration: once again his instinctive feeling for image and text has – seemingly effortlessly – allowed him to come up with a near ideal vehicle through which to show the work of a remarkable father and son to its best advantage.

H.J.N.

Further Reading

CHADWICK, O. (2004). Raven, Charles Earle (1885–1964) in *Oxford Dictionary of National Biography* (eds H.C.G. Matthew & B. Harrison) 46: 118–120. Oxford: Oxford University Press.

DAVID, R.W. & SELL, P.D. (1981). John Earle Raven (1915 [sic] – 1980). *Watsonia* 13: 244 – 246.

DILLISTONE, F. W. (1975). *Charles Raven: naturalist, historian, and theologian*. London: Hodder & Stoughton.

JAFFÉ, M. (ed)(1974). *Botanical Drawings from the Broughton Collection*. Cambridge. Ftizwilliam Museum. [Note. This includes an introductory essay by John Raven; there are shorter ones by him in the similar catalogues from 1976 ('Gardener's Pride'), 1977 ('Roses, Roses ...') and 1979 ('Men versus Women')].

JAFFÉ, M. (ed)(1981). *British Flower Drawings*. Cambridge. Fitzwilliam Museum. [Includes notes on 14 drawings by Charles and John Raven].

LIPSCOMB, J. & DAVID, R.W. (eds)(1981). *John Raven by his Friends*. Privately published by Faith Raven, Shepreth.

MARTIN, W. KEBLE (1938). *Over the Hills* London: Michael Joseph.

PORTER, R. (1996). The two cultures revisited. *Boundary 2* 23: 1–17.

RAMSEY, I.T. (1965). Charles Earle Raven 1885–1964. *Proceedings of the British Academy* 51: 467–484.

RAVEN, C.E. (1925). *In Praise of Birds: pictures of bird life, described and photographed*. London: Martin Hopkinson & Co. Ltd.

RAVEN, C.E. (1927). *The Ramblings of a Bird Lover*. London: Martin Hopkinson & Co. Ltd.

RAVEN, C.E. (1928). *A Wanderer's Way*. London: Martin Hopkinson & Co.

RAVEN, C.E. (1929). *Bird Haunts and Bird Behaviour*. London: Martin Hopkinson & Co. Ltd.

RAVEN, C.E. (1931). *Musings and Memories*. London: Martin Hopkinson & Co. Ltd.

RAVEN, C.E. (1942). *John Ray Naturalist: his life and works*. Cambridge: University Press.

RAVEN, C.E. (1947). *English Naturalists from Neckham to Ray: a study of the making of the modern world*. Cambridge: University Press.

RAVEN, F., STEARN, W.T., JARDINE, N. & FRASCA-SPADA, M. (eds)(2000). *Plants and Plant Lore in Ancient Greece* [lectures by J.E. Raven]. Oxford: Leopard's Head Press.

RAVEN, J.[E.] & WALTERS, [S.]M. (1956). *Mountain Flowers*. London: Collins

RAVEN, SARAH (2011). *Wild Flowers*. London: Bloomsbury.

SABBAGH, K. (2000). *A Rum Affair: the exposure of botany's 'Piltdown Man'*. London: Penguin Books.

SAUMAREZ SMITH, BETTY (2009). *Childhood Memories*. Privately published.

Index of Plant Names

Modern names are shown in [square brackets] after the names employed by the Ravens. Page numbers in **bold** refer to illustrations.

gromwell, blue 123

Habenaria albida [*Pseudorchis albida*] 64
— *conopsea* [*Gymnadenia conopsea*] 64
— *intacta* [*Neotinea intacta*] 65, 68, 163
hare's-ear, slender 98
hartwort 104
hawkbit, autumnal 136
heath, Cornish 100
— Dorset, 123
— cross-leaved **49**, 52, 83
— Mackay's **163**
— Mediterranean **161**
— St Dabeoc's 35, **160**, 161, 163
heather, bell, 86
Helianthemum chamaecistus [*H. nummularium*] 139
— *guttatum* [*Tuberaria guttata*] 43, **44**, 153
hellebore, green 64
— stinking **40**, 55
helleborine, narrow 65
— red 71, **72**
— white 64
Helleborus foetidus **40**, 55
— *viridis* 64
hemlock 94
hemp-nettle 86
Heracleum sphondylium 92
herb paris 55
Herminium monorchis 64, 82
Hieracium alpinum **170**, 183
— *opsianthum* **28**
— *raveniorum* 30
— *scoticum* **29**
hogweed 92
horsetail, great 86
Hottonia palustris 86
Hutchinsia petraea [*Hornungia petraea*] 103
hyacinth, grape 80, **82**
Hydrilla verticillata 163, 165, **166**
Hydrocharis morsus-ranae 86
Hydrocotyle vulgaris 94
Hypericum elodes **132**, 135

Impatiens noli-me-tangere [*I. noli-tangere*] **146**, 147
Inula crithmoides **140**
— *salicina* 157, 160, 201
Iris pseudacorus **14**
Isoetes echinospora 136
— *hystrix* **8**
— *lacustris* 136

Jasione montana 52
Juncus alpinus 110
— *capitatus* 32
— *biglumis* **125**
— *bufonius* 141
— *bulbosus* 136
— *castaneus* 123
— *maritimus* 141
— *squarrosus* 136
— *trifidus* 24, 182
— *triglumis* 125
juniper, Siberian 161
Juniperus nana [*J. communis* subsp. *nana*] 161

knapweed, greater **50**, 53
knotgrass (Ray's) 141
Koenigia islandica 31, **32**

lady's tresses 52, 64
lady's-mantle, alpine 119
Lamium purpureum 53
larkspur 82, **84**
Lathraea squamaria 73
Lathyrus palustris **83**, 86
— *tuberosus*: frontispiece
lavender, sea 139
Ledum palustre [*Rhododendron tomentosum*] 151
leek, Babington's **164**
— sand 108
Leontodon autumnalis var. *pratensis* [*Scorzoneroides autumnalis* var. *pratensis*] 136
Lepidium ruderale 88
lettuce, alpine 171, 179
Ligusticum scoticum 95, **98**, 141
lily, Snowdon 113
Limnanthemum nymphaeoides 86
Limonium humile 139
— *recurvum* subsp. *humile* **138**, 201
Limosella aquatica 136
Linaria vulgaris 53
ling 52, 82
Linnaea borealis 47, 150, **151**, 173, 176, 181
Linum perenne 80
Liparis loeselii 68, 78, 82, 95
Listera cordata [*Neottia cordata*] 67, 71, 73, **74**, 179
— *ovata* [*Neottia ovata*] 64, 67, 73
Lithospermum purpureocaeruleum 123
Littorella uniflora 136
Lloydia serotina 113